LIVING THROUGH POP

We are all 'living through pop'. In 1956 many people thought rock 'n' roll was a passing fad, yet over forty years later pop music is more than ever a part of contemporary culture, reinventing itself for successive generations. Pop embraces its own history, with musicians and bands from every genre routinely sampling the sounds of the past, cutting them back into the present.

Living Through Pop explores pop's history and the ways in which it has been produced by musicians, broadcasters, critics and fans. For Britpop bands and many of their fans, the music that inspired them was history, lived at second-hand. Celebrating the contemporary diversity of popular music, contributors discuss a wealth of genres and significant moments in pop music history, from the Rolling Stones and the Velvet Underground through the Sex Pistols and Kula Shaker.

Refuting any simple correlation between taste and age, contributors demonstrate how pop fans can now identify with multiple genres simultaneously, and explore the diversity of contemporary pop music, from French rap culture to the meaning of the Spice Girls.

Andrew Blake is Head of the School of Cultural Studies at King Alfred's College, Winchester.

LIVING THROUGH POP

Edited by Andrew Blake

Routledge
Taylor & Francis Group

London and New York

First published 1999
by Routledge
11 New Fetter Lane, London EC4P 4EE

Simultaneously published in the USA and Canada
by Routledge
29 West 35th Street, New York, NY 10001

Routledge is an imprint of the Taylor & Francis Group

Typeset in Galliard by Routledge
Printed and bound in Great Britain by Clays Ltd, St Ives PLC

British Library Cataloguing in Publication Data
A catalogue record for this book is available from the British Library

Library of Congress Cataloguing in Publication Data
A catalogue record for this book has been requested

ISBN 0–415–16198–3 (hbk)
ISBN 0–415–16199–1 (pbk)

CONTENTS

CONTENTS

CONTRIBUTORS

Imruh Bakari is an independent film-maker who teaches Film Studies at King Alfred's College, Winchester. He is the author of several influential articles on African-Caribbean film and music, and co-editor of the 1996 BFI volume *African Experiences of Cinema*.

Tim Barnes works in music retail in London, and promotes parties at which he DJs. In the downtime from these activities he is working on the definitive history of the Rolling Stones.

Andrew Blake teaches Cultural Studies at King Alfred's College, Winchester. A musician in the 1980s, he has since written books on fiction and sport, and two on music. The second of these, *The Land Without Music. Music, Culture and Society in Twentieth Century Britain* was published by Manchester University Press in 1997.

Jude Davies teaches American Studies at King Alfred's College, Winchester. He has written on punk, and British and American television and cinema. His book, *Diana in the Eyes of the Nation: Constructing the People's Princess*, is published by Macmillan in 1999.

Jeremy Gilbert teaches Cultural Studies at the University of East London and at Sussex University, where he is working on a cultural and political theory of contemporary 'post-political' youth cultures. He is a member of the Editorial Board of the journal, *New Formations. Discographies: Dance/Music/Politics*. This promises to be the definitive volume on the rave decade, and is also published by Routledge in 1999.

Steve Hawes has worked as a journalist, and as a television and film producer for Granada in Britain and DUNE in France. He is currently Head of Community and Performing Arts at King Alfred's College, Winchester.

Rupa Huq is research assistant in youth cultures, education and ethnicity at Manchester University. She is a widely experienced journalist. Among her publications is 'Asian Kool? Bhangra and Beyond', in the 1996 Zed volume, *Dis-Orienting Rhythms. The Politics of the New Asian Dance Music*.

James Ingham was inspired by the early rave scene to explore the relationship between sound and space. Working at the University of East London, he is producing a 'sonic geography', an integrated model of the spatialisation of sound to be used within geographical studies.

Alexei Monroe is based at the School of Arts and Image Studies at the University of Kent, Canterbury, and is working on the Slovene 'industrial' group Laibach and the Neue Slowenische Kunst collective. Besides the cultural politics of Slovenia and ex-Yugoslavia, his research interests are based around the theorisation and production of industrial and electronic music. He writes for the Slovene music magazine *Muska*.

Ben Watson is a freelance journalist and broadcaster who rose to fame with the publication of *Frank Zappa, the Negative Dialectics of Poodle Play* (1993), which was followed by *Art, Class and Cleavage* (1997), both published by Quartet, and by the less rebarbative Omnibus publication, *The Complete Guide to the Music of Frank Zappa* (1998). He writes regularly for *The Wire* and *HiFi News*.

PREFACE

> Time no longer flows in a linear fashion; sometimes it crystallises
> in stable codes in which everyone's composition is compatible,
> sometimes in a multifaceted time in which rhythms, styles and
> codes change...and rules dissolve.[1]

Pop lives through history, and we live and relive ourselves through it. As do our parents, and our children. But it is all tangled up. The music of youth has become the music of life-style and life-time. From the global success of Elvis Presley in the 1950s, through the Beatles in the 1960s and Michael Jackson in the 1980s, to the Spice Girls' chart monopoly of early 1997, an Anglo-American form has been created, subdivided into genres, subgenres and microgenres, and sold to the world. It is an inescapable part of contemporary culture, massively influential in all kinds of leisure practices. Pop pervades our social selves; we live through pop. Four examples:

1 In June 1996, Angela McRobbie, an academic in her forties, wrote an article discussing her dream-fantasy that she was 'going out with' Noel Gallagher of Oasis, a Mancunian band whose intergenerational success made them the British band of the first half of that year (the Spice Girls dominated the second half).[2] Oasis, leaders of a pack of bands conveniently grouped together by the media under the name 'Britpop', unashamedly recycle the music of the mid-1960s, especially the Beatles. McRobbie, looking back to another aspect of a vanished age, commented that Oasis stood for the preservation of the craft values of working-class masculinity in the music business, one of the few remaining male-dominated industries.

2 In the autumn of 1996, a new line-up of the band Spirit recorded an album, *California Blues*. The band first toured Europe in 1968 (supporting Led Zeppelin); on one 1977 tour they were supported in their turn by the pre-successful Police. In the Spirit's latest incarnation were guitarists Randy California (the band's founder) and Matt Andes, both in their forties; the 73-year-old drummer Ed Cassidy; and as vocalist Andes's daughter Rachel,

ix

aged 16. Randy California's death in a swimming accident early in 1997 cancelled the band's scheduled 1997 tour.[3]

3 In May 1997, a new British Prime Minister, Tony Blair, entered his official residence at 10 Downing Street. In his early forties – and therefore a member of a generation that has lived through pop – he took his Fender guitar with him, and his publicity department ensured that the guitar's entry to political power was as widely photographed as its owner.

4 Later in 1997, the BBC produced a charity pop single and video in which they assembled a galaxy of musicians working in classical and light music, jazz and pop, each performing, sequentially, a few seconds of the same song – Lou Reed's 'Perfect Day'. The song had been featured in the film, *Trainspotting*, where it formed part of a music-video sequence that represented one aspect of the junkie's experience. This hymn to heroin, sung by artists ranging in age from their early twenties to their late fifties, became a number one single. Immured to the presence of pop, no one seemed to notice the song's recent meaning....

The music that started as a supposedly brief teenage fad, rock 'n' roll, has stayed the course, and its performers, audiences and critics have grown with it. Pop (especially in its 'rock' derivative) has made 'history' in the schoolbook sense, playing its part in revolutions and other political moments such as the failure of the Americans in Vietnam or their successful siege of General Noriega in Panama, and indeed in the fall of communism in and after 1989,[4] but it is more important for its cultural presence across three generations – a presence that tells one of the most important stories of the last half century. From the viewpoint of post-colonial Britain, the story has physical and ethical components. Pop has loosened us up, changed what we are, how we can be, how we want to be. Playing its part in the long narrative of the twentieth century, the diaspora of African-derived cultures in their American, Latin, Caribbean and British forms, pop has serviced new languages of the body and desire; yet at the same time, waves of new technology have serviced pop – technologies that have the potential to displace the body altogether. Pop is anti-humanist, and although much of it has been and is Anglo-American, it has devastated the Western sense of self. As Ian MacDonald has recently argued of the Beatles, pop's history is part of a massive cultural shift, a 'revolution in the head' that has moved the perceived centre of life from the social to the personal.[5] We would only emphasise that there has also been a revolution of the body, changing the ways in which desires and pleasures are expressed. Constantly mutating, fragmenting, and redrawing its own boundaries, pop has undermined the sense of stable development that Europe and North America, their individuals, nation states and cadet civilisations took for granted a hundred years ago. Pop has thrown fuel on to the Bonfire of the Vanities,[6] celebrating all and anything that is not subject to rational, bureaucratic Western masculinity.

The contributors to this book explore these themes, the head and body revo-

lutions from the 1960s to the 1990s, the ethnic, gendered and generational interactions that have become a companion to the Black/White dialogues that created rock 'n' roll and which in turn brought forth pop as we know it. The book is dedicated to anyone, anywhere who has lived through pop.

Notes

1 J. Attali (1985) *Noise*, trans. B. Massumi, Manchester: Manchester University Press, p. 147.
2 A. McRobbie, 'Lads of Hope and Glory', *The Times Higher Education Supplement* 16 August 1996.
3 P. Perrone, 'Randy California' (obituary), *Independent* 17 January 1997.
4 See Lou Reed's essay on his own part in this, 'Interview with Vaclav Havel', in H. Kureishi and J. Savage (eds) (1995) *The Faber Book of Pop*, London: Faber & Faber, pp. 696–709.
5 See I. MacDonald (1994) *Revolution in the Head. The Beatles' Records and the Sixties*, London: Fourth Estate.
6 I refer to Tom Wolfe's great novel: *The Bonfire of the Vanities*, London: Jonathan Cape, 1988.

ACKNOWLEDGEMENTS

Rebecca Barden and Christopher Cudmore at Routledge, and their anonymous readers, have been very helpful in putting this volume together; as have Scarlett Thomas, Colin Zetie and John Parham. A version of Chapter 4, 'Making Noise: Notes from the 1980s' was published in *Popular Music and Society* vol 21, no. 3 (fall 1997). The current version is printed here with the permission of Bowling Green State University Popular Press.

The publisher, editor and contributors have made every effort to trace the holders of copyright in any work reproduced. If any proper acknowledgement has not been made, we kindly invite copyright holders to inform us of the oversight.

INTRODUCTION

What's the story?

Andrew Blake

The mid-1990s moment of 'Britpop' produced an abiding revaluation of a troubled word, 'pop'. Nonetheless, as this introduction to the debates and the work of the various contributors will show, the meanings of pop, as of music in general, are widely contested, and it is a purpose of the book to sharpen our sense of the many things we mean by pop.

One of the happier effects of that celebration of Britpop was precisely its use of 'pop' to label a music that everyone agreed at the time was of great cultural significance. Thanks to that moment, it is easier to do as the contributors to this book do, and take 'pop' as the overall term for popular music since rock 'n' roll. Even that most serious of bands, U2, used the name *Pop* for their 1997 album. Some, such as Ben Watson, still feel that pop is a negative term, a commodity category associated with the rankly commercial mass product, rather than the carefully tailored outcome of a taste profoundly shared between audience and musicians; yet there is no easily available alternative. Certainly the word 'rock', which would once have been put forward as a less commercial alternative, has lost its aura of authentic expressivity. The very workings of the music business have rendered this kind of distinction between the commercial and the authentic insupportable. In a market whose geo-demographic assumptions about its potential audience depend on precisely the kind of segmented taste that requires 'rock' and other terms to function as sales categories, the word pop remains inclusive.

Pop, in this widest sense, forms the basis of the near-constant aural experience that accompanies us in shops and bars, in transit lounges and cars, and in the broadcast media. Advertising and the public relations media have used pop in the selling of people, ideas and more traditional commodities like jeans and cars. *We are saturated with pop; but we are not yet sated*. The microchip's rhythms pervade our senses, as we move towards a promised virtual future, providing us with both dance music and beeping consumer electronics. But even as an agreed actuality is replaced with a screen-based informationality, an increasingly desperate, and increasingly personalised, search for the authentic takes place – and newly 'authenticated' musical forms using conventional

1

instruments, chords and lyrical ideas, such as Britpop, haunt the airwaves. In both past and future forms, pop remains naggingly pervasive, in the mall and the stadium, in the market and the festival field.

Perhaps this would be easier to deal with if there were a simple, linear history – a narrative of change and development, of 'progress'. There never has been. Even when this seemed to be the case, as in the later 1960s when it appeared that a set of simple pop forms had been superseded by what its adherents saw as the more complex, emotionally mature and intellectually respectable 'rock', pop's death had in fact been grossly exaggerated, and throughout the 1970s forms like glam, punk and disco, in their very different ways, offered a refusal of those 'progressive' values. At the turn of the millennium, as music employing only computerised information coexists with music relying on real-time human performance (and neither can be said to be dominant), there is no unilinear history, nothing of which a story of 'progress' could be made. Techno, apparently, refuses history even as it refuses orthodox notions of musical narrative (through lyrics or harmony); it merely repeats itself, within a given number of bass drum pulses per minute. But musics that might appear more historically aware, such as British guitar pop and its equivalents elsewhere – the music of the Fugees, say – refuse history just as obstinately, by locating themselves at an agreed point of origin (usually the music of the 1960s). By refusing any sense of narrative, or by adopting, nostalgically, the signs of a musical past, such forms inhabit a world in which change cannot happen, and repetition is the only remaining value. New music repeats itself immediately and *ad nauseam*, new bands play old music – and meanwhile old bands such as the Rolling Stones or the Sex Pistols (who reformed in 1996 for a cash-in tour and album) play their old songs, or new songs that sound very like the old ones. Radio stations targeted at an older audience provide a vehicle for old bands, even as younger-targeting radio stations search anxiously for some sort of innovation that will keep their audiences interested (but often end up by playing music by younger but similar-sounding bands).

And yet there *is* a history here, a history through which music changes, constantly mutating within and against the contextual frames of the beliefs and practices of musicians, dancers and fans, and the financial and technological structures of the music business. Among the most important of these mutations is the ageing of the fan base: the rock 'n' roll generation, the Merseybeat generation, the Woodstock generation, the punk generation, and so on. These words are being written in late 1998, twenty-one years since the Sex Pistols' 'God Save the Queen' spat forcefully at the popular celebration of Queen Elizabeth II's Jubilee Year; 1998 is the tenth anniversary of the 'second summer of love', in which many people lived through late adolescence, or their twenties, to the sounds of acid house, with the considerable help of the drug Ecstasy. Neither punk nor acid house, nor their original fans, have vanished, though they have grown older; those two moments of upheaval are among the focal points of this book.

Steve Hawes recalls the moment when he and a number of other liberal university graduates working in television looked at each other appalled (but remained true to their liberalism) while the entrepreneurial Tony Wilson persuaded them to run the first series of punk television showcases, on Granada Television's *So It Goes*. He draws attention to the complexities involved in the production and broadcasting of taste – a set of problems on which Rupa Huq also reflects in her account of the rap scene in France, and Jeremy Gilbert in his account of a lived relationship with the sounds of a band important in the long pre-history of punk, the Velvet Underground.

Punk already has a complex historiography of sources (sonic and visual texts), and scholarly commentary, juxtaposed against the memories of partici-pants and the evolving musics and cultures of those who see themselves as punk's inheritors. These include bands that play a recognisably punk or post-punk music; but punk's DIY/small-label ethos also informs the most successful of the outstreams of recent pop, the dance forms of the acid house generation, which at first hearing seem lost to history. The dance musics of the last decade are in fact deeply historicised: compilations of tracks which can be historically located by reference to their sounds, tempos and the clubs that promoted them are already serving a market for rave nostalgia, fuelled by a number of books published in celebration of the dance decade.[1] Alexei Monroe, who writes here on European extreme techno, told me that, early in 1997, many clubs in Berlin were playing a historicised music – the techno of *c.*1992, a moment when Berlin was fully, and arguably more happily, involved in the first wave of post-cold war reconstruction, but the economic and social costs of this process had not yet become fully visible. In entering such a club, the good citizens of Berlin can re-experience their own times, an experience as profound as that offered by the Rolling Stones or Eric Clapton, or by the stars of Britpop, to the generations who were teenagers when those musics were new in the 1960s and 1970s.

Dance music is often associated with a loss of conventional memory, an ecstatic suspension of the usual norms of identity. James Ingham points out that for a dance event to work satisfactorily, the audience must, in fact, be able to recognise and respond to its favourite tracks and patterns: memory cannot disappear altogether. Reflecting on his own experience of living through the brief moment of the Blackburn warehouse parties, he investigates the archae-ology of their sound, illustrating how 'acid house', a music that was thoroughly imbued with a sense of the perpetual present, was brought into being by its sonic and cultural past – in the sonic transformations of the Black, gay club environments of Chicago, and Jamaica's dub studios. In a complementary argu-ment Imruh Bakari, in analysing the traces of a jazz aesthetic in African-American and African-Caribbean music, locates their outcome in the music of contemporary Black British musicians such as Courtney Pine and Roni Size. Alexei Monroe, while delineating the minutiae of a contemporary dance music scene that seems to evolve too quickly to be located via such careful historical referents, also acknowledges the traces of history in the technologies

and modes of musical construction within which the dance audience's mode of suspended being can achieve its collective ecstasy.

It would be perhaps too easy to take this argument, alongside those of Jude Davies on the Spice Girls and Rupa Huq on French rap, and underline the importance of pop as an index of changing identity in the late twentieth century. We would end up with something like subcultural theory, which tends to describe relatively fixed generational identities that can be read off from a grid of stylistic taste in dress, music and leisure pursuits. This may still be possible, but what is clear from this book's contributors is the *absence* of any fixed sense of taste and identity. The dual location of many of the contributors' interests (Tim Barnes, Rupa Huq and Jeremy Gilbert) in both rock and rave seems to indicate a fluidity of choices and knowledges far from the inhibited and anxious world of the subcultural fashion victim. Music-related identities can be and are inhabited multiply and simultaneously. Pop's fragments, and its histories, are drawn on unpredictably to form a myriad of collective taste publics, coming together for certain moments – a sharing which at one extreme forms the Temporary Autonomous Zones identified by Hakim Bey, and described here by James Ingham.

This flexibility makes any potential pop politics (such as the 'identity politics' celebrated in much subcultural commentary) a matter of temporary, specific alliances based on unpredictable moments – such as the opposition to the 1994 Criminal Justice Act's draconian attempts to control parties, or the parallel collective opposition to the imprisonment of French rap group NTM noted by Rupa Huq. This is the politics of chaos theory, not of linear causality, and needs an appropriate language well beyond the orthodox sociological languages of class, ethnicity and gender as predictable and isolatable categories.

Such a politics would also need – indeed, contemporary culture desperately needs – a new conceptual framework for relating culture and age. One of the tragicomic tendencies within cultural studies is its attempt to conflate 'youth' with 'resistance'; to rediscover the politics of class opposition within the antics of the young. Rupa Huq's chapter demonstrates both that this has some relation to the lived conditions of the suburbs of the French cities and their rap music, *and* that an anti-police attitude is a rhetorical position within which routinised oppositional gestures can be used to sell mainstream pop commodities. As Ben Watson complains in his typically polemical chapter, pop made by the young, *including* that rhetoric of resistance, is often seen to be a routine part of the structuring of youth – and therefore written off as an aspect of (pre)adolescence. Jude Davies considers the ways in which this relationship has been innovatively reworked in the early careers of the Spice Girls, among whose target audience was prepubescent girls.

But there is no longer (if there ever was) a predictable relationship between musical taste and age – indeed, this is one of the starting points for this book. In a 1993 survey of thirty students taking a course in popular music studies at the University of East London, eleven claimed the Rolling Stones as a major

favourite. The average age of those eleven was 23; none had been born when the Stones had their first chart success. One of that course's graduates, Tim Barnes, whose own music-making is as a techno DJ, contributes here an assessment of the 1960s Rolling Stones, which argues that their *sound*, rather than their behaviour, was their most distinctive contribution to the 'loosening' of the cultural construction of Whiteness that marked the general take-up of Black American music and style in that decade.

The place of both the beat boom and punk in loosening the formal structures of belief in Western cultures away from deferent social values and towards an individualised hedonism is undoubted. However, many young White men rejected the loss of power implicit within this loosening. Jeremy Gilbert, celebrating the Velvet Underground, notes their appeal to the thin White boys of suburbia who, suited and groomed, are even now influential in the British New Labour Party. The Velvets' polyiconic position includes some responsibility for the 'indie' and 'grunge' rocks of the Anglo-American dialogue. Jeremy Gilbert relates the Velvets and their musical fluidity to an aspect of the theorised decline of Western hegemony, the 'deconstructionist turn' of Jacques Derrida. His account is marked by his astonishment at the entrenchment, what could be called the *reconstruction*, of the music of 'indie' rock. Britpop's success has given mainstream exposure to the anorak-indie tendency which was a comparatively peripheral component of the music scene in the late 1980s. This is in part a product of the music business's talent scouts, usually White males with a college background and a preference for live-performance rock over other musical genres – people with similar tastes to the early-1970s graduates, trying to defend rock values against punk, described by Steve Hawes.[2] While the dance revolution was in full flow, and while British ragga, hip-hop, soul and swingbeat remained on the fringes of pop success (as did the musics described by Imruh Bakari), the men in the music business helped to turn some existing 'indie' acts – such as Pulp, a band which was already a decade old in 1993 – into the bright young hopes of Britpop.

Many of these scholars are reconstructing a past through knowledges other than direct experience. They share a musical past that hasn't been personally lived, but for which they have a strong sense of ownership – they are working with a view of pop that has quite simply been unavailable to previous generations. Pop is now unimaginable without this sense of shared and relived history; in France, for example, as Rupa Huq points out, both orthodox pop and rap are constantly connected to literary and musical precedent. For Imruh Bakari, all this still adds up to one of the grandest, if most tragic, narratives of modernity – the African diaspora, its cultural appropriation and its transformative possibilities; like Ben Watson and Steve Hawes, he sees jazz as the paradigm of diasporic popular music, and thus draws away from any celebration of any music that he sees as closely tied to the operation of capital.

There is, on the other hand, no universal acknowledgement or awareness of pop's past. The journalist and musician David Toop has described an encounter

between Steve Hillage, of progressive rock band Gong and dance outfit System 7, and the Orb's Alex Patterson. Hillage introduced himself to Patterson, who was using a 1960s Gong sample. Patterson did not realise this, or who Hillage was, despite the fact that they were signed to the same label.[3] Pop's history here is being lived subliminally, through the semi-conscious manipulation of past sound into present music. And yet there are also signs of a more deliberate and aware historicisation working within dance music. Using the theoretical emphases of Jacques Attali, I interpret the work of the Art of Noise, my own band Man Jumping and others in the mid-1980s, as demonstrating the importance of repetition, in a framework established by previous dance music, and by the possibilities – the noisy/disruptive possibilities – of the new technologies of sampling and sequencing. Alexei Monroe's chapter reports on post-techno musics that can stabilise themselves (if only momentarily) by reference to an electromechanical past of analogue synthesisers and drum machines. Repetition here (the repetition of certain familiar *sounds* such as the Roland TR808 cowbell) has a historicised value, opening a Utopian memory to a better past time – even if that time was 1992 and the listener/dancer's hedonistic and optimistic late teens, rather than her unemployed immediate future.

Writing through pop

Monroe also points out, however, that any notion of scholarship in this fluctuating world of white labels, microlabels and remixes is impossible: too much product is released for any single person to be able to hear it all. The same could be said of music from almost any genre. A similar flood of information helped, at the end of the nineteenth century, to create academic history and literary study, as the late Victorians attempted to *select*, and produce, *value*, from the unknowable sea of publications that surrounded them. The young graduates of Steve Hawes's generation, attempting this, produced a set of values that were simply too limited and exclusive to function in a living culture. Something both more encyclopaedic and more genuinely critical was needed than this rock-centred taste. To this end, the 1990s have witnessed a deluge of companions to pop's history. Pop scholarship, in the very basic sense of lists of records and chart positions, such as the *Guinness Book of Hit Singles*, has been around as long as pop itself. Useful companions for DJ, journalist and fan, they were inclusive, offering nothing of selection and valuation. More recent products have taken two forms that signal a greater anxiety to order knowledge. First, there have been a plethora of encyclopaedic guides, offering alphabetical entries covering forms and performers.[4] Some of their function has been archaeological (e.g. the many mid-1990s books on women musicians,[5] which are recovering work that has been hidden from history). Much of this encyclopaedic tendency, however, has to do with the construction of a canon – all these books include as well as exclude, and all allocate praise or blame to particular acts, particular albums and so on. They select; they produce value.

Here, for example, are a few key editorial sentences from one of these encyclopaedias, the *Rough Guide to Rock*:

> We wanted a book with its feet firmly in the present, and one that gave at least as much space to Indie/Alternative groups as to the MTV/radio establishment. But we also wanted a book that reflected rock's history, and might introduce new audiences to enduring or seminal figures from decades past. So we made decisions to include key rock 'n' roll, R&B, Motown and soul musicians – people who retain an influence in the rock world. And we decided to fade in and out of hip-hop, rap, dance, techno and country areas, again focussing on bands exerting a rock influence or with a rock audience.[6]

The result is an eclectic mix of ins and outs; it is also a canon – a proposed valuation of the entire history of this Anglo-American genre. And as the almost throwaway inclusion of 'R&B, Motown, and soul' reveals, this is a canon that makes a welcome attempt to reveal, rather than hide, the connection of 'MTV/radio establishment' rock with Black American, and contemporary dance, musics: an act of interpretative bravery that puts an interesting gloss on their claim that 'there's nothing academic about rock'.

Rough Guide contributors would no doubt consider themselves fans or journalists. Or both. We live through pop; we also live through pop journalism, seeking through its texts valorisation or contestation of our own opinions. Throughout pop's history journalism has been a companion to the music. Newspapers routinely incorporate pop criticism; lifestyle magazines vie with dedicated music magazines in the breadth of their coverage – and indeed at the time of writing threaten to replace them. While magazines such as *Smash Hits* continue to present current pop for teenagers, one continuous development has been the concern with the canon; two British magazines, *Q* and *Mojo*, spend most of their time on established, older acts. The developing history of pop journalism has been incorporated in a number of collections of essays, from the solo volumes produced by Tony Parsons and Nick Kent[7] to several heavyweight anthologies.[8] Here, the canon is subtly transformed as attention wanders from the musicians and focuses instead on the 'writer' and his/her experiences and/or prose style. The cover of one anthology announces proudly that '*Love is the Drug* travels with nearly a score of famous rock writers through the back pages of their rock 'n' roll past'.[9]

It's only a small step from that self-regarding moment in which 'living as a pop fan' is subtly transformed into 'living as a writer' to the pop novel; and sure enough the early 1990s saw a new efflorescence of that justly neglected form. One aspect of this phenomenon was the rise and rise of Irvine Welsh, one of the earliest explorers of the experience of 'the chemical generation' (his work – especially *Trainspotting*, thanks to its subsequent filming – is often taken as a documentary record of this experience). Another tendency, although based in

the same realist mode, added the self-deprecating humour of bourgeois masculinity in crisis. Building on Nick Hornby's success in *Fever Pitch*, a whimsical, semi-autobiographical exploration of life as a soccer fan, a number of writers explored their whimsical selves in relation to various other sports, while Hornby and Hanif Kureishi produced novels about living through pop. Hornby's *High Fidelity*, in which the author's record collection is substituted for the previous novel's football season ticket, steps lightly through the undiscovered territory of male heterosexual comic-romantic fiction. Kureishi, a non-White, non-heterosexual suburban, explores in *The Black Album* the relationship between a student and a lecturer in cultural theory whose interests include post-structuralism and Prince, and who uses the latter's music to teach the former.

This is on interesting territory, acknowledging that pop has gone beyond pop. Cultural theory has dealt with pop for a generation *not* because academics like to play the anthropologist, observing and analysing the Other from a safe distance (though Sarah Thornton's *Club Cultures*,[10] referred to here by Jeremy Gilbert, is a recent reminder that such an approach remains possible), but because *cultural theorists themselves have lived through pop*. The ideas of Roland Barthes, Guy Debord, Michel Foucault, Jacques Derrida, Jean Baudrillard, Gilles Deleuze and Felix Guattari are the theoretical applications of the pop generations, guiding many of the insights in this volume – and helping to generate some of the music. Malcolm McLaren's use of 'situationism' in his manipulation of the Sex Pistols is well known, and is one justification for Jon Savage's heavily theorised account of those events in *England's Dreaming*. Alexei Monroe points out the relation between techno and the post-Freudian thought of Gilles Deleuze and Felix Guattari. This is not academic serendipity: one record label, Mille Plateaux, deliberately echoes their book's title. Deconstruction Records is another prominent dance music label. When Green Gartside of Scritti Politti met his hero Jacques Derrida (whose insights inform Jeremy Gilbert's treatment of the Velvet Underground), the theorist informed him that pop music and his own work were part of the same deconstructive project of undoing and unsettling, and that what set the musician apart was the 'possibility of his meaninglessness'.[11] Commenting on this exchange, Simon Frith has remarked that the 'point of music' is to 'flout the strict sense of the word'.[12]

This is an important acknowledgement of the part pop has played in the deconstruction of rationalist Western hegemony (though similar claims could be made about Western classical music, or indeed the many non-Western musics in which lyrics are absent, or are subordinate to other aspects of the music). It is also an acknowledgement that the study of popular music has had to progress beyond a concern with songsheets and subcultural style, and to involve itself in the analysis of sound. It is no coincidence that many academic musicologists, of the generations that have lived through pop, have begun to produce a musicology of popular music, treating the sonic texts of pop seriously for the first

time.[13] Tim Barnes, Jeremy Gilbert, James Ingham and myself all contribute to such an analysis, while Ben Watson argues the political necessity for one. This may well add fuel to the ire of the editors of the *Rough Guide to Rock*, and the many others for whom analyses without explicit value-judgements are incomprehensible (and intellectuals are regarded with deep suspicion); it is, nonetheless, an important aspect of the way pop is turning under the burden of its own history; and of course another way of producing a canon.

This belated pop musicology is far from pop's first brush with academia. There is a history here that runs in parallel with those of journalism and music. Simon Frith's groundbreaking study, *The Sociology of Rock*, appeared in 1978. Frith's exemplary academic publications list has led academic work on popular music. Many others have followed, and there is now more than enough academic writing on music for Frith himself to have co-edited an anthology that makes a useful companion (and in many instances a useful corrective) to the journalistic encyclopaedias mentioned above; while others have tried to produce all-purpose 'textbooks' for the study of pop on popular music, media and cultural studies courses.[14] Frith's influence is widely acknowledged here. Yet, as both Jeremy Gilbert and Ben Watson remark, this type of work, emphasising the social structures behind music-making rather than interrogating musical practices and values themselves, has always been problematic precisely because it is *not* a musicology: it has no adequate vocabulary for dealing with the effects of sounds – an absence also explored here by myself, James Ingham and Tim Barnes. For Ben Watson, still after all these years intent on keeping the red flag flying, the whole project of rock and pop sociology is dangerously complicit with the political economy of the music business. Living through pop consumption is for him a form of victimhood encouraged by what he sees as the anodyne observations of pop academia; instead, he encourages a return to the rigorous embrace of the avant-garde theorised ascetically by Theodor Adorno, and celebrated joyously by Joe Carducci.

Frith's groundbreaking *Sociology* was followed closely by another classic academic engagement with popular culture, Dick Hebdige's *Subculture: The Meaning of Style*. *Subculture* catalogues youth cultures from the teds of the 1950s to the punks of the 1970s. British youth subcultures are, he claims, engaged in a long 'phantom dialogue' with Black American and Caribbean culture, a dialogue focused around dress and music, and embracing the marginality of those cultures against mainstream Whiteness. British culture – including most centrally, pop – is inexplicable without these transatlantic connections, which Imruh Bakari's chapter here interprets from the complementary African-Caribbean perspective.

Subculture, even more than Frith's work, was carried into the mainstream. Much of the music and style journalism of the 1980s and after is clearly influenced by Hebdige's work. Needless to say it has problems; it cannot serve as a model for the ways in which we have lived through pop. First, it is implicitly about men and masculinity; yet gender as an issue a notable absentee. Some of

its gaps have been filled by feminist cultural studies, work by Angela McRobbie, Mica Nava and others that addresses the absence of women, or indeed any notion of a politics of gender, from the 'youth' studies of the 1960s and 1970s; other gaps by a growing body of work towards a feminist musicology.[15] Women are young too, and have their combative youth cultures. Jude Davies's chapter here relates the Spice Girls' supporting market ideology of 'girl power' to an aware 'post-feminism' that can at least be partly attributed to the Girls themselves.

The second problem is that academics, who are usually politically on the Left, too often read antagonism as 'resistance'. Perhaps more damagingly, they often fail to examine cultures that appear, to them, conformist. Addressing some of these weaknesses, Steve Redhead announced new terms of engagement with popular culture and with subcultural theory: ' "Authentic" subcultures were produced by subcultural theories, not the other way round. In fact, popular music and "deviant" youth styles never fitted together as harmoniously as some subcultural theory proclaimed.'[16] To differentiate these, he calls one strand of the music of the late 1980s 'post-political' pop; it is not, he argues, 'post-cultural' or trivial. Music continues to play its part in the making of new cultural formations.

Critic Phil Johnson, for example, has charted a particular British syncretism among blues parties and punk, whose devotees learned and created new forms of expression, including new forms outside the accepted channels of the music business and its definitions of property and creativity.[17] There is, then, a fluid legal/semi-legal/illegal boundary: traditional notions of musicianship, composition, even improvisation, break down around such a 'found' culture. Whether using records spun and mixed from double decks, or sampling breakbeats, it involves living through pop in a way that some (including music business lawyers) routinely define as 'theft'. The Bristol music scene Phil Johnson writes about – Massive Attack, Tricky, the 'trip-hop' of Portishead, the drum 'n' bass of Roni Size/Reprazent and so on – is, like that of Man Jumping (which I discuss in Chapter 5) dance music for the head as well as the feet; but it is made by segmenting other existing music. Portishead's 1995 hit, 'Sour Times', made breakbeats from 1960s film music; similarly, one of the surprise hits of 1996 was an 'acid jazz' track by Goldbug that used 1960s advertising music as a running breakbeat in a cover of Led Zeppelin's 'Whole Lotta Love'. This is not avant-gardism; not threatening to an industry that has, since the first impact of hip-hop, restructured itself around digitalised notions of intellectual capital; and yet its aesthetic makes something *new* of the past – in contrast to the stylistic repetition of the Rolling Stones or Oasis. Pop of all genres routinely has one foot in the past, and we must live and write its story in relation to the rest of culture, including the 'ageing population', with this in mind.

Notes

1 See for example W. Anthony (1998) *Class of 88: The Acid House Experience*, London: Virgin; M. Collin (1997) *Altered State. The Story of Acid House*, London: Serpent's Tail; S. Garratt (1998) *Adventures in Wonderland: A Decade in Club Culture*, London: Headline; H. Rietveld (1998) *This is Our House*, Ashgate; S. Reynolds (1998) *Energy Flash*, Picador.

2 K. Negus (1992) *Producing Pop*, London: Edward Arnold.

3 D. Toop (1995) *Ocean of Sound. Aether Talk, Ambient Sound and Imaginary Worlds*, London: Serpent's Tail, p.58.

4 See for example D. Clarke (ed.) (1989) *The Penguin Encyclopaedia of Popular Music*, London: Penguin; P. Gammond (ed.) (1991) *The Oxford Companion to Popular Music*, Oxford: Oxford University Press; C. Larkin (ed.) (1994) *The Guinness Encyclopaedia of Popular Music*, London: Guinness Publishing, 14 vols; J. Buckley and M. Ellingham (eds) (1996) *Rock. The Rough Guide*, London: Rough Guides.

5 See for example L. Evans (1994) *Women, Sex, and Rock 'n' Roll, in their Own Words*, London: Pandora; K. O'Brien (1995) *Hymn to Her. Women Musicians Talk*, London: Virago; L. O'Brien (1995) *She Bop. The Definitive History of Women in Rock, Pop and Soul*, London: Penguin.

6 Buckley and Ellingham *Rough Guide to Rock*, p.v.

7 N. Kent (1994) *The Dark Stuff*, London: Penguin.

8 See for example H. Kureishi and J. Savage (eds) (1995) *The Faber Book of Pop*, London: Faber; C. Gillett and S. Frith (eds) (1996) *The Beat Goes On. The Rock File Reader*, London: Pluto.

9 J. Aizlewood (1994) *Love is the Drug*, London: Penguin, back page blurb.

10 S. Thornton (1995) *Club Cultures. Music, Media and Subcultural Capital*, Cambridge: Polity.

11 S. Frith (1992) 'Adam Smith and Music', *New Formations* 18, p.83.

12 Frith 'Adam Smith', p.83.

13 See for example A.F. Moore (1992) *Rock. The Primary Text*, Buckingham: Open University Press; R. Walser (1993) *Running with the Devil. Power, Gender and Madness in Heavy Metal Music*, London and Hanover: Wesleyan University Press .

14 See for example B. Longhurst (1995) *Popular Music and Society*, Cambridge: Polity.

15 See for example S. McClary (1991) *Feminine Endings*, Minnesota: University of Minneapolis Press; M. Citron (1993) *Gender and the Musical Canon*, Cambridge: Cambridge University Press; S. Whiteley (ed.) (1996) *Sexing the Groove*, London: Routledge.

16 S. Redhead (1990) *The End of the Century Party. Youth and Pop towards 2000*, Manchester: Manchester University Press, p.25. A further critique of subcultural theory can be assembled from the essays in S. Epstein (ed.) (1998) *Youth Culture: Identity in a Postmodern World*, London: Blackwell.

17 P. Johnson (1996) *Straight Outa Bristol, Massive Attack, Portishead, Tricky and the Roots of Trip-Hop*, London: Hodder & Stoughton.

Part I

LIVING IN HISTORY

These first two chapters are written by men in their twenties, about bands whose music they love but which they were born too late to hear when it was first made. Tim Barnes looks back at the heyday of the Rolling Stones, noting their impact on an entertainment world dominated by the physically inhibited and careful mass cultural products of variety and vaudeville, and the sanitised White rock 'n' rollers who preceded them as British pop stars. He argues that their rhythmically 'loose' and timbrally 'dirty' sound was the crucial component of their sonic signature, giving their music a very specific air of excitement. This, Tim Barnes concludes, gave their take on the blues a very specific part in the social loosening that accompanied their impact in the 1960s.

Jeremy Gilbert is also concerned with the relationship between sound and social structure. Noting the ways in which music physically connects to the identity of the listener, and in which music as a commercial product is made available, he acknowledges both global capitalism's outreach, and the creation of virtual communities of fans who build their heaven despite that outreach. The recording, in other words, creates a disseminated community, and its continued presence *continues* to make such communities of like taste. Through this repetition, he argues, with acknowledgement to Jacques Derrida, a continuance of meaning is possible. Turning to the sound of the Velvet Underground, and to the pop psychoanalysis offered by Simon Reynolds and Joy Press, he claims that the Velvets' power stems from their musical androgyny, an ambivalence towards the ways in which gender is constructed in contemporary culture.

1

LOOSEN UP

The Rolling Stones ring in the 1960s

Tim Barnes

The Rolling Stones are a known quantity. Everyone has heard them. The sheer bulk of critical appraisal, tabloid sensation, fan club pulp and spotterish biographical study published over the last thirty-four years dictates that virtually the entire English-reading population of the world will have read *something* about them. As uninteresting an act as they have become, their albums continue to sell – as this chapter was being completed *Bridges to Babylon*, a new album, was released, and its promotional tour was in full swing. But ours is not to wonder why. Ours is to add a few more sheets to the pile on the subject of their outstanding cultural product – their contribution to popular culture in the 1960s. This means examining the blues in Anglo-American culture, and looking at the band's place in the swinging, classless 1960s; above all it means listening to their sound, appreciating the looseness that took them away from the back-water of rhythm 'n' blues (R 'n' B) and into one of the wilder tributaries of mainstream pop.

A great many of the better books about the Stones, and most about rock music in general, discuss the development of the blues, a musical form with heritage enough to lend a reassuring air of historical grounding to any text. Too often, this scholarly reassurance involves the oversimplification of histories and the unhesitating validation of the author's taste. While the first half of Dave Laing's book *The Sound of Our Time*, for example, is lucidly informative in its presentation of a chronological history of rock, it takes no account of the essential subjectivity of appreciation (and resultant arbitrariness of location of the boundaries between 'adjacent' musical genres), in order that every last form and sub-form of popular music receives a label, meanwhile tending to suggest that each musical form is, eventually, entirely superseded by one or another of its derivative strands.[1] It's a theory of progress, in which the subsequent is the superior. The first paragraph of Simon Frith and Andrew Goodwin's introduction to *On Record* refers to this common myopia, denouncing 'false assumptions about the way in which pop music progresses....In theories of progress by attrition, each musical "revolution" is held to wipe out the last'.[2]

This is not to deny that there have been revolutions in music – or the efficacy of the scholarship that identifies them. The beginnings of the musical

15

revolution that was rock 'n' roll now belong for the most part within the realms of nostalgic fantasy. However, Dave Laing's identification of the first appearance of rock 'n' roll, citing the radio programme *Moondog's Rock and Roll Party*, appears convincing.[3] Alan Freed, a White disc jockey in Ohio, having received mail suggesting that R 'n' B was growing in local popularity, experimented in using the music for his show. He replaced the words 'rhythm' and 'blues' with two of the most frequently used words from the R 'n' B lyric ('rock' and 'roll': pseudo-onomatopoeic verbs describing the sound and the related dance response) in order to avoid R 'n' B's connotations of racial exclusivity. This is the first recorded instance of the application of the *term* 'rock 'n' roll', and is thus the first isolatable incidence of the music. It would seem that, to paraphrase the Stones' most often paraphrased song title, 'It's Only Rock 'n' Roll When You Call It That' (and the general consensus of opinion throughout the audience is in agreement).

If rock 'n' roll was, in the first instance, R 'n' B for White listeners, and gradually became a music in which increasing numbers of White musicians were involved, how was it that the Rolling Stones were, on their first arrival in the public eye, unusual in the fact that they were a White R 'n' B band? It would seem, when one considers certain of their 1962 contemporaries (such as Freddie and the Dreamers) that much of the 'deviance' associated with rock 'n' roll in the 1950s had already by this time disappeared into a comfortable pop owing much to music-hall-derived light entertainment. The reasons for *real* rock 'n' roll's initial brevity of existence are not particularly important to our aims here (*The Sound of Our Time*'s citation of Buddy Holly's death, Chuck Berry's imprisonment and Jerry Lee Lewis's public humiliation for marrying his teenage cousin are three very good reasons). It is certain, however, that those examples of (White) rock 'n' roll that were still in existence in 1962 were far removed from their R 'n' B roots. An interpretation of the musical form had developed that was discernibly removed from – one might say it was a mainstream sanitisation of – that which had initially emerged.

The Stones in the Blues Continuum

While 'musical revolutions' do not arrange *genres* running nose-to-tail chronologically, *subgenres* do not align themselves perfectly with respect to race and class. The Stones appeared at first to occupy a no-band's-land. They were not commercial enough to be a mainstream pop group, committed as they were to their own particular notions of what constituted 'authentic' R 'n' B; but they were dropped by the jazz club highbrows from the Marquee after their first few gigs, because, as Chris Barber (whose jazz band, featuring Alexis Korner and Cyril Davies, incorporated the first recorded British R 'n' B) put it, 'they weren't authentic enough'.[4] Whilst it would seem essential when celebrating the Stones' achievements (and I think that's what we're doing here) to study the

music that inspired and influenced them, it is difficult to pin-point their precise location within 'the Blues Continuum'[5] – the spectrum of musics descended from those first, 'primitive', folk blues, and ending, for the purposes of this chapter, with the (largely White middle-class) British Blues Boom of the 1960s. Certainly, canonisation of early forms as 'the originals' and rejection of later forms as 'debasements' is a preoccupation with a specific notion of 'authenticity' that is counterproductively regressive. And yet the Stones *did* start from some-where along that continuum; perhaps even from somewhere like this:

> The blues occurs when the Negro is sad, when he is far from his home, his mother, or his sweetheart. Then he thinks of a motif or a preferred rhythm and takes his trombone, or his violin, or his banjo, or his clar-inet, or his drum, or else he sings, or simply dances. And on the chosen motif, he plumbs the depths of his imagination. This makes the sadness pass away – it is the blues.[6]

This remark is credited to the Swiss conductor Ernest Ansermet; at first sight I (quite appropriately) misread it as 'Earnest Assessment, 1918'. Dating from soon after the first major migrations of American Blacks from the rural South to the industrialising cities of the North and Midwest, and *before* the Okeh Record Company produced the first commercial recording by a Black singer (Mamie Smith's 'Crazy Blues')[7], Ansermet's sympathetic response resembles the vast majority of considerations of blues since. When the subject of 'original' folk blues is approached in such texts, quixotic significances are frequently attached to the music, apparently in place of critical analysis. This is a common condition amongst studies of any form of 'folk art' – the writer's concern that s/he is in no position to be critical of the products of a culture from which one is so distant.

A prerequisite of considering blues music as a whole is the understanding that it is not just a manifestation of the sadness of an oppressed people. LeRoi Jones writes: 'Blues is *not*, nor was it ever meant to be, a strictly social phenomenon, but is primarily a verse form and secondarily a way of making music'.[8] The transmission and inheritance of certain musical motifs, instru-mental techniques (and instruments themselves), lyrical approaches and 'plot' features, usually built upon a foundation of a basic three-chord progression, are features of an oral tradition that is just as apparent on every track of *Peter Green's Fleetwood Mac* (CBS, 1967) as it is on Blind Lemon Jefferson's 'Black Snake Moan' (Okeh, 1927). The 'authenticity' bestowed upon the likes of the latter in some texts can smack of the White liberal big-hearted gesture – allowing the Black man something in return for centuries of subordination.

It is possible, however, that a laboured technical-musicological analysis would prove even *less* fulfilling to the average (even the average academic) reader than Ansermet's earnest assessment, as there is little to reveal. Jones's primary structure of the blues – the verse form – is built around the AAB line sequence of 'call and response' singing that has been identified in African-

American music since the beginnings of slavery.[9] Complementing this line sequence is a simple three-chord progression; the 'home' chord of the key, the chord of the fourth or subdominant, and that of the fifth or dominant (often with added seventh), which are, in the simplest twelve bar blues, played sequentially, one for each line: I, IV, V^7, then back home to I. The secondary structure of the blues – its 'way of making music' – is characterised by musicians 'blueing' notes, that is, altering their pitch slightly around the 'true' note, as can be achieved by bending a guitar string. Herein also is something that Ansermet *does* refer to, plumbing the depths of emotion on the chosen motif; the strong role of improvisation, whether it be by slightly altering the second line of the vocals to emphasise a subtle difference from the first, or by the early jazz convention in which all the instruments improvise at once around a central theme, before all return eventually to the original riff, or by the individual virtuoso lead guitar breaks made so popular in the 1960s.

The great virtue of this formal simplicity is that it allows for incredible versatility within the framework. To study and compare the lyrical content of a performance from Ansermet's first-generation industrialised bluesman and a late 1960s Bob Dylan album track would demonstrate this, but would also detract from more important considerations such as the difference between the singers in their primary motivations for making music (and their priority objectives – what they aim to *achieve* – by making it). It is inextricable from their environmental dictates – whereas Dylan is consciously attempting to explore the limitations of the form, and is doing so for substantial financial reward, the blues singer's efforts were strictly an expression of the moment; 'It didn't matter whether an artefact...resulted, or even whether there was an audience'.[10]

By the mid-1960s, White performers such as Dylan and the Stones dominated what was once a specifically Black music. In *The Death of Rhythm and Blues*, Nelson George writes: 'The ties between the music known as rock & roll and its original black audience were being severed, and black America didn't seem to care.'[11] He asserts that the second wave of rock 'n' roll – hailed by the international success of the 'beat' groups – had become almost the sole province of the White teenage audience, leading to a bias in favour of the White performer. He describes such an audience at a particular event in the United States in 1965:

> That they could cheer as Mick Jagger jiggled across the stage doing his lame funky chicken after James Brown's incredible, camel-walking, proto-moon-walking, athletically daring performance – greeting each with equal decibels – revealed a dangerous lack of discrimination. To applaud black excellence and white mediocrity with the same vigor is to view them as equals.[12]

Popular music is not, however, a competitive discipline in which participants are judged by measurable elements of their performance alone (as can be the case in

very simple sporting contests such as the long jump), nor is it a form of expression that is assessed categorically by a forum of expert individuals to facilitate what is commonly seen as the most objective representation possible of the performance's true worth (as in more complex sports such as ice skating or gymnastics). No, music is hugely *subj*ective – and, in view of the prevailing 'mindset' of an audience composed predominantly of White teenage girls, to see a White man dancing and singing like a Black man (however poor the impersonation) is far more interesting than to see a Black man dancing and singing like the abundance of media-distributed stereotypes tell you they all, always, do.[13] This transracialised imaginary was part of Elvis's great (pre-draft) moment; it has always been part of Mick Jagger's fascination.

The fact that the Stones' early music appeared original to White, teenage audiences was largely due to the fact that White and Black audiences in the States had their own specific radio stations to cater for what the programmers thought they wanted, while the British assumption was (and even after the mid-1990s reinvention of BBC Radio One, to a surprising and depressing extent remains) that the White majority of the population would wish to hear music made by White people. Few White listeners, therefore, had even heard of Muddy Waters or Jimmy Reed, or would have considered it their place to be listening to them. Even Chuck Berry, one of the few Black figures who *can* be identified as essential to the development of rock 'n' roll out of rhythm and blues, achieved virtually no commercial success in Britain until his influence had been publicly announced by the Stones and the Beatles. Nelson George quotes Elvis Presley in examining the same situation during the 'first phase' of rock 'n' roll: 'The colored folk been singing it and playing it just the way I'm doin' now, man, for more years than I know. Nobody paid it no mind till I goosed it up.'[14] The fact was that no White people *could* pay it any mind until it was performed by another White man, as it was simply absent from television broadcasts and from mainstream radio stations and record shops.

The fundamental characteristic of the R 'n' B sound, if it is decided that there must be one, is its rhythm's efficacy in eliciting a dance response (or those reactions that Dick Bradley considers 'lesser forms of it':[15] tapping the foot, nodding the head, etc.). It was these rhythmic properties that made the Rolling Stones' music so apparently different to the majority of popular music at the time, and, as a result, many of those people whose opinion of it was generally favourable were (if only indirectly) almost as guilty of casting the Stones as metaphorical Black men as those parents who viewed them through racist stereotypes. The music they produced, like virtually any other, is most frequently written about via convenient metaphor, using certain adjectives and predicates (the application to music of which Barthes so vehemently criticises in 'The Grain of the Voice',[16] but the absence of which from language would surely try the patience of even the most tolerant reader of record reviews) such as those referred to by Bradley: ' "rough", "dirty", "hard", "earthy", "raw sex", the "blues feel", etc.' These words, he continues, 'all acquire their

resonance…in the first place from the notion that "the Negro" is the repository of "corporeal" qualities in a way in which (most or all) white people are not'.[17]

This assumption was in fact extended into a positivist reappropriation of concepts such as 'primitivity', as LeRoi Jones suggests:

> One gets the idea that a man who falls down on his back screaming is doing so, even though he might be genuinely moved to do so, more from a sense of performance than from any unalterable emotional requirement. But…for the Negro who found his most complete state-ment in rhythm and blues, the dramatic or *burlesqued* part of the performance might be as integral a part of the expression as the blues itself, since it made the departure, the separation, from the social impli-cations of the white popular song complete.[18]

Similarly, the retention of the explicit, lewd or smutty lyric within Black song-writing (evident in blues and R 'n' B from their beginnings, and present today in subgenres such as gangsta rap and swingbeat) further indicates a tendency to purposefully exaggerate those practices that might perpetuate racist stereotypes of Black embodiment among Whites – it could be seen as a process of throwing the oppressor's petty concerns back in their faces. The two concepts are inextri-cably linked – discussions of the rhythms of R 'n' B and rock 'n' roll as metaphors for sexual activity abound in texts within all intellectual strata.

Listening to the Rolling Stones

In 'Start Making Sense! Musicology wrestles with rock', Susan McClary and Robert Walser expose the shortcomings of the most familiar form of written analysis of popular music (the record review with its extended metaphors) as well as the failures of traditional musicology to express the power of popular music in terms that make sense to those whom it affects most. As a more direct explanation of a particular way in which music might 'work' – that is, elicit a dance response or other favourable reaction – McClary and Walser cite an account by Steve Cropper, one of the musicians involved in the introduction of a specific, and very conscious, musical 'tactic':

> He [Jerry Wexler, head of Atlantic records] said this was the way the kids were dancing: they were putting the accent on two…[t]he back-beat was somewhat delayed, and it just put it in that rhythm…[w]e play a downbeat and then two is almost on but a little bit behind, only with complete impact.[19]

McClary and Walser rapidly expand this alternative approach to musical timing into a major sociological phenomenon: 'Along with this quirky shift of accent came, of course, a new set of images, flooding the mainstream, presenting chal-

lenges on many fronts: race, gender, class.'[20] Although this development makes a whole new approach to the music possible, which could, in turn, lead to all those positive developments that are characteristic of the effects of music crossing cultural divides, their account ignores the intermediate steps involved, and oddly enough (particularly since both McClary and Walser are eminent musicologists) no direct example is given of the rhythm Cropper describes. Wilson Pickett's 'In the Midnight Hour' is a perfect example (indeed it could be the very track that was being recorded when Wexler intervened, which was a Pickett session); the emphases are on the second and the fourth beats of the bar, and both Cropper's swiftly struck guitar and Al Jackson's snare drum are played right on the 'back' of the beat; that is, as late as they possibly can be without being *too* late. The overall effect is that the horn section seems to be dragging these percussive sounds along with it – to employ a few metaphors, with apologies to Barthes, it might be described as 'loose', 'lazy' or even 'sleazy'. McClary and Walser conclude with two entirely contradictory sentences: 'We all have learned how to "pick up on this thing here"....It's engrained in our bodies.'[21] This rather muddled statement is, however, representative of the complex process that is involved in overcoming those repressive social forces that have, apparently, prevented White people from reacting to rhythmic music in a natural and spontaneous fashion – it is a conscious overruling of, or studied detachment from, self-consciousness.

This 'playing *around*' the beat is a prominent feature within the Rolling Stones' overall 'tight but loose' sound. In their first original single 'Time Is On My Side', the emphases are again on the second and fourth beats of the bar, but never '*right* on it' – the tambourine (with the exception of a number of mistakes, which are *themselves* an important characteristic, considered below) is struck on the front of the beat and the snare drum on the back. This makes interesting use of the tambourine's longer decay. In addition, at the end of each vocal line, the snare drum is struck on the back of every half-beat (or quaver) for a length of musical time that varies – most often for three whole beats, but often four and sometimes more. This, the most frenetic instrumental activity in the song, has an effect of 'running to catch up'. The unregimented drumming is a familiar feature of the Rolling Stones. Whereas most bands take the drums, or at least the bass drum, as a standard zero around which the other instruments can move, Charlie Watts' style, perhaps indicative of what he considers to be his true vocation – jazz drumming – places shifting emphases on beats, on different parts of beats, and is also susceptible to noticeable fluctuations of tempo.

Another key feature of the Stones' music is their use of the guitar. Carl Belz explains the 'controlled excitement' of the *Beatles*' songs as a direct result of the way they 'used the guitar as a unifying element, instead of allowing it to break out of a particular song structure as it does, for instance, in many of Chuck Berry's pieces'.[22] It might be naive, but is nonetheless irresistible, to suggest that if the subtlety of the Beatles' guitar sound (which was probably largely due

to the influence of an experienced classical music producer in George Martin) fostered a 'controlled excitement', then the Rolling Stones' comparatively loud and piercing guitar sound lent an air of *un*controlled excitement to their music.

Compare for instance the bubbly, and very euphonious, pop of the Beatles' 'Can't Buy Me Love', with its exact contemporary, the Stones' 'Not Fade Away' (both were in the charts in March 1964). For all its bluesy verse chords and Paul McCartney's gutsy delivery, 'Can't Buy Me Love' is driven by rapidly strummed acoustic guitar chords towards a major-key middle eight which owes little to R 'n' B; only in George Harrison's brief guitar solo are the ghosts of music past, notably Chuck Berry, audible. Here is a clear connection to the Stones' emerging sonic signature – when one thinks of Chuck Berry's guitar, one thinks, as Belz says, of his lead guitar breaks, and Keith Richards' emulations of these are important to the Stones' sound; on 'Not Fade Away' his guitar solo is far more strident, using a harsher sound, than Harrison's. Yet it is the use of the rhythm guitar that is more central to the music. 'Not Fade Away' features the familiar shuffling 'Bo Diddley' rhythm, most apparent on his signature tune, 'Bo Diddley' (which Buddy Holly had 'covered'), and consisting of a repeated two-bar cycle of emphases – on the second and fourth beats of bar A, and the second and *third* of bar B. The result is an infectious 'stop-start' rhythm, which was effectively 'softened' in Holly's version, wherein the subtle instrumental emphases on guitar and 'patty-pat' drum are dominated by what resembles close-harmony doo-wop singing – 'bop, bop, bop-bop'. What the Rolling Stones (and particularly Richards's guitar) did, by contrast, was to *exaggerate* the Bo Diddley element – 'jang, jang, jang-jang'. The emphases in bar B are further accentuated by use of a tambourine on the second beat only. The overall sound is, by comparison, both energetic and offensive.

We have here, from a brief study of the Stones' first Top Ten single, a useful angle on their *sound*. The factor that originally differentiated them from their contemporaries gradually influenced others, and finally became apparent as an essential theme of rock could be characterised as an 'acceptance of the unmusical' – of those sounds that, taken out of the context of the music, might be considered wholly unpleasant. These qualities are in Jagger's voice, in Jones's wailing harmonica, in the 'stabbed' chords of the acoustic guitar and in the piercing chords of the sixteen-bar electric-guitar break. A handclap on the second and fourth beat of every bar serves to 'drive the rhythm forward' – and here another acceptance of the unmusical is apparent, when, as the song (rather ironically) begins to fade out, the handclaps go markedly out of time, and Richards starts messing about with the chord pattern. Once the Stones achieved the perfect distillation of this attitude – not bothering to re-record such a simple but important performance – they had developed a musical and stylistic approach that was eventually to become more of a rock 'n' roll standard than any of the songs they began their career covering.

A major landmark in the development of 1960s rock, and thus in the Stones' career (not vice versa), was the genesis of album-orientated rock with the release

of the Beatles' *Rubber Soul*. This important development, coupled with the emergence of the long player over the single as the most commercially successful recorded format in the late 1960s,[23] allowed the Stones to incorporate more and more different discrete styles into their own unique approach to the production of an artefact. Country, folk, gospel and soul songs appeared more and more alongside the more familiar strict R 'n' B material. The idea of 'montage' is useful in studying the Rolling Stones – their more successful (critically *and* commercially speaking) albums are comprised of a collection of influences – one or two country songs, two or three slow 'ballads', a downbeat acoustic blues number or two, and perhaps five upbeat, dance-oriented, rock 'n' roll tracks, these disparate contributions placed together in a predetermined sequence to form a semblance of a unified whole.

Much the same is true of many individual songs, including their best known:

> ['Satisfaction'] was the perfect synthesis of the musical styles that had influenced the group – particularly Solomon Burke, Chuck Berry and Muddy Waters – and, for the first time, generalised feelings entered the Stones' lyrics as Jagger screamed out his anger at the attempt at complete manipulation he saw around him.[24]

As much as 'Satisfaction' is often considered, from today's lofty historical perspective, to be an 'early development' in rock music – an 'old standard' – it was itself a *montage* of previous influences. In another sense, the Stones' musical arrangements could also be described as 'montages' – where many bands will strive to unite their separate instruments into one multi-layered, carefully engineered overall sound, there is scarcely one track that comes to mind in which the Rolling Stones appear to have made any effort to do this, the sounds of the five separate main instruments often being unusually easy to identify.

As with the playout of 'Not Fade Away', there is a considerable element of entropy evident in the music's overall feel – a musician might remark that there is little evidence of any instrument playing a set 'part'; they appear instead to be 'jamming' even in studio recordings where the final master has been composed of multiple tracks, which in turn might themselves be the result of a number of 'takes'. The interplay between the two guitars commonly used cannot often be realistically separated into 'lead' and 'rhythm', which can elsewhere (for example in the work of Creedence Clearwater Revival) be easily identified, as the former plucks the solos, the single-string and double-stopped riffs and breaks, while the latter strums the chords. Again, Charlie Watts' drums rarely play the role of the solid base upon which the rest of the music is built, but in 'Satisfaction', the rhythm is 'driven' along by the muted snare drum (which might as well be a cardboard box for all its tonal qualities), struck on every beat of every bar. The Stones' entirely untutored playing styles dictated Jagger and Richards' early songwriting to a great degree, reflecting, to their credit, their respect for the oral tradition of the blues. Despite the fact that as the group

became more experienced, these romantic traditions were increasingly hidden beneath preconceived tactics, their most effective riffs and most inescapable chord progressions still come across as having been written without much technique – importantly, therefore, being incredibly easy to sing along to.

Most written accounts, perhaps due to the various difficulties in writing about music discussed by McClary and Walser, will extend a token nod of acknowledgement to 'Satisfaction''s guitar riff before engaging in a deep and reverent consideration of the social implications of the lyrics. This is not necessarily a bad thing, as there is not a great deal that one can say about ten repeated notes, played by a wonderfully 'dirty' guitar sound, over a variety of just three pitches, but it seems that something important has not been mentioned (at least not explicitly). There is a certain *inevitability* in the riff's frustratingly (to unsuccessful songwriters) simple effectiveness that seems, on a personal level, to go beyond the fact that it is probably the outstanding feature of a song that was one of the most famous of its type well before I heard my first sound. It might be suggested that the pattern sounds inevitable; that if Keith Richards had not written that riff, somebody else would have done so before long.

The song's success, however, has been described not through that wonderful riff, but through its lyrics; as

> largely due to the fact that it 'explained' Mick Jagger and the Rolling Stones. As Jagger described his frustration and alienation, he spoke to youth's similar feelings about the world, and he helped young people understand why the Stones looked and acted the way they did. The song functioned like traditional folk music, expressing a life situation more immediately than it expressed a 1960's version of the Rhythm and Blues musical tradition.[25]

Much too neat. The British youth of the 1960s is frequently represented as frustrated and repressed. Maybe they were; but the point is that many of them didn't think so. David Stafford's *Guardian Weekend* column recently cheered, 'I belong to a charmed generation. Everything fell into place just as I needed it.'[26] The evidence he provides for this claim is quite persuasive – the end of the war and subsequent improvement in the economies of both Britain and America (which not only gave the Baby Boomer generation greater spending power than any previous generation of under-twenty-fives, but also made improvements to the further and higher educational system possible, including the entertainment budgets that produced the college rock circuit). *They felt free.* The abolition of National Service, the invention of the contraceptive pill, the subsequent permissive society and the connected drug revolution – to which we could add the end of publishing and theatre censorship, a (limited) legalisation of homosexual acts, and a very positive valuation of the young as heralds of a new classless society – empowered many young people. Pop stars, actors, and figures like Lord

Snowdon and Princess Margaret, met on equal terms in the social life of 'swinging London', where Mick Jagger, surrounded by every physical indulgence and luxury that he could possibly desire, was a perfect spokesman for this seemingly fortunate generation – somebody who was in the same situation, only more so. Philip Norman hit the button when he wrote that 'Jagger's voice, in ['Satisfaction'], the quintessential Stones anthem, is riven with the delicious *angst* of finding the world too much at one's feet; the insufferable *ennui* of being handed everything.'[27] Jagger's yowling melismata express a desire born not of street-level poverty but of achieved sufficiency, even of excess; he's a man of wealth and taste.

The band's fluctuating instrumental resources likewise seem to express the experimentalism of *ennui*. Dick Bradley observes that the 'variants of rock which flourished in the later 1960s were themselves very close to Beat music, in terms of the basic instrumental techniques used (drum styles, rhythm guitar, single-string 'plodding' bass). The variety was largely a matter of superimposed recording tricks, or unusual instrumental decoration.'[28] This description would appear to hold true for the album *Aftermath*, which was differentiated from the Stones' earlier work (apart from its status as their first entirely self-penned album) by Brian Jones' experimentation with a variety of instruments: the sitar, marimba, dulcimer, and recorder.

Andrew Oldham once said 'Brian was a power within the Stones as long as he could pick up any instrument in the studio and *get a tune out of it* [my emphasis].'[29] This reflects the depth of artistic endeavour very accurately – the use of ethnic instruments on these pieces was about as profound an excursion into the sphere of Eastern music as eating a McPizza is a sampling of Italian cuisine; it is performing an exercise that would not have been possible but for the products of another culture, but enjoying that advantage entirely within the context of one's own. (A perfect example of Brian Jones 'getting a tune out of' an instrument is audible on one recent release – the Beatles' *Anthology No. 2*. When listening to his saxophonic contribution at the end of the lengthy sub-Bonzo Dog good-cheer workout 'You Know My Name', the observation may be made that if he is so determined to get a tune out of the instrument, he might as well bang it against the table to keep time.)

Walter Benjamin's influential essay 'The Work of Art in the Age of Mechanical Reproduction',[30] draws attention to the changed role of the film actor from that of the stage actor, and the way in which, thanks to the editing process, the former is never seen by the audience to make a mistake. Quoting Rudolf Arnheim, Benjamin describes this approach as 'treating the actor as a stage prop chosen for its characteristics and...inserted at the proper place'.[31] This example may be extended to audio recording technologies – multiple-track recording allowed Brian Jones to pick up the sitar, play it for as long as it took to write and record his part for 'Paint It Black', and never play it again. In a review of *Aftermath* in the *Record Mirror*, Peter Jones wrote: 'Brian played the

sitar like he played rhythm guitar. It probably made George Harrison cringe, but it worked brilliantly.'[32]

The album that followed, the unprecedentedly unsuccessful *Their Satanic Majesties Request*, appeared to follow this pattern to its natural conclusion. A mishmash of overdubbed ethnic instruments and electronic sound effects, packaged in a psychedelic sleeve, the album was bound to be considered a poor imitation of the Beatles' *Sergeant Pepper*, which it followed by five months. It was. What it did, however, was confirm that a change of image was not necessary. The Stones' next single, 'Jumpin' Jack Flash', their first UK number one single in two years, had nothing to do with the *Satanic* psychedelia, working instead within the guitar-led soundworld of 'Satisfaction'.[33] The following album, the split with Andrew Oldham allowing the introduction of a more technically adept producer, Jimmy Miller, is often regarded as their best. *Beggar's Banquet* is described by Belz as 'reminiscent, as was their earlier *Their Satanic Majesties Request*, of the Beatles' *Sgt. Pepper*', but only in the sense that it 'exhibits the internal unity of a recorded rock symphony'.[34] The unifying concept throughout the tracks on *Beggar's Banquet* is one that was present in the Stones' earlier work in varying degrees but that is rarely *absent* from their work (although not always effective) since – those notions of an utterly real dark side to the Stones' character, presented in conjunction with an apparently contradictory air of sophistication. It might be suggested, therefore, that it is not so much *Beggar's Banquet* that is a concept album, as the Rolling Stones that are a 'concept band'. The title *Beggar's Banquet* itself explains this unifying concept – two apparently contradictory words, one symbolising poverty, or suffering, or despair, and the other wealth, or health, or happiness. The Stones' lyrics spoke consistently of this contradiction.[35]

Antoine Hennion is informative here, employing a Levi-Straussian interpretation of the function of myth: '[Popular music] often reflects the eternal opposition between rich and poor, between strong and weak...in other words it is familiar to the casual listener and solidly anchored in popular mythology through the intrigues and situations which that mythology holds dear.'[36] It occurs that to complete this paradoxical image of sleazy but sophisticated, malnourished but gorged, is rather more easy if one is already internationally known to be phenomenally wealthy. Half of the dipole is already in evidence – the only necessary additions are the allusions to drug addiction, Satanism, sadomasochism and murder. The albums following *Beggar's Banquet* are littered with blatant and literal references to sex and drugs (and, obviously, rock 'n' roll). 'Like the socially-minded songs,' writes Belz, 'those implying drug [and, one might add, sexual] experiences reveal the traditional folk orientation of rock music in the 1960s. After all, these are the subjects with which the lives of the rock audience are intimately involved.'[37]

The politics of looseness

The Stones' significance within a counterculture could be considered a contribution to political discourse, but the magnitude of this contribution has frequently been overestimated. 'Anyone who took the somewhat ambivalent lyrics of "Street Fighting Man" as a sign of genuine left-wing sympathies was sadly mistaken'[38], says journalist Sean O'Hagan, supporting this assertion with the evidence of Sir William Rees-Mogg, editor of *The Times* (in those far-off days not an oily entertainment/lifestyle rag, but the authoritative newspaper of the Establishment) who met Jagger to speak about the morality of 'Young People Today' in July 1967. Jagger had just been busted; a *Times* leader had defended him. The grateful vocalist told Rees-Mogg he felt that if people *wanted* to take drugs, surely that was *their* business, so long as they didn't hurt anyone else. Jagger could have been quoting John Stuart Mill; Rees-Mogg, anticipating the Thatcherites' imaginary leap, a decade later, from Mill's classic Liberal position to their free-market Toryism, concluded that Jagger was 'one of nature's conservatives'.[39] Certainly it's hard to read this individualism as part of class politics: Jagger's place in the (upper) classless society was assured by this time, for all that older members of that British elite were so concerned about drugs.

Within the Stones' recorded output, specific political orientations are never stated, and one has to examine the culture of which they were a part to become aware of the political implications of their particular brand of entertainment. Their essential contribution to that culture was in their publicising a model of 'nonconformity' for (specifically White male) youth. LeRoi Jones writes of the White 'beboppers' who appeared, particularly in New York, in the 1940s; their behaviour – their modes of speech and dress, their preferred social venues – he says, are 'indicative on most levels of a conscious nonconformity to important requirements of the [white] society....the white musicians and other young whites who associated themselves with [bebop] identified the Negro with this separation, this nonconformity [and therefore identified *themselves* with the Negro]'.[40]

In turn, Dick Bradley attends to the similarities between 1940s and 1950s White 'boppers' and the numbers of White rhythm and blues fans who began to appear in Britain (particularly London) around the beginning of the 1960s, both booms 'being mainly middle class and often idealistically anti-commercial'.[41] This was simply one element evident within a general tendency in twentieth-century Western art and popular culture, away from the existing 'repressed', 'dignified', White European forms, and towards a more 'natural', sensual form of expression, which has resulted *in*, as well as being a result *of*, improving communications between the mainstream and peripheral (predominantly Black) cultures. Jones speaks of two opposing forces of assimilation between Black and White cultures that have between them dictated to a great

extent the direction that Western art (and especially popular music) has taken in the twentieth century:

> On the one hand, the largely artificial 'upward' social move, demanded by the white mainstream of all minorities, and the psychological address made to that demand by the black bourgeoisie, whereby all consideration of local culture is abandoned for the social and psychological security of the 'main'. On the other hand, the lateral (exchanging) form of synthesis, whereby difference is used to enrich and broaden, and the value of any form lies in its eventual use.[42]

This lateral assimilation facilitated a communication of an alternative to the mainstream existence with its strict code for life and limited opportunities for experience through music and other art forms. The Rolling Stones were instrumental in the communication of one of those many messages, which, particularly through the erosion of what can be considered the 'master identity' of social class, allowed the individual the luxury of a number of identities – the ability to relate to different causes according to one's own contemplation and conception of the circumstance of reality.

In other words, the montage of influences and the looseness of playing style is an analogue of a more deeply individualised, personalised and less social common sense: a politics of the post-modern, maybe, but one which as Rees-Mogg saw could easily be colonised by free-market conservatism. It's rewarding, I think, to conclude by reflecting on the now-traditional antiphony of 1960s music, between the (satanic) Stones and the (angelic) Beatles. In his recent study *Revolution in the Head. The Beatles' Records and the Sixties*, Ian Macdonald argues that the musical, sexual and chemical innovations of the 1960s destroyed a largely Christian culture of deference to the Establishment and deferred gratification in consumption, replacing it with a secular culture of consumerism dedicated to the immediate satisfaction of personal desires. One outcome, claims MacDonald gloomily, was Thatcherism/Reaganism.

Whatever the merits of this argument, such an unfortunate outcome cannot be laid at the door of the Beatles alone. In sexual 'liberation', in the use of drugs, and in the loosening of performance in pop, the Stones were there first; their *un*controlled excitement, the mix of loose, back-of-the-beat playing and aggressive sounds which form their sonic signature make them world leaders of a revolution which transmitted aspects of Black American body language to an eager world. There was a revolution in the body, as well as the head, and it was led by the Rolling Stones. They were bad boys, and everyone knows it. In the New Year Honours for 1997, Paul McCartney received a knighthood. I doubt if we will ever hear the Monarch say 'Arise, Sir Mick'…

Notes

1 D. Laing (1969) *The Sound of Our Time*, London: Sheed & Ward.
2 S. Frith and A. Goodwin (eds) (1990) *On Record. Rock, Pop, and the Written Word*, London: Routledge, p.ix.
3 Laing *The Sound of Our Time*, p.65.
4 P. Hardy and D. Laing (eds) (1976) *The Encyclopedia of Rock, Volume II: from Liverpool to San Francisco*, St Albans: Panther, p.297.
5 L. Jones (1963) *Blues People: The Negro Experience in White America and the Music that Developed from it*, New York: William Morrow, p.166.
6 E. Ansermet, cited in Jones *Blues People*, p.175.
7 Jones *Blues People*, p.99.
8 Jones *Blues People*, p.50.
9 Jones *Blues People*, p.60.
10 Laing *The Sound of Our Time*, pp.5–6.
11 N. George (1988) *The Death of Rhythm and Blues*, London: Omnibus, p.92.
12 George *The Death of Rhythm and Blues*, p.92.
13 Jones *Blues People*, p.84.
14 George *The Death of Rhythm and Blues*, p.63.
15 D. Bradley (1992) *Understanding Rock 'n' Roll: Popular Music in Britain 1955–1964*, Buckingham: Open University Press, p.114.
16 R. Barthes (1977)'The Grain of the Voice', in *Image-Music-Text*, ed. S. Heath, London: Fontana.
17 Bradley *Understanding Rock 'n' Roll*, p.14.
18 Jones *Blues People*, p.173.
19 S. McClary and R. Walser (1990) 'Start making sense! Musicology wrestles with rock', in S. Frith and A. Goodwin (eds) *On Record*, p.288.
20 McClary and Walser 'Start making sense!', p.288.
21 McClary and Walser 'Start making sense!', p.288.
22 C. Belz (1969) *The Story of Rock*, New York: Oxford University Press, 1972 edition, p.133.
23 S. Frith (1978) *The Sociology of Rock*, London: Routledge, p.102.
24 Hardy and Laing *The Encyclopedia of Rock, Volume II*, p.299.
25 Belz *The Story of Rock*, p.155.
26 D. Stafford (1995) 'Mind the generation gap', *Guardian Weekend* 29 April 1995, p.78.
27 P. Norman (1989) *The Life and Good Times of the Rolling Stones*, London: Century Hutchinson, p.10.
28 Bradley *Understanding Rock 'n' Roll*, p.73.
29 Norman *The Life and Good Times of the Rolling Stones*, p.42.
30 W. Benjamin (1973) 'The Work of Art in the Age of Mechanical Reproduction', in W. Benjamin and H. Arendt (eds), *Illuminations*, London: Fontana.
31 Benjamin 'The Work of Art in the Age of Mechanical Reproduction', p.232.
32 N. Goodall (1995) *Jump Up: The Rise of the Rolling Stones*, London: Castle, p.41.
33 P. Gambaccini, J. Rice and T. Rice (1987) *British Hit Singles*, London: Guinness, p.207.
34 Belz *The Story of Rock*, p.156.
35 Listen to, for example, 'Dead Flowers', from the Rolling Stones album *Sticky Fingers* (Rolling Stones Records, 1971).
36 A. Hennion 'The production of success; an antimusicology of the pop song', in S. Frith and A. Goodwin (eds) (1990) *On Record*, p.188.
37 Belz, *The Story of Rock*, p.170.

38 From the television programme *Without Walls: J'accuse – the Rolling Stones* (produced and directed by Jeff Morgan for Fulmar Productions, Channel 4, 1990).
39 *Without Walls: J'accuse – the Rolling Stones.*
40 Jones *Blues People*, pp.187–8.
41 Bradley *Understanding Rock 'n' Roll*, p.13.
42 Jones *Blues People*, p.191.

2

WHITE LIGHT/WHITE HEAT

Jouissance beyond gender in the Velvet Underground

Jeremy Gilbert

Where were you in '88?

I turned 17 at the end of the summer of 1988, and I might as well tell you now
that acid house meant nothing to me. Where I was at least, it was something for
people with money. I didn't have any. I was a not untypical bored (White, male,
straight-if-that-counts-for-anything) adolescent, in a provincial town, in a
region (the North-West of England) battered by a decade of economic depres-
sion and political defeat. I belonged to a generation that was learning to be
articulate only in the languages of frustration and resignation, any other being
just too painful to speak.

So anyone with any knowledge of recent cultural history could tell you what
I should have been listening to. The Smiths, whose narratives of bored, frus-
trated North-Western adolescence seemed to sum up the experience of that
generation so acutely, and for whom I do retain *now* an inordinate affection,
were the band I should have had playing on my Walkman and emblazoned
across the back of my jacket. But I hated the bloody Smiths. Not that I didn't
know all of their songs (they were inescapable) and grant them a grudging
degree of respect; I knew that, in some sense, we needed them. But I didn't
want them. If there was one band that I wanted, that I was proud of (despite
them coming from another place, another era), that – it has to be said – I liked
to dress like, it was, as for so many generations of Thin White Boys, the Velvet
Underground.

I tried to explain *why* to a friend once, years later: 'I didn't need *telling* how
to be bored and lonely in a northern town', I said.

'You wanted someone to tell you it could be different!', he replied. He was
right.[1]

Not that I entertained any illusions about the glamour of heroin addiction or
urban alienation; even at 17 I knew enough about life in general and those
subjects in particular to have nothing but scorn for those who did. So what was

31

it that made the Velvets work on me (and so many other people that I grew up with) in quite that way, seeming to offer the promise of an urban intellectuality that would always be able to decode its own alienation successfully enough to avoid succumbing to it? (Unlike that of our friends the Smiths fans, the Cure fans and, worst of all, the goths.) What was it, if not the bleak pictures they painted of deprivation and despair? Was it nothing more than the New York cool of wraparound shades?

Answering this question properly will require a consideration of the effectivity of music in terms rather different from those provided by the cultural studies tradition to date. For that different mode of being that the Velvets seemed to offer was not encoded primarily in Lou Reed's post-beat, street poetry, or in the classic black-leather androgyne image that they perfected, but *in the sounds that they made.* However important all those factors might have been (as well as details such as the Andy Warhol artwork, the critical discourse that had already taught us to revere the Velvets as the fountainhead of the proto-punk, punk and post-punk canon, etc., etc.), they would have meant nothing if the air hadn't vibrated – shaking your ear-drums, your skin, your nerve endings, your bones – in just the ways it did whenever needle touched vinyl.

This is an account of the relationship between a set of musical texts and the articulation of an identity that would sit uneasily with received (sociological) models of such relationships. Most of what has been written on the subject would tend to imply that *music itself*, the sonic experience, is a largely insubstantial and incidental feature of our cultures. The belief (one which runs deep in Western culture) that it is only ever the codes of style and presentation, or the lyrics of songs, which confer any meaning at all on the radically indeterminate musical text is one that most writing in the cultural studies tradition has tended to replicate. In a field dominated by the interaction of sociologies with theories of the visual and the linguistic, it's hardly surprising that records have tended to be thought of as relatively secondary markers of cultural identity, to be chosen on the grounds of their (sub)cultural appropriateness only *after* one has chosen a hairstyle, a dress code, a lifestyle. And this choice is in itself generally thought of as little more than the inevitable expression of a pre-existing social identity, the making visible of one's specific sociological category. I want here to try to move beyond this approach in two related ways, emphasising both the significance of those irreducibly non-determined (or rather over/under-determined) moments at which cultural identities are *assumed* (rather than being merely *conferred*) and the frequent centrality of musical experiences to those moments.

The sound of the suburbs

I want to consider first just what it is that the sociological tradition of pop music studies would or would not have to say about my relationship to the Velvet Underground – what it might get wrong and what it might leave unsaid

– in order to get a clearer idea of just what a new and improved approach might need to do. The standard mould into which sociologists continue to try to fit any cultural activity engaged in by young people and focused on music is that of 'subculture', despite a tradition of critiques of that model almost as old now as the model itself. But it's a model that clearly doesn't offer any realistic account of my relationship to the Velvets, or to the various friends and chance acquaintances with whom I shared (and have continued to share) something *more* than the empirical accident of knowing the same tunes, but which can hardly be said to characterise us as belonging to a discrete and homogeneous cultural group. It doesn't offer a realistic account of the relationships of many other people to the various musical texts and events that have shaped their subjectivities. We can begin to get a sense of this by looking back briefly to the high moment of subcultural theory and practice: punk.

Dick Hebdige's seminal work *Subculture: The Meaning of Style*, despite all of its radical implications and its historical indispensability, did manage to exemplify the elitism with which much subcultural discourse – especially around punk – has been charged. In particular, a certain character is left out of Hebdige's story of punk. He writes that

> not...all punks were equally aware of the disjunction between experience and signification upon which the whole style was ultimately based. The style no doubt made sense for the first wave of self-conscious innovators in a way which remained inaccessible to those who became punks after the subculture had surfaced and become publicised.[2]

As it happens, punk's most self-conscious innovator quite agreed.

> Interviewed in *New Music News*, [Malcolm] McLaren provocatively declares that buying the Pistols' records was never the point of punk. The interviewer suggests that playing the records was the only way that a 'sixteen-year old kid in his room with nowhere to go' could feel involved.
> MC: That's sad, really sad. I would prefer him to play nothing. Kick the TV in, smash his mother...[3]

The 16-year-old, pogoing around the bedroom, deciding to 'be a punk' after seeing the Sex Pistols on TV; this is the character that Hebdige and McLaren collude in excluding from their subcultural narratives. And yet there have been a lot more 16-year-olds stuck in their rooms in the world than there have been militant situationist *bricoleurs*. Note that both of these passages imply that only by being present in punk's originary situation (presumably one of the 'legendary' early Pistols gigs) could one fully enter into punk identity. Note that (if only by implication) the denigrated, secondary, inessential mode of

experiencing punk is in both cases the utilisation of a particular commodity: the *record*. And yet, it can hardly be a controversial statement that had 'punk' been confined to the few hundred people who went to see the Pistols before they released any records, it would have been a small local event of absolutely no historical importance whatsoever. It was precisely its dissemination away from its privileged originary sites, away from the sites that would guarantee its full and self-present ('self-conscious') meaning, into the dispersed and commodified culture of adolescent bedrooms, record shops, local discos and sixth-form common rooms that gave it any importance it might have had. How much more removed from the originary site of the Velvet Underground (the New York art scene of the late 1960s) was my own experience of them, and that of the countless young British people – including many who have gone on to become some of our most innovative musicians – who have grown up listening to them.

These comments from Hebdige and McLaren are examples of the persistent attachment of both sociologists of subculture *and* self-styled participants in subcultures to a notion of authentic experience, unmediated by the mass media and outside the networks of commodified exchange. Recent commentators such as Steve Redhead[4] and Sarah Thornton[5] have consistently demonstrated the theoretical *and* empirical inadequacy of such a notion. I want here to push these arguments still further and consider the implications of the observation that in contemporary culture it is *only* once they enter into the disseminating networks of media culture and commodity circulation that events or texts acquire any significance. It isn't hard to see that what we have in these subcultural dreams of unmediated, uncommodifiable experience is a quite literal manifestation of what Derrida calls the metaphysics of presence.[6] While Hebdige's own account of 'style' as a conscious collective reworking of commodities already involved an implicit understanding of the always already commodified/disseminated status of contemporary cultures (an understanding that his own subsequent work was to develop with clarity and perception), gestures such as the one just referred to have persistently constituted subcultural discourse in the terms of this eminently traditional (and inherently elitist) metaphysics. An ideal of undifferentiated experience in a unique and undispersable moment ('the underground', or sometimes simply the 'real') is always counterposed to a denigrated notion of inauthentic repetition and fragmented experience (the 'mainstream', the 'commercial').[7] And yet, as we might expect if we have internalised Derrida's claim that all 'communication' actually occurs under conditions of 'dissemination', it's clear enough that at least for people like me, it is *only* that process of dissemination that has made available and rendered significant some of the most important shared experiences to have shaped our senses of self and of our places in the world. For just about anyone who grew up listening to records more than attending gigs,[8] it would be true to say that commodification and dissemination are not things that simply *happen to* our cultures, they are the very medium in which those cultures exist and function.[9]

34

This is quite different from making the claim – which we might make if we were to follow Baudrillard[10] – that the commodification of meaning in the post-modern world has led to the disappearance of some authentic objects: reality, lived experience, truth. For as Derrida makes us aware, dissemination has always been a condition of possibility of meaning itself. On the other hand, this is not to deny that the conditions we live under now are historically specific. As Laclau has pointed out, 'The dissolution of the metaphysics of presence is not a purely intellectual operation. It is profoundly inscribed in the whole experience of recent decades.'[11]. Indeed, as the Marx of the *Communist Manifesto* was already noting 150 years ago, our experiences of self and others, meaning and identity, have been increasingly subject to the specifically dislocatory logic of capitalism as it has penetrated our daily lives over the past two centuries, making our experience of these phenomena far more disseminated than they might once have been. But the disruption and dislocation of traditional communities of meaning does not necessarily always leave us floating free in a world of simulacra without referent, anomic individuals with no sense of place, self, or society. It can, at times, enable the construction of new identities and even new communities (what Dick Hebdige has termed communities of *affect*[12]).

Disseminated communities

My experience of the Velvets was certainly a disseminated one. In literal terms they had nothing to do with my life or its situation. But they formed a part of a common culture of large numbers of adolescents and young adults at that time. This was a moment at which the articulation of the then emergent (although we didn't recognise it as such) 'indie' culture still depended very much on a particular evaluation of the key historical moments of the mid-to-late 1960s and 'punk', and their respective legacies, an evaluation that generally acknowledged the Velvets as both the key link between these moments (godparents of punk, simultaneous advocates and critics of 1960s decadence) and the key originators of rock avant-gardism's Great Tradition. Their self-conscious synthesis of the extremes of both avant-garde music (John Cale had worked with La Monte Young) and pop (Lou Reed had worked as a tin-pan alley songwriter) seemed to be the starting point for all of the various (and at times contradictory) agendas that had been propagated by every significant rock 'movement' since the mid-1970s. And yet it was only their dispersal *away from* this originary moment and into the networks of exchange and relay, influence and rediscovery that lent them their mystique and their importance. Only when their radical *heterogeneity* had been played out to the point of being cited as 'key influences' on *both* arch quiet-rockers like the Cowboy Junkies *and* their New York noise merchant contemporaries Sonic Youth did they acquire the status of a unitary (mythic) origin. Always already disseminated, 'the Velvet Underground' only existed through their dispersal and fragmentation.

At the same time, they constituted in themselves an important point of

semi-identification, of shared (if always differentiated) experience. One probably knew just about everyone in town who owned a Velvets' record. Not that that would have been the only thing you had in common with them; they'd also own Smiths, Jesus and Mary Chain and – depending on inclination – either Crass or Neil Young records. They'd probably smoke dope, but without the self-conscious ritual of Gong fans. They probably wore black jeans and DMs but would have avoided doing anything too gauchely extreme with their hair. Even if you didn't know each other you could certainly recognise each other in the street. And this wasn't just local to where I lived. When I first moved to London to go to university, *liking the Velvets* was something to have in common with Spanish students as much as other provincial English kids. They too had experienced them as a constant of a culture that was made in second-hand record shops, market stalls selling cheap posters, and occasional 'indie–alternative' discos, in music press retrospectives and in the potted biographies of countless bands citing them as progenitors and inspirations.

But it still wasn't as if one would have felt that one had a *great deal* in common with other people who owned Velvets records; one wouldn't accost a stranger who was wearing a Velvets T-shirt (although the fact that people wore Velvets T-shirts at all – 20 years after their last release – says something in itself). Nobody belonged to a Velvets fan club. This wasn't a coherent and homogeneous 'subculture'. What was significant about the Velvets was the simple fact that they had – unlike almost any other band you could think of – probably been a fixture of every punkish or post-punkish person's record, poster and T-shirt collection for at least ten years; that Mark E. Smith (benign dictator of the Fall), Siouxsie (and the Banshees) and Ian Curtis (tragic hero of Joy Division) might have all hated each other's music when competing in the post-punk market-place of 1979, but would certainly all have known all the words to 'Heroin', just as could be said of Ian McCullough, Bobbie Gillespie or Johnny Marr (competing for top slots in the indie charts then). It wasn't just their awesome influence and the mystique of originating authorship, or their subcultural significance, or even the devoted passion they inspired (they didn't necessarily), but the simple dis/continuity of a shared experience of *listening to them* that rendered the Velvets as crucial to some sense of *tradition*.

David Fricke writes:

> Just about every artist or band that has subscribed to the avant-garage ideals of 70s and 80s rock owes a great debt of influence and sacrifice to the Velvets. Covering Velvets songs has, for many of those acts become a major industry and art form in itself. Any dream compilation of VU remakes would certainly include Bowie's high-voltage thrashing of 'I'm Waiting For the Man' during his 1972 Ziggy Stardust stage shows; Mott the Hoople's Glam-jam on 'Sweet Jane' (a major car-radio treat in the early 70s); REM's pastel treatments of 'Femme Fatale' and 'Pale Blue Eyes'; and the scruffy crunch-pop of Kurt

Cobain's version of 'Here She Comes' recorded for a 1991 Velvets tribute LP.

But then there were all the people who didn't form bands, the ones who communed with those records in private – listening to them over and over again the way you'd return to a favourite book or poem – and who found their own pleasure and solace in the Velvets' uncompromising sound and intensely focused vision. Being a Velvets fan has always been something of a loner's joy, the common bond of rebel fraternities.[13]

So this was a culture of disseminated meanings and circulated commodities, a culture whose significances were undoubtedly *real* but that were never homogeneous and that radically problematised the metaphysical distinctions of traditional subcultural discourse (real/artificial, original/secondary, live/recorded, presence/absence, commercial/underground). A culture constituted within the horizon of dissemination, but also – as I've already suggested and as Fricke makes clear – constituted according to processes of *repetition*: repetition in the form of covers; repetition in the form of repeated listening. What do we make of this paradoxical phenomenon, this community of loners constituted only by these insistent repetitions?

I'm led back – again – to Jacques Derrida. Derrida has pointed out that *iterability*, the possibility of repetition in a different context (a context whose specificity will always render the specific event of repetition as a unique and *singular* event), is a necessary characteristic of any mark, text, event which can *mean* at all:

A written sign, in the usual sense of the word, is...a mark which remains, which is not exhausted in the presence of its inscription, and which can give rise to an iteration both in the absence of and beyond the presence of the empirically determined subject who, in a given context, has emitted or produced it....

...a written sign carries with it a force of breaking with its context, that is, the set of presences which organise the moment of its inscription. This force of breaking is not an accidental predicate, but the very structure of the written....

Are these...predicates, along with the entire system joined to them, reserved, as is so often believed, for *written* communication, in the narrow sense of the word? Are they not also found in all languages, for example in spoken language, and ultimately in the totality of *experience*...?[14]

In the context of this discussion, it's precisely the persistent iterability of the Velvet Underground albums that has enabled those records to act as points of identification for, and points of contact between, various groups and individuals

for almost thirty years. Derrida insists that the *readability* of texts is always dependent on their rupturing force, their capacity to break with the original moment of their inscription. Undeniably, certain texts seem to be more able to effect these ruptures, establishing themselves in different contexts, *meaning* something to large numbers of people over time, than others. It seems that what's notable about the Velvet Underground albums is precisely their extraordinary capacity for just such (re-)iteration. They have been able to 'stand the test of time' not, as that phrase would usually imply, by remaining intact and integral despite the passage of time, but on the contrary by remaining iterable and disseminable long after the moment of their inscription has passed, resisting those cultural, economic, political forces that would tend to drive them into obscurity and ineffectuality. By the same token, the cultural formation, what we might call the *listening community* in which that significance has been effected, must be understood as being constituted precisely by its very *dissemination*.

Musical identifications

The observation that a community (however dispersed) can exist on the basis of the dissemination of a particular set of texts raises an obvious question: just what is the nature of the relationship between the subjects making up this community and the texts that are so central to it? Now, in this case, asking this question brings us back to the problematic issue of the relationship between music and the listening subject. What's at stake, in fact, is the question of just how it is that music works on us and who we are. The models of musical identity that have informed much work around 'youth culture' in particular tend to fall into the (intimately related) categories of what we might call the 'representative' and the 'sociological-expressive'. People identify with particular music discourses because they see *themselves as they believe themselves to be* represented in them, or they identify with music discourses that can be heard as possessing a strict homological relationship with the values and lifestyles of the social group to which they belong. In either case the identity of the listening subject and the community to which s/he belongs is presumed to be fully constituted prior to any musical activity (active or passive) taking place. Music discourse[15] simply represents or expresses that pre-constituted identity (and in general the actual sonic aspects of that music are treated as relatively incidental anyway).

These accounts are inadequate because music, as Simon Frith has recently suggested,[16] can *shape* identities as much as it can reflect them. I didn't (and I suspect that the thousands of others who've listened to them didn't) listen to the Velvets to find out who I *was* but in order to consider who I *could be*. Understanding this process requires a psychoanalytic rather than a sociological account of such relationships; they occur along the imaginary axis of fantasy rather than as functions of an existing social location, and it is as such that they can constitute both identities and communities in themselves, acting as powerful points for collective identification.

So what models can we look to to help us understand this process? We might choose to think in terms of Lacan's account of imaginary identification;[17] we look up and see ourselves as we would like to be, and this somehow shapes our sense of who we are. Certainly this is an invaluable model with which to understand the types of libidinal relation that young people often have to their role models. Just as the Lacanian infant, seeing his or her reflection in the mirror,[18] constructs an ideal ego on the basis of this image of wholeness and self-present integrity, a young person might look at a TV screen or a photograph and see in the apparently self-contained cool of a Lou Reed (or a Madonna or a Noel Gallagher) an image of contradictions resolved, identity made whole and perfect, to which he or she might aspire. What artists like the Velvets do is to add a powerful and powerfully reiterable element to what Barthes calls 'the image repertoire', the menu of possible ideal egos according to which we can relate to the world.

On the other hand, really to understand both the Velvet Underground and the reasons why someone might want to identify with them in Lacanian terms,[19] we must consider the account of *symbolic* identification as identification with the Other whose desire is sought, identification with *position of the gaze* from which the subject is viewed and found desirable. Here we might have an account of why so many people have identified with a band whose most famous songs are mostly records of abjection, isolation, alienation and loss. For although these may be the subject matter of the Velvet Underground's songs, and although on an imaginary level this was the position taken up by the Velvets themselves, the *symbolic* identification of both the Velvets and their fans is not with the junkie, the paranoiac, the hustler or the freak, but with an idealised image of the detached observer who can walk through this urban twilight and (through the intellectualising and distanciating medium of avant-garde rock) make it into something beautiful. What the Velvets offer, when their records are thus read along the symbolic axis, is not a romanticisation of urban alienation, but a promise of survival, and even pleasure, under the difficult and often painful conditions of late twentieth-century modernity. It is the fact that their songs retain a beauty despite the horrors they narrate that makes them powerful points of identification for so many trying to survive the rigours of that modernity.

And yet this brings us already to an impasse. For it is surely not enough merely to assert that the Velvets' records somehow create beauty out of abjection; we must work towards some account of where this 'beauty' comes from, how it works. And to do this we must find ways of discussing what is specific to the Velvet Underground's *music* that has enabled such identification. Lacanian theory frankly stops dead at this point. Constructed entirely within a *specular* economy, the Lacanian subject might well look at a picture and see *himself as he would like to be* in an image of the Velvet Underground. He might well identify with the gaze *of* the Velvet Underground, taking pleasure in the ability to look

on the most frightening scenes of urban modernity and to turn those sources of fear into sources of pleasure. But she wouldn't *hear* anything.

I'm not the first to suggest that it's impossible to break out of this oculocentric schema without breaking with the Lacanian model of the subject, moving towards a model which does not consign the body (the site of sexual difference) to the unalterable realm of the Real. Irigaray pointed out 20 years ago[20] that Freud and Lacan perpetuate a model of subjectivity, identification and desire that privileges the specular and the masculine entirely at the expense of the tactile, the material, and the feminine. It's hardly coincidence that the entire history of writing on music within the Western tradition has maintained just this same hierarchy, always becoming uncomfortable when asked to consider *sound* as something other than a meaningless accompaniment to word and image. The phallogocentric tradition with which Lacanian theory seems so often complicit doesn't want to know about those mysterious vibrations which seem to affect the body itself.

Music, unlike all those visual and linguistic media with which Lacanian cultural theory has traditionally concerned itself is not registered only by the optic nerves and the brain. It vibrates through the whole body. Sound waves, vibrating far more slowly than light waves, render music in a certain literal sense *more material* than other media. Music, it seems, is experienced on a level that is not that of the symbolic or the imaginary (however much its effects may interact with those levels). To understand this process properly, we would perhaps therefore need new ways of understanding processes of identification in general. We would need models that, following Derrida's 'thought of the *trace*', go beyond the rigid distinctions between symbolic and imaginary, linguistic and non-linguistic, signifiers and signifieds, body and mind. Borch-Jacobsen's model of 'mimetic identification', according to which *mimesis* is seen as the originary form of all identification,[21] might be seen here to converge with Richard Middleton's model of musical effect conceived in terms of somatic *gesture*.[22] This might lead us still further away from the image of the already constituted subject entering into relations with a series of objects, towards a model of subjectivity literally *shaped* by its encounters with those objects (and this model would have to problematise the very subject/object distinction), of which music would be one. Such an account would in fact sit very neatly with those accounts of musical meaning/effect that posit an isomorphic relationship between the body itself and the structures, the very physical *shapes* of music (how far such an account would hold for all forms of discourse, not just music, would be a question for another place and time).

Such writers have in particular sought to explain music's meanings/effects in terms of an isomorphic relationship between music and the *gendered* body. It's perhaps fitting, given the implications of her critique of psychoanalysis, that it's Irigaray who would appear to provide the (often unacknowledged, but obvious enough) inspiration for such work. The critical musicologists John Shepherd[23] and Susan McClary[24] both link the predominance of certain forms and certain

aesthetic hierarchies within the Western musical tradition to the hegemony of masculine sexuality within Western culture, in terms very similar to Irigaray's account of the denigration of the tactile, the material, the plural and the feminine in Western philosophy. The phallically powerful and unilinear symphonies of the Romantic tradition are read as material enactments of masculine hegemony. In opposition to it, minimal and cyclical forms (from the Renaissance to the work of Cage, Glass and Riley) and polyphonic arrangements are valorised as offering a counter-discourse to this dominant one, a feminine music not a million miles away from Cixous's *écriture feminine*. And it isn't just the classical tradition that can be mapped according to such a scheme.

Queer rock

In the field of rock music, where the Velvet Underground surely belong, a similar map has been drawn by Simon Reynolds and Joy Press. In their book *The Sex Revolts*, they read the entire field of male-produced rock music according to a particular psychoanalytic dichotomy. They divide all such music into two camps: rebel rock, motivated by a hyper-Oedipal rejection of the maternal-feminine in all its forms (and obviously intimately connected to the dominant Western tradition as conceived by McClary and Shepherd); and/or pre-Oedipal psychedelia, always nostalgic for the undifferentiated experience of the womb (obviously a form of *musique feminine*). The two most obvious political questions raised here, the question of how one fits rock music made by women into this scheme and the question of whether one reads the discourse of feminised, pre-Oedipal rock as reinscribing or subverting patriarchal norms, are both acknowledged by Reynolds and Press as key questions – which remain resolutely unanswered. The logical politico-aesthetic conclusion of their psychic cartography, however, would seem to be to take up a difference-feminist position much like that of Shepherd and McClary, and Reynolds's advocacy elsewhere of 'wombadelic' 'oceanic rock'[25] would seem to confirm this.

I would suggest that McClary, Shepherd, Reynolds and Press have almost got it right. Almost, but not quite, and it's a consideration of how the Velvets might fit into this schema that will enable us to unravel it and rewrite it. As well as being commonly cited as 'godfathers of punk' and influential on any number of noisy guitar bands (e.g. the Jesus and Mary Chain), the Velvet Underground's later work is also commonly cited as influential on a number of bands whose music is characterised by quiet sounds, minimal percussion and ethereal vocal lines (e.g. REM). In fact, the very presence in the rock canon of the Velvet Underground (who barely get a mention in *The Sex Revolts*) poses serious problems for Press and Reynolds's binary model. Any proper consideration of their traditions of 'oceanic rock' on the one hand and 'warrior punk' on the other would end up revealing the Velvets as not just straddling the two, but occupying a central place in *both* 'opposing' traditions. Speed-freak noiseniks *and* drone-smothered slackers, the Velvets did (indeed, for the most part

invented) everything that Reynolds and Press posit as defining each of their two opposing camps of Rock.

This doesn't mean that Reynolds and Press's schema is invalid. Rather, it can be said that the Velvets belong to a third rock (or perhaps, to re-contextualise a current term, *post-rock*) tradition, an avant-garde tradition that has always sought to *disrupt* the gender binaries that inform the musical forms ('classical' and 'popular') of Western culture. What the Velvet Underground did was to challenge not just the stylistic but also the *formal* conventions of rock in a way that still upsets the terms both of 'rebel rock' and 'oceanic psychedelia'. For instance, while conventional rock instrumentation maintains the phallic drive of the rhythm section primarily through the persistent and monologic unity of the bass and drums, the Velvets would frequently abandon this formula altogether, while adding to the guitar/drums/vocal ensemble the fluid drone of John Cale's viola (but without allowing the rhythm to become entirely submerged),[26] creating an effect that departed from rock's phallocentric norms without simply reversing its terms, a sound that according to the criteria of a simplistically psychoanalytic aesthetic, it would be hard to characterise as either 'masculine' or 'feminine'. Other such disruptions include their use on one track of a merely spoken vocal line over an ambling improvisation,[27] breaking up the usual unity of voice and instruments. Another key example is their use of electric feedback; while Jimi Hendrix deployed the resources inherent in electronic amplification largely to extend the melodic range of his instrument and thereby to secure his place as the ultimate phallocentric guitar hero – while always staring heroically into the abyss of white-noise oblivion[28] – the Velvets treated the moment of over-amplification as a moment at which the musician's individual control is *problematised* by the materiality *and* collectivity of sound without being merely *relinquished*.[29]

This list could go on, as could the list of artists (the Fall, New Order, the Raincoats, etc., etc.) who – more often than not directly inspired by the Velvets – carried out similar procedures and who also hardly get a mention in *The Sex Revolts*. Disrupting (rather than merely reversing) the very terms of the discourse (the phallocentric discourse of rock) in which they participate and intervene, the artists in this tradition have consistently created musical texts that have proved able to break with the situation of their inscription, enabling the possibility of their own persistent reiteration *as* new situations.

I would argue, therefore, that the Velvets' music derives its power precisely from its material subversion of the terms of those deeply sedimented discourses that define the parameters of gender in our culture. The discourses that our feminist musicologists see as shaping both gender and music do indeed, I think, function as they suggest, and as such the articulation of 'feminine' musics can at times be a radical and important gesture. But at other times what is needed is not simply a reversal of those hierarchical binaries that define our culture but a deconstructive displacement of them. Following Judith Butler, we might argue that the materiality of gendered bodies is itself an effect of power, of the cita-

tional authority of some of the most deeply sedimented discourses in our culture.[30] But also following Judith Butler, we could argue that we must at times – if we are not merely to reinscribe the phallocentric terms of patriarchal culture and the imperatives of the heterosexual matrix – seek to disrupt these discourses altogether. While essentialists and Lacanians would tend to refute the very possibility of such displacements, the Velvet Underground's music stands as a material example of both their possibility and their effectiveness. In vibrating in its precise patterns it offers a mode of experiencing the body that moves outside, beyond, between, *beneath* the limitations of the gender binary. If we were to call such a music – in deference to Judith Butler – 'queer', it could hardly be applied more appropriately than to the band whose first album was (nominally, at least) produced by Andy Warhol and who directly inspired (among many others) the original pop gender bender, David Bowie.

And there's no one better placed to help us understand the godfathers of punk than a writer who might arguably deserve to be recognised as a godfather of queer theory: Roland Barthes. It was Barthes who years ago wondered if a very different musical aesthetic to that dominant in the West over the past two centuries might not be available to us if we were to consider the timbral, textural, material, corporeal qualities of sound rather than the merely tonal. In his famous essay, Barthes draws attention to the significance of attending to what he calls the *grain* of the singing voice: 'The "grain" is the body in the voice as it sings, the hand as it writes, the limb as it performs'. For Barthes the role of 'grain', material texture, in singing is to open up *signifiance*, that plea- surable process that derives from the action of the signifier itself, beyond, superfluous to and independent of the act of signification, making 'grain' some- thing much more than merely timbre. Making it, in fact, the route to *jouissance*. Now, different writers have given different inflections to this term, designating as it does an excessive, ecstatic pleasure that is beyond (or before) meaning. What is perhaps most significant about Barthes's deployment of the term is his claim, in *The Pleasure of the Text*,[31] that *jouissance* is (unlike, in, say, Lacan's account) *neuter*. And if *jouissance* is neuter it can only be because it escapes or precedes the regulating discourse of gender.

We can clearly see the relevance of Barthes' account to a consideration of the Velvet Underground. They were the original noise band, the first to explore properly the *timbral* possibilities of electric amplification (of guitars, organ, even viola), such that few would dispute Dave Thompson's claim that 'It's a convoluted route from David Bowie to The Mary Chain, but wherever there's feedback, The Velvets will be lurking.'[32] If rock music's most significant (*signifiant?*) contribution to the exploration of *grain* is (and it surely is) the exploration of electric distortion, then the Velvets can claim an unrivalled importance in the history of that exploration. At their most memorable moments (*Sister Ray* above all), their noise and static overturns every conven- tion of bourgeois song, always teetering on the brink of chaos, *without* ever collapsing into the white noise of a sound that – imagining that it can escape

altogether music's metaphysical moorings – would lose itself entirely in the primal roar. Deconstruction.

Boys keep swinging

And yet, we mustn't forget that deconstruction always occurs *within* a given situation. Clearly listening to the Velvet Underground would not have this astonishingly liberating effect, this instant queering power, on the vast majority of the human race. A deconstruction of rock's gender binaries isn't going to mean much to anyone who hasn't to some extent already been constituted by them. And it's this observation that will bring me back, in fact, to the observation that no attempt to grapple with the complexities of contemporary culture can afford to forgo sociology entirely.[33] There are, in fact, fairly predictable sociological co-ordinates for your typical Velvets fan. A friend of mine has a wonderful phrase to describe that quite specific cultural formation to which the Velvet Underground have always been central. They are the epitome, he insists, of 'Thin White Boys' Music'.[34] This has been a music by and large for young White men coming from or aspiring to the class of salaried intellectuals (professionals, artists, media workers, etc.) – with all of the ambiguity of class identity which that implies – and uncomfortable with the conventional gendered identities offered by the dominant strands of popular culture, but unable – usually for the fairly obvious reason of not experiencing themselves as homosexual – to fully embrace gay culture. A specific sociological position, then, but also a specifically *political* one.[35] It's perhaps only the coincidence of these two factors that has ever caused the Velvets to mean anything to anyone: on the one hand, being culturally located *within* rock culture (in ways which, for instance, relatively few women have ever been) and those versions of White heterosexual masculinity that it so powerfully constitutes; on the other, wishing to articulate an identity that could refuse the normalising imperatives of hegemonic masculinity. We could, in fact, put an even more reductively sociological spin on this observation, and point out that such identities may frequently be accounted for in terms applicable to most post-war avant-garde movements, in music at least. What do you do if you are a White middle-class man who nevertheless wishes to oppose the dominant values of your society because of a commitment to a socialist and/or feminist and/or anti-racist and/or anti-homophobic politics?[36] Answer: either you appropriate the culture of some other, more marginal group (always risky), or you work from within your own culture to subvert its terms in the most extreme manner possible (or both; in fact this is probably the most common strategy). This arguably, is the logic that has informed most avant-garde musics at least since the 1960s, and the tradition of post-Velvets rock avant-gardism is no exception.

This isn't, however, as simple a explanation as it may sound, for it begs the question of just where it is that such political commitments come from in the first place. Well, they may come from our parents, from our work experiences,

from books or from TV. But let me tell you that in my case, to paraphrase Nick Hornby's Rob Fleming,[37] I know that I've been a Velvets fan longer than I've had a clearly articulated commitment to anti-essentialist feminism. And although, as the story of my musical identity continues it becomes less and less typical, it must mean something that of all the music I listened to when I was 17, of which there isn't much now that doesn't leave me feeling just a little uncomfortable (and almost always because of its relative complicity with phallo-centrism, compulsory heterosexuality, bourgeois individualism or 'fear of a Black planet'), the Velvets are one thing that this almost-grown-up Professional Cultural Theorist can still listen to without a tremor of embarrassment. And I can say, and perhaps many others can, that although I may not have been conscious of it at the time, that I might not have adopted such political positions so easily had the only available soundtrack to a speed-fuelled teenage drive through the city been Guns 'n' Roses or the Smiths. If *Sister Ray*'s deconstructive noise hadn't made available to me a *jouissance* beyond the confines of masculinity or its mere abjection, I might have been a different (and it has to be said, in political terms, *worse*) person than I am today.

The Velvets offered – and still offer – an image and a mythology with which a suburban White boy (or girl; but that would be another story, and not one I'm entirely qualified to tell) could identify while at the same time finding in it the resources for the articulation of a counter-hegemonic identity. And as important as the image and the mythology have always been, it remains the androgyny of their *music* that enables them to effect such a radical problemati-sation of the masculine-heterosexual imperatives of rock discourse. Their records offer not just a set of slogans and catch-phrases, but a physical experience with potentially transformatory implications, a possible rearticulation of one's own experience of one's body. And it's their very radicalism that explains their peculiar aptitude for reiteration and dissemination; their break with the moment of their inscription was such that the force of that rupture continues to carry them and disperse them into many different contexts. Of course, those multifarious contexts will constitute multifarious specific situations, in which the effects and meanings of the Velvets' records will always be different. But at the same time, the discourses that construct our gendered identities are among the most ubiquitous and the most deeply sedimented in our culture, and as long as the phallocentric discourse of rock continues to be one of the primary sites for the articulation of identities (young and old), the Velvets will be there to offer the resources for its deconstruction and its refusal. At a moment when that emergent marginal formation of the late 1980s, *indie rock*, appears to be taking part in a bid for genuine hegemony, when record companies, the press, the BBC, the leadership of the Labour Party, and huge sections of the population all seem intent on (re-)inscribing a notion of Britishness to which Oasis's reactionary rock masculinity will be absolutely central, we may need them more than ever.

After '88...

They were a weird coalition, those indie discos. The now 'legendary' *NME C86* compilation album that had defined their genre had been a strange collection of definitive jangly pop, post-punk avant-garde and pure 1960s retro. 'Indie/alternative' nights catered to punks, goths, indie kids, rockers (not that the boundaries were always clear), even the odd hip-hop tune got played. But they were mostly places where no one got much of what they wanted, and that moment of disparate disaffection was never likely to last. For many of us it was only a matter of time before we realised that the term 'dance music' had ceased to designate a Thatcherite soundtrack for yuppies and lager boys, that disco didn't suck any more (not that it ever should have done; but that's another story). Acid house had paved the way for a whole new world, where both our tastes for formal musical experimentation and our dreams of narcotic *jouissance* could be indulged as we had ever imagined possible. But the rest? The indie kids and retro-rockers who never really bought into rave's brave dream (sure, they necked the odd E, and probably still do; they bought Primal Scream, and later, Chemical Brothers records, but they never really *believed* it...) regrouped as well. And where once guitar rock was fragmented, the province of Smiths fans, U2 fans and Guns 'n' Roses *aficionados* who hardly shared the same universe, let alone the same tastes in music, it seemed for a while that Britpop – above all Oasis – had managed to bring together a whole new constituency around an ideal of musical classicism, cultural nostalgia and ethnic purity.

At least, those are the terms in which indie's aspiration to hegemonic status were initially cast. I don't think that the early versions of this discourse had much room in them for anything as dangerous as the Velvets. Between 1993 and 1996 it was the Kinks (whose potential affinities with the Velvets were carefully overlooked), the Who (ditto) and a version of the Beatles that somehow managed to forget that they invented the-recording-studio-as-instrument and pop-as-the-deconstruction-of-rock that were looked back on as the best things from the 1960s. But Britpop's high moment having passed, the cultural landscape looks different in ways that I can only say I could never have dreamed of in 1988. Despite the BBC's almost obsessive support for that particular movement, it continues to make more space for rap, reggae, house and jungle than has ever been available before. The revolution to which acid house was central changed too many terms, created too many possibilities, broke open too many new routes for any mere conservative reaction to hold ground for long. Even the Gallagher brothers are obliged to make oblique gestures of affiliation to a sensibility which is indisputably *post-'88* (if only in the form of a simplistic hedonism and a stated nostalgia for the innocent pleasures of rave's golden moment). And it remains the case even today that wherever pop and possibility converge, however unlikely – even, not so long ago, unthinkable – the setting, the Velvets will be there as a reminder and an inspiration. On a summer afternoon in 1997, Jo Whiley played the Velvets classic 'Venus in Furs' on BBC

Radio One. What's perhaps more exciting is that, as impossible as such an occurence would have seemed three years before, it now seemed barely surprising.[38] But if someone somewhere wasn't having their life changed at that moment, I'd be very surprised.

Notes

1 Simon Coppock is the name of that friend, and I'd like to thank him for the insight.
2 D. Hebdige (1979) *Subculture: the Meaning of Style*, London: Methuen, p.122.
3 S. Reynolds and J. Press (1995) *The Sex Revolts*, London: Serpent's Tail, p.39.
4 S. Redhead (1990) *The End of the Century Party*, Manchester: Manchester University Press.
5 S. Thornton (1996) *Club Cultures*, Cambridge: Polity.
6 See in particular J. Derrida (1973) *Speech and Phenomenon*, trans. D. Allison, Evanston: Northwestern University Press.
7 Thornton *Club Cultures*, Chapter 2.
8 For a brilliant account of the development of this central phenomenon of contemporary culture, see Thornton *Club Cultures*, pp.14–25.
9 I would emphasise here that this simple observation in itself demonstrates the validity of many of Derrida's philosophical claims and the (extraordinarily undervalued) applicability of his work to key problems in contemporary cultural theory.
10 J. Baudrillard (1988) 'Simulacra and simulations', in *Jean Baudrillard: Selected Writings*, ed. M. Poster, Cambridge: Polity. Jacques Attali offers a rather more complex, if not entirely dissimilar, consideration of the changing order of representation within which music is constituted in Chapter 4 of his *Noise*, trans. B. Massumi (1985), Manchester: Manchester University Press.
11 E. Laclau (1996) *Emancipations*, London: Verso, p.82.
12 D. Hebdige (1989) 'After the Masses', in S. Hall and M. Jacques (eds) *New Times*, London: Lawrence & Wishart.
13 Essay accompanying the boxed CD set *Peel Slowly and See* (Polygram, 1995).
14 J. Derrida (1988) 'Signature, Event, Context' in *Limited Inc.*, trans. Jeffrey Mellmann, Evanston: Northwestern University Press, p.10.
15 I'm using the term 'music discourse' following Robert Walser's brilliant account of music as discourse in his *Running With the Devil: Power, Gender and Madness in Heavy Metal Music*, Hanover and London: Wesleyan University Press, 1995.
16 S. Frith 'Music and identity', in S. Hall and P. du Gay (eds) (1996) *Questions of Cultural Identity*, London: Sage.
17 For an interesting Lacanian reading of the functionality and meanings of a piece of popular music, see Sean Cubitt's essay (1984) 'Maybellene: meaning and the listening subject', *Popular Music*, vol. 4(2), which is useful and precise as far as it goes, but which does not even consider going *beyond* Lacan.
18 J. Lacan (1977) *Écrits. A selection*, London: Tavistock.
19 This is most clearly explained in S. Zizek (1989) *The Sublime Object of Ideology*, London: Verso, p.104.
20 L. Irigaray (1985) *Speculum of the Other Woman*, trans. G. Gill, Ithaca: Cornell University Press. See also Chapter 1 of J. Butler (1993) *Bodies that Matter*, London: Routledge.
21 Kristeva, who acknowledges music's pre-linguistic status, might offer some answers, although the notion of a 'pre-linguistic' perhaps still maintains too rigid a distinction between the linguistic and the non-linguistic. Laplanche might offer a more finely grained alternative.

22 R. Middleton (1993) 'Popular music and musicology: bridging the gap', in *Popular Music*, 12(2), pp.177–90. Middleton's notion of musical gesture might be here read as not a million miles away from Lyotards's notion of *figure*.

23 J. Shepherd (1991) *Music as Social Text*, Cambridge: Polity.

24 S. McClary (1991) *Feminine Endings*, Minneapolis: University of Minneapolis Press.

25 S. Reynolds (1993) *Blissed Out: The Raptures of Rock*, London: Serpent's Tail.

26 Hear, for instance, 'Venus in Furs' on *The Velvet Underground and Nico* (MGM, 1967).

27 'The Gift' on *White Light/White Heat* (MGM, 1968).

28 Okay, I admit it: this is a cheap shot at Hendrix. His articulation of the blues tradition with a certain avant-garde aesthetic was tremendously important for reasons not entirely dissimilar to those that make the Velvet Underground so significant. But the received image of Hendrix the lone guitar hero is in stark contrast to that of the four members of the Velvet Underground immersing themselves and each other in the wall of noise that was 'Sister Ray' or 'Black Angel's Death Song'.

29 For example, 'Sister Ray'.

30 Butler *Bodies that Matter*, p.14.

31 R. Barthes (1980) *The Pleasure of the Text*, trans. R. Miller, New York: Rei Edition.

32 D. Thompson (1989) *Beyond the Velvet Underground*, London: Omnibus.

33 A similar approach is taken to the study of 'cult' TV fan culture in Matt Hills's excellent unpublished paper on 'The Sociology of Romanticism and the Psychoanalysis of Perpetual Hermeneutic'. Hills point to the need for approaches that can take into account the specific structures of specific texts, the libidinal relationships between individuals and texts, and the sociological location of texts and audiences for an understanding of contemporary media cultures.

34 A big 'hello' to Andy Jones!

35 This isn't to deny for a moment that many other people can draw a great deal from this music and have done.

36 Of course the objection could be made that members of an intellectual elite who find themselves short of real power or capita will develop avant-garde discourses as a strategy to promote their own power and prestige, but that's another story.

37 In *High Fidelity*, Rob tells us that he has been listening to records likely to induce a state of romantic melancholia for longer than he has been (as he is) a melancholy romantic. A directly causal relationship is posited.

38 A postscript: this event was followed by the recording of Lou Reed's 'Perfect Day' – complete with Reed himself, various pop, jazz, light and classical musicians – by the BBC. The surreal result was a number one single in December 1997.

Part II

LIVING THE BUSINESS

These chapters offer two views of the decisions, by people involved in the entertainment business, which allow music to join the modes of circulation described by Jeremy Gilbert. Steve Hawes offers a unique example of the place of personality and corporate decision-making in the dissemination of music. He recounts the experience of working at a commercial television company whose managers did not wish to impose their artistic tastes on the watching public, but whose middle-level producers defended their own elitist cultural values. Through the articulate persuasion of presenter (and subsequent music–culture entrepreneur) Tony Wilson, the first wave of punk was televised by Granada *despite* such producer elitism, and Steve Hawes's narrative offers an opportunity to consider the ways in which commercial culture is precisely not constituted according to canonic high cultural values.

Andrew Blake then considers the ways in which a set of partly connected musics emerged in mid-1980s Britain, as a new sense of cultural alienation (from Thatcherism, and from hegemonic forms of classical music, jazz and commercial pop) galvanised some producers of music to utilise new music technologies and produce forms of theoretically aware dance music. In doing this, he claims, both his own band Man Jumping, and the far more commercially successful Art of Noise, were in effect prophesying the dominance of technologised dance and small-label anonymity that has characterised much of the music of the dance decade. And in prophesying, they were fulfilling the theoretical insights of Jacques Attali's *Noise*, a book that appeared as punk was dying, and through a set of complex historical and theoretical arguments, foretold much of the musical and cultural change of the 1990s.

3

I WAS THERE

Putting punk on television

Steve Hawes

So It Goes was Granada Television's 'alternative' rock 'n' roll magazine of the mid- to late 1970s; if remembered for anything it is for putting punk rock on television. Even at the time this singular distinction sat uncomfortably with a programme title lifted from that arch-sentimentalist of hip humanism, Kurt Vonnegut – the phrase appears every time a character dies in *Slaughterhouse Five*, Vonnegut's howl of despair at the brutal inanities of war.[1] The novel was published in 1969, the year of the Mai Lai massacre in Vietnam – and of Woodstock – and was immediately adopted into the peace movement's *right on* canon. The title implied things in common with Vonnegut's stance;[2] if it had such sympathies at the beginning, it progressively cast them off.

There were two series. The first, from the summer of 1976 was largely unremarkable, with the exception of its final five minutes. The second, which appeared some eighteen months later, collected an extraordinary archive of live footage of punk, post-punk and fringe punk performance, all recorded on location in pubs and clubs most of which have long since closed. It featured among others Nick Lowe, Elvis Costello and the Attractions, the Clash, the Jam, XTC, Ian Dury and the Blockheads, the Buzzcocks, the Foxes, John Otway and Willie Barrett, Iggy Pop, John Cooper Clark, Howard Devoto, John Dowie, Graham Parker and the Rumour, Tom Robinson, Siouxsie and the Banshees,[3] most of them doing television for the first time and all of them 'spotted' by the show's presenter, Tony Wilson.

Going too far

The last few minutes of the first series featured its only really memorable item: the Sex Pistols' first appearance on television. To Sid Vicious's manically imbecilic pogo rhythm, springing with gleeful menace, Johnny Rotten's body contorted into paraplegic jerk and spasm, his eyes bulging, his mouth scowling wilfully perverse rhymes straight to the camera. Meanwhile a woman in torn fishnets, show-all leather skirt and swastika armbands, appeared alongside the band. Was she *with them* or not? No one knew – she didn't sing, didn't dance, didn't seem to do anything; just crashed about the stage gurning hideously at

the cameras. But nor was anyone prepared to ask, for fear of provoking worse excesses. And the band seemed not to care.

In the control room, sleek-haired technicians in Bri-Nylon shirts exchanged significant glances, unable to conceal their pleasure at the growing conviction that the production team – producer, researchers, director, all feckless jeans 'n' beads university types, all on inflated salaries – had come a cropper this time. As it happened, the production team thought so, too. Researchers eyed their bosses nervously, sensing careers in the balance. 'Can we, uh,…retake the last couple of minutes?', the floor manager asked anxiously through the intercom. A camera picked him up. He looked haunted.

'There will be no retakes', said the producer emphatically. 'Tell them we're out of time.'

White faced, he turned to his researcher. 'Just get them out of here, Malcolm. Out of the building. Now.' At that point Tony Wilson appeared on a monitor. In contrast, he looked pleased with things, pumped up, energised by what had just occurred. He rubbed shoulders with the band, seemingly enjoying their company.

'I think he likes them. Christ!', said Malcolm on his way out.

There and then everyone on the team decided it was Wilson's fault. He had found these fucking neo-nazi goons in the first place, and then talked everyone into having them on. Now it was too late, how they hated him for it. 'He's gone too far this time. Someone should tell him. Just because your name's Tony Wilson doesn't mean you've got a job for ever.'

Then the really crucial question was voiced: 'Who's *in*?' This meant which senior executive, programme controller, managing director or chairman was in the building and likely to have seen events on closed-circuit monitor? In other words, who needed appeasing if careers were to be salvaged? As it happened, the answer was no one. They were all out, or in meetings, or on the train back to London. And by the time the show was aired, nobody cared. The truism had been proven once again: 'alternative' rock shows don't get audiences. Or even reviews. Nobody watched. The series fell out of the ratings and ended up being scheduled after midnight.

'With the band'

So it goes. The failure to attract an audience was a predictable reversal, typical of almost all efforts to put non-mainstream pop on television: so why try in the first place, let alone start lobbying for a second series? One answer, the smart one, is that the programme had nothing to do with ratings or public service or pleasing advertisers: it was a crucial part of the ideology of those middle-class television professionals themselves. As well as reproducing their own musical tastes and values whatever the wishes of the watching public, they, we, all desired to be – in the words of the song – 'in with the in crowd': to move among our heroes; above all, to move among our peers' heroes; to say to real

and imagined stage-door Cerberuses, 'I'm with the band'; to have *the* pass badge on your lapel, 'Admit backstage'; to say, later, 'I was *there*'; to have earned the status of rock 'n' roll hajji. Journalists, producers and the rest of the television circus climbed, and were in a powerful position to climb, in their peers' estimation (and therefore higher on the career ladder) on the back of those they worshipped.

Granada's history was fairly rich in opportunities for a happy few to have 'been there' at one of popular music's epitomising moments. A Miles Davis live session in the Chelsea studios was an early taster.[4] Johnny Cash's prison concert in San Quentin provided the definitive experience – to those who were there to film it – of being 'on the inside among the outsiders'. The Doors' *Opening*, filmed at the Marquee, inevitably created a similar wee band of brothers. But, most of all, there was the Rolling Stones' free concert in Hyde Park in the summer of '68, the open event that gave rock 'n' roll's barriers their sharpest definition. Were you *there*? Or not?[5] In the park, watching? Or, *hey!*, were you up there making it happen? Thus did the cruel hierarchical dispositions of inse-cure (male) adolescence resurface in the professional life of television programme makers in the 1970s.

But the smart answer to 'why bother televising rock 'n' roll?' is only a partial answer. There was pure exhilaration as well, of course. There is a particular reason why cultural apartheid should be so rife and compelling among the select few – and this naturally included every single producer, presenter, director and researcher on the *So It Goes* production team – who had been to university in the previous decade. At that point British universities were elitist institutions serving some 14 per cent of those aged between 18 and 21 (the corresponding figure in 1998 is 33 per cent) – and a fairly socially homogeneous, mainly White, middle-class 14 per cent at that; unsurprisingly, then, the values internalised by students were more distinct, and more distinctly elitist, than they have since become.

Dining halls in colleges throughout the 1960s emptied at 7.25 p.m. of a Thursday evening in readiness for the BBC's chart show *Top of the Pops* on the junior common room television. But the half hour that followed was masochistic rather than joyous. Far from rock 'n' roll carnival, it was usually a gruesome collective experience. Not because of the dancers *Pan's People*, though they were bad enough; not because it was painful to observe figures you modelled yourself on miming badly, though they did;[6] but because for every weekly 3 minutes and 20 seconds of communion with the likes of John Mayall or Them, Booker T or Tyrannosaurus Rex, Zoot Money, Family, Hendrix, the Small Faces, Joe Cocker, or whoever seemed to have bite and edge, we had to endure at least 20 minutes of middlebrow-or-below Petula Clark and Englebert Humperdinck, P.J. Proby, Kathy Kirby, Tom Jones, or Ken Dodd, each more unctuous than the other. No 'Life on Bare Wires', which only made it to number seventeen and got just one play, not even 'Gasoline Alley', but, inter-minably, 'Downtown'; not 'The Weaver's Answer' or 'Voodoo Chile' but 'It's

not Unusual' and 'Tears'; instead of 'Nights in White Satin' there was 'Happiness'; instead of 'Delta Lady', which failed to make number one, we got 'Claire' which seemed to stay there for a year. Even as the music press attempted to form a living canon of musical virtue, the pop charts, and their televised representation, were omnivorous refusals of any other criterion than commercial success. In an almost Adornoesque way, student watchers despaired of the mass taste reproduced on *Top of the Pops*.

Such all-inclusiveness,[7] which, despite the supposed public-service remit of the BBC replicated the commodity production of the music business, created a longing for separation. We wanted *barriers* reinforcing our university-related elitism in a broadcasting parody of the selective and exclusive artistic practices subsidised by the Arts Council: which is what the first series of *So It Goes*, 10 years or so on from the common room purgatory of *Top of the Pops*, was hell-bent on creating. Above all it wanted sharp, unambiguous definition. Through the presenters – Tony Wilson's link role and the Clive James monologue – it stalked and hounded anyone it suspected of going for the *Top of the Pops* middle ground. Unable to forget that Tom Jones once had hard edges – reputedly, at least – it sneered, nagged and brayed even at Mick Jagger and Rod Stewart for their posturing, for being audience-aware, finding weekly evidence to charge them with the apostasy that led to Las Vegas.

So It Goes series one knew what it didn't like, but was less sure of its positive aspirations. It ached to be cult, but it found itself embarrassingly short of hierarchs, let alone shamen, in that mid-1970s moment when rock already seemed intent on self-congratulation rather than changing the world. *Faute de mieux*, it led its first show with Gallagher and Lyle. They had good R 'n' B pedigree and sang nice harmonies – but they were hardly what you would call *defining*. Worst of all, they were heavily featured on *Top of the Pops* around the time of the programme's first transmission: 'They're *number one* for God's sake!' The second show made something of a *coup* in getting the McGarrigle Sisters into studio on their first UK tour. Here was music with an unimpeachable Greenwich Village pedigree, and even nicer harmonies; better still, it had genuine cult status: no one but a few *aficionados* had heard of them. But they lacked impact and went unnoticed. Bettina Jonic, in a later show, sang Dylan brilliantly; but how in the mid-1970s did you link into a studio recording of 'Like A Rolling Stone' without sounding, well, nostalgic? There was a rousing set by the David Bromberg Band – remarkable at the time for the readoption of a brass section. For sure, the Bromberg Band was best known as Dylan's accompanists from the 1960s, but they played with a kind of brilliant hilarity that sounded fresh in the solemn mid-1970s, and they were recorded on film, on location at Dingwalls, in front of a joyful audience. Live clubland atmosphere combined with Bearsville chic and a sense of fun might just have given the series something to aspire to, and even celebrate, but the Musicians' Union intervened to prevent transmission.[8] By the time Frankie Miller appeared to remind us of how Rod Stewart used to sing, it seemed all over for the series anyway –

time for Wilson to prepare his link into 'Anarchy in the UK' and a period on what was euphemistically called 'other projects'. So it goes.

Out there

Surprisingly, it wasn't the end. Television controllers at the time – some of them at least, and Granada's perhaps more than most – were in the habit of going along with the taste and judgement of their younger generation of programme makers: even consciously against their own taste and judgement. So long as it didn't cost too much. They knew that there was a danger of being remote from their viewers and the processes by which public taste was formed. And they knew, too, that some of the biggest successes in television's listings had seemed accidental at the outset – as if they were formed in the echo of an interaction with the public after transmission.[9] So they knew that they didn't always have to like things in order to justify taking a risk on them. In fact not liking them was sometimes a good sign. The Programme Controller had been editor of the documentary series *World in Action* when they had filmed the Doors for a one-hour special in 1967. He had disliked it, sanctioned it nonetheless, and been congratulated.[10] What's more, as little as he cared about rock 'n' roll, he was inclined to indulge Tony Wilson, who was by far the cleverest presenter Granada had in the 1970s and who had yet to find his right vehicle.

Wilson himself was nicely poised between two worlds. A devotee of post-1960s psychedelia, he had come across Johnny Rotten, Malcolm McLaren, *et al.* in 1976 – a few months before recording began on *So It Goes* series one – and had sensed some of the change that punk was about to bring. Torn, he nevertheless fronted the series dressed as a cleaned-up Pretty Thing: hip but cute, longish blond hair bouncing to his shoulders across a baby-face *moue*, silk kerchief dangling over a white shirt that billowed from an exquisitely cut black leather jerkin. It was expressive of his uncertainty – or at least the ambiguity of his position – that it was in this persona that he cued the Sex Pistols on to British television. Verbally, too, rather than purveying the sense of an order in the making (that the production team working on the first series wished to promulgate), he perpetrated a sense of semiotic ambiguity: he insisted on lacing his scripts with oblique and knowing references to the desentimentalising purge which situationism[11] apparently promised – most of them cut by the producer – and yet, caught within the symbolic vortex of the moment, he signed off each show with a peace sign.

However, by the time the second series was given the go-ahead, Wilson had cast off such uncertainty. He now had what the show had lacked. He had seen the future, and there was no need any more to slag off survivors from the 1960s for enclosing themselves in their own self-absorbed virtuosity[12] or in parodic simulation of previous energies. They didn't matter anymore. What Wilson had found was something both to relate to, and to relate. This was not something prefabricated to be relayed by television but rather something to engage with,

something open-ended: not just a sound, but mood, drive, clarity of attitude, an unspoken sense of class war being waged through a new cultural formation. His problem was that now he had aspirations, hardly anyone on the production team shared them.

The team was a newish collection of television hopefuls, all more or less turning thirty. In fact, Wilson was the only real survivor from the first series. But the distance between him and his team was confirmed in a poll taken early in the pre-production process. Wilson demanded that everyone write down the names of three acts they most wanted to see on the show – no name from the previous series was admissible, and only one in three could be American. He left the room. When he returned he was handed the list. It was something like, in alphabetical order: Asleep at the Wheel, Captain Beefheart, Joe Cocker, Chick Corea, Ray Davies, Drupi, Dave Edmunds and Nick Lowe as a duo, Tim Hardin, Doctor John, Dick Morrissey, Sad Café, the Stranglers, Stevie Winwood, Neil Young, and Frank Zappa.[13]

'Very nice,' he said. 'One question. Why?'

'There's a story in each one of those names.'

'Don't tell me. Life after death.'

'Let's hear *your* names then.'

'You won't have heard of any of them.'

Pressed, he produced three names. Nobody had heard of any of them.

'So what?' he countered. 'They change all the time. There's hundreds of them out there, all at it. That's the point.' And it *was* the point. It was not only deliberately formless, it was leaderless. For those who aspired if not to cult status at least to familiarity with cult leaders, this was a seriously bleak prospect. For those with a set of musical values, learned in the sixth form and affirmed at university, which aped the high-culture values of good taste, individual expressivity and trained musical virtuosity, the prospect was the replacement of something with what sounded like nothing. As if to underline the point, Wilson produced a demo from his coat pocket. It was Pete Shelley of the Buzzcocks singing 'What do I Get?', sounding as if it had been recorded in a telephone box near a busy roundabout. The office listened in antagonistic silence.

'Is that it?,' someone asked when it finished. 'Is that what we're turning down Stevie Winwood for?'

Wilson appealed to our journalistic self-esteem. He snatched the recording from the machine and waved it at the window. 'That's our audience. Kids out there. And it's happening to them now. And if we miss it because we're down at Stevie Winwood's secluded farmhouse studio, filming him thinking aloud while he listens to himself on multi-track playback, we lose our audience for ever. And we deserve to.'

But if you didn't do that kind of intimate portrait of the stars, what *did* you do on a rock 'n' roll *magazine*? If you didn't seem to share moments with Stevie, Keith, Mick, Muff or Ray – relaxing between takes in studio, backstage, by the pool, intercut as voice-over to go with shots of airport arrivals, concert depar-

tures, snatched interviews in the back of limos or arriving at film premières – and then to share that intimacy with the viewer, what was a rock 'n' roll magazine *for*?

Wilson played another Buzzcocks' song. It sounded just as bad.

'It's revivalism', I said. 'So simple anyone can play. But if anyone can do it, why listen? Boring. Revivalism is always boring. This is no different from Bunk Johnson in 1940 taking jazz back to its roots in New Orleans. Meanwhile Hugues Parnassier, who knew what mattered, was writing hymns to 'the genius of Dickie Wells' in *Jazz Notes de France*.[14] What matters is virtuosity, virtuosity which perpetuates itself by providing the platform or perhaps the provocation for the next piece of virtuosity. No Dickie Wells, no Lester Young. No Lester Young, no Parker. No Parker, no Lateef. No Lateef, no Zappa....'[15]

'Get yourself a slot on the Third Programme. Don't play Punk Johnson. Be happy. But don't expect an audience.'

Where we had an image of ourselves as, potentially, the rock stars' accomplices, inserting ourselves into the same interpreters' space as literary critics explaining the text for the reader, in order to privilege our own position *vis-à-vis* the consumers of television and music, Wilson wanted to open up a world that explicitly scorned stars and stardom, and deliberately substituted fandom for criticism. He sought interaction with his audience, while we craved separation.

Antipodes

The arguments were rehearsed day after day. Slowly he began to get his way. He had conviction and we didn't.[16] And he knew more about how things were on the street. He spent most of his time in Manchester clubland, and had already acquired a reputation for unearthing talent. Rows were frequently punctuated by Wilson's claim that he was 'in touch' with the audience, bitterly countered – both from inside the team and out – by the assertion that the only people that he was in touch with were the weak-minded and disadvantaged ones who admired him. But this charge revealed more about the anxieties of the people who made it, clinging to their authority as part of a television elite, than it did about Wilson's thinking. What he was prepared to do and his production team wasn't, at least initially, was precisely to step into a world in which he had no *a priori* authority, either as television person or as rock stars' friend. He was responsive to the people he met, and – in truth, the last thing *we* wanted – he met them on equal terms. He wasn't just a scout. He bounced off the people he came across. As his later blossoming showed – with the Factory label, the Haçienda night-club, etc. – he not only found bands and then found them their audience, he helped to form the taste for them and then to create the interactions that honed them: the Diaghilev of Daveyhulme.

In the end he won us over. Once we got used to the idea that 'being there' now meant being there while the gob was flying at the Pit in Croydon, the Hope and Anchor in Islington or the Warehouse in Manchester, we got on with the job. And on one thing we were all in agreement: the only way to show it

was to capture the live event on its own terms. Journalistic instinct saved us. We hid our reservations behind a pose of Lardneresque objectivity: this was the story like it was – like it or not. In a way, this spared us further discussion about the music: you didn't have to like it, it was happening, good, bad or ugly. Had we tried to *televise* the bands, drag them into the studio, take them through elaborate sound checks and so on – let alone make up! – we would not have been able to avoid arguments among ourselves about musical 'quality' which, in retrospect, wasn't the point. And, actually, the mock coffee-bar studio set of the first series was such an obvious fake that bands somehow compromised themselves by appearing in it. The process was all wrong. You couldn't imagine the Clash in there. Apart from the look of it, they would have refused to submit to the dispiritingly slow grind of it all – sound balance, rehearse-record, playback, retake, check tape, cue audience applause...[17] – and no punk audience would have applauded on cue. So we had to go to them.

Ironic that once it was our turn to be there, 'with the bands', it was the last place we would have chosen to be. But, as Wilson anticipated, once we got there, like it or not, we found its ways contagious, and our filming inevitably took on the aesthetic manner of the subject matter. It would, after all, have been nonsense to impose our own conventions, to look for fixed camera positions for example, and cut between the safe high wide shot and rehearsed close-ups of soloists in turn. For that you would have to rehearse. Directors and cameramen, relying as much on the snatch-it-and-run techniques they had picked up on the news documentary *World in Action*, began to relish the material if not the circumstances, got in among it, and made it up as they went along.

Definition

The series did have a defining event, but it was not a punk, post-punk or even fringe punk event. It was the opposite: a private concert by Van Morrison and small backing band in an intimate West End niterie called Monkberry's. On somewhat dubious grounds, we, in what was by now the Wilson-led consensus, consented to filming three acts which were outside the new wave:[18] Mink de Ville because he was latinising R 'n' B, which seemed new;[19] Muddy Waters because he was The Ur; and Van Morrison because he was The Man – and because it was something of a *coup* to get any of them.

By far the biggest *coup* was Van Morrison. To persuade him to come out of his hermitage, let alone agree to be filmed, was so rare an event at the time[20] that it was easy to believe the record company 'word of mouth' about the guest list. The whisper was that, let alone Jeff, Jack, Ginger, *et al.*, all four Beatles were going to be there and would probably announce their reformation. To his eternal credit, Wilson did not rise to such bait, not because he disbelieved it but because it didn't interest him. Van Morrison did. Why? Because *he* was different, said Wilson, with emphatic tautology. 'You're talking about The Man. You're talking religion.'

I thought he was being facetious, laughing at his own weakness for the ulti-mate 1960s survivor. I should have known better: he would never have acknowledged weakness.

The guests who eventually showed up were unsurprising. The music wasn't. Van Morrison's latest album had been produced by Dr John[21] and 'The Good Doctor'[22] had prescribed performance for his new patient. In keeping, The Doctor sat at the Hammond leading a small band of session men while The Man sang as if the whole process was painful but exquisite therapy. Three or four longish tracks from the latest album blending into one continuous perfor-mance, no breaks for applause, half an hour in all, and then one completely new song, 'Restaurant in Venice', which the band seemed, magically, to be making up as they went along. I'm still not sure that they weren't. To Wilson's delight, it contained no 'standards' at all.[23] 'Close your eyes, listen to The Man, and pray,' said The Doctor as he counted the band in. 'Tomorrow tell the people you was there. Two, three, four.'

One was too hypnotised at the time to realise it but we *were* in church. It was – could only have been – Pentecostalist. Nothing could have been more intensely ceremonial than the deliberate, measured spiral of chords by which the hierarch, plump and stately at his keyboard, led the shaman into trance. The Man's head rolled from side to side, his diction became less and less distinct, the tonal speculation more and more unfamiliar: he started to sing in tongues. Words became mere syllables, abstracted vocal sounds, dematerialised, tran-scending the tawdry reality of the night-club fittings and even the singer's odd, unalluring shape and homely dress sense, alluding to unidentifiable pain, bearing witness to a battle with faceless demons. The set had three movements, each one more intense than the previous one, then resolution, abatement, Zen. It was over: *ita missa est*.

'Tell the people,' The Doctor reminded us.

What defined the event from what was happening 'out there' was its reli-giosity. Not that it was a solemn recital from the rock 'n' roll canon. On the contrary, it was breaking new ground of a kind, and its manner was charismatic not dogmatic. What made it so essentially different from an encounter with the Buzzcocks, Siouxsie or the Jam, or any of the authentic punk bands[24] was that, at his best, The Man transcended the real world where punk confronted it. He made pain exquisite, heightened emotion: punk collided with them head on. Keats's distinction between poet and dreamer, 'diverse, sheer opposite, antipodes', applies as well here:

The one pours out a balm upon the world,
The other vexes it.[25]

When Van Morrison sang of Eros and erotic revelation in his new song, it was an evocation of another world, something like that of Coleridge or even Baudelaire – the world of the Beast,[26] or The Sublime. Horrible, maybe, but

idealised. Punk never idealised. Eros did not figure at all in punk iconography – sex was neither nightmare nor idyll, it was rut. The world where Van Morrison engaged with his beasts was apart and enclosed, the punk world was here and now and open. Even in the intimate setting of Monkberry's, *he* sang as if lost in that other world and as if his audience were not there – and his audience knew better than to approach him. In the concerto grosso of the Hope and Anchor, the Pit and the Warehouse, there was no such separation.

Punk was never ceremonial, never ritualised. When Pete Shelley sang his un-rhetorical question 'What Do I Get?' in a live gig, the answer was a very tangible rain of gob. When a voice from the wings called for John Cooper Clark's best known poem[27] he said 'I don't do old favourites', and the audience hooted their approval. They wanted the latest: better unfinished than old hat. Punk, in truth (as we had known as we listened in horror to Wilson's Buzzcocks demo), wasn't even music; indeed its formal distinctiveness – if that's what you can call it – implied a rejection of the very idea of organised sound that music, by definition, requires. Rather, it was a pretext for what Boal and students of carnival would call the theatre of flux and chaos, not ritual but provocative give and take – not something finished or enclosed, to be witnessed and passed on – but improvised mayhem, live and lived theatre. Arguably you killed it by catching it on film: you actually had to *be* there, even if you didn't want to be.

This is what *So It Goes* series two put on screen. The impact, however, was minimal. The truth is that the audience for punk, like the best of the punk bands, had a healthy disregard for television, and the people who watched television didn't care for punk. History repeated itself as the second series, like the first, fell out of the ratings and was rescheduled after midnight; there was no third try. In the end, you still needed Petula, Sasha and their kind to get anything like sustaining audience numbers for pop music on television. So it goes. Watch the shows now and you may wince. But cut out the dressing and you have something unique, a record of a short-lived but genuinely demotic movement seen from the inside: one that died before it got old.

Notes

1 Vonnegut himself borrowed the motif from L.-F. Céline's *Journey to the End of the Night* (itself a howl of despair at the First World War).

2 In his interview with the *Paris Review*, Vonnegut summed up the dictates of his civic conscience: 'Not to take more than [you] need, not to be greedy...not to kill, even in self defense...not to pollute water or the atmosphere...not to raid the public treasury.' Not the stuff of situationism (see note 11), which is what the propitiators of punk claimed to draw from.

3 If some of these names now seem to represent very different musical outcomes, they were nevertheless part of the new wave that embraced punk and that consciously and deliberately rejected all that was slick, overblown and self-regarding about pop music in the mid-1970s; and, at the time, they all acknowledged a kind of complicity with each other.

4 This produced, among other things, a collector's 'I was there...' anecdote about Davis's theatrical cool. In the middle of a number, he finished a solo and abruptly walked off stage to light a cigarette. Left to play alone, John Coltrane wove an inspired and protracted lyrical performance on tenor saxophone. A camera picked up Davis in the wings, smoking, blasé, apparently not even listening. He slowly finished his cigarette, stubbed it out and ambled back on stage. As soon as he reached the microphone, he started playing again, as if Coltrane wasn't even there. The timing was of course impeccable.

5 If not, you could retain cred by claiming that you had turned up only wanting to see the support band, Family, and cleared off – or passed out – before the main act started.

6 Though that *was* unsettling, for as much as rock 'n' roll's appeal seemed to lie in the sexual connotation of the performers' superior ability to co-ordinate, so it was dispiriting to see Bolan, say, straying out of synch. like any other singalong.

7 It was a hang-over from television 'variety'. People who had had their first glimpse of Chuck Berry on *Sunday Night at the London Palladium* or of the Beatles on the *Royal Variety Show* were used to it. But that made it no more bearable.

8 At the time, strictly speaking, you had to have a man-for-man exchange deal in order to use musicians from the United States: for every American performer who appeared on British television a member of the British Musicians' Union had to appear on an American network. Bromberg's was quite a large band, and in 1976 there wasn't that much call for British musicians in the United States. Sometimes you could wangle concessions, but this time the Musicians' Union weren't playing.

9 Granada's own *Coronation Street* was a case in point. It began as five half-hour slices of local life that no one payed much attention to. It was word of mouth in the pubs and corner shops of Manchester and Salford, and in Granada's canteen, that persuaded the controllers that it was worth persevering with.

10 For the *World in Action* team of radical journalists, soi-disants at least, to devote a whole hour of schedule time to an American rock 'n' roll band was decidedly eccentric, and probably meant trouble with the broadcasting authorities. David Plowright had allowed himself to be persuaded to approve the filming, nonetheless, knowing he would have the final say when it came to transmission or not. Later, when he sat in the cutting room and watched the director's cut, it was obvious he didn't like what he saw. But he knew he wasn't supposed to. His only instruction, famously delivered without a flicker of approval, was 'You'd better show part two first'. So the Doors opened with the solo organ introduction to 'Wheels of Fire' and went straight into Jim Morrison without a murmur of explanation. The conventional shots of the band arriving at Heathrow and the voice-over explaining who they were and why anyone thought they were worth an hour's prime-time on a current affairs programme were saved for the beginning of the second half – as if anyone who didn't know was still watching.

11 A 1960s Parisian underground movement that believed in and practised violence for its own sake, as purge, and offered vacuity as the prime value – an alarming combination of Sartre, Sorel and Dada – which Malcolm McLaren regarded as potentially exemplary.

12 Anyway, John Cooper Clark did it better:

> Toying with their sense of the sublime,
> Playing with themselves
> Endlessly. Is that a crime?
> (link into 'Beasley Street where lager turns to piss', *Celebration 9, 1979*)

13 This makes five Americans out of twelve. But Beefheart – Don van Vleet – was included as European on the probably erroneous grounds of his Dutch origins.

14 Dickie Wells was trombonist with the Count Basie Band in the 1940s: progressives of a kind.

15 I can't be sure if this was exactly the list of names I recited. Anyway, others can be substituted: the obscurer the better. What mattered at the time was to suggest that one was somehow translating semi-sacred text from memory.

16 Wilson was lucky in that, early in pre-production, he acquired a new producer, Geoff Moore, who had the confidence, musically, to back him. Moore had been on the road as a professional musician, was bored by supergroups and superstars and had the journalistic nous to see where the story was.

17 Jools Holland's *Later* deliberately works against this. The studio is not dressed up as anything. It is simply a space big enough to contain several bands – a studio is a studio is a studio. They play one number after the other with no rehearsal–retake gaps in between: bum notes, stumbles and missed cues are fine – anything, so long as you don't have to hang around.

18 Four if you count Dave Edmunds – but he was 'with' Nick Lowe.

19 And also because he was chic in New York and virtually unknown in the UK. And he – and his backing singers – had the good grace to agree to turn up on the same bill as Tom Robinson and XTC at Middleton Civic Hall, half-way between Bolton and Manchester, on a wet Tuesday evening.

20 He was in one of his difficult periods. At a recent event in Los Angeles, in front of an audience of thousands, he had walked off stage and refused to return simply because a stills cameraman had used a flashgun.

21 Mac Rebonack, 'out of New Orleans, here via somehere else…', the Night Tripper, the gris gris man, the gumbo ya-ya.

22 So labelled by Robbie Robertson of the Band (1982) *The Last Waltz*.

23 That is until the main set was over and they were joined on stage by Brian Auger (at a second Hammond), Julie Driscoll (back from Cairo) and Roger Chapman (formerly of Family, see note 5), the latter two intoning respectful backing vocals for a final half hour. Bliss.

24 The consensus – and Wilson most vehemently of all – refused, for example, to accept the Stranglers as *authentic*. They seemed too slick, their aggression feigned, parodic. 'The Rockin' Berries without the jokes', as someone described them. In fact we did film them, at the Hope and Anchor, but they refused to let us transmit on grounds of sound quality. 'What did I tell you,' said Wilson.

25 From 'The Fall of Hyperion'.

26 Fanciful, perhaps, but the lyrics do suggest the Book of Revelation: and Venice is at one end of Route 66: add a six and you get *the* number.

27 This was me. We wanted it on film. It was about the flagship of Beaverbrook news-papers, and the chorus line always raised a cheer:

> Margaret Thatcher looks stunning, yes!
> But you'll never see a nipple in The Daily Express.

4

MAKING NOISE

Notes from the 1980s

Andrew Blake

Line in

One of very few genuinely intellectual books about music, Jacques Attali's *Noise* was published in translation in 1985. It's a theory of music in history, and a work of prophecy – and it works both ways.

Attali claims that music's organised sounds (emerging from chaotic noise) were part of the first human rituals that had, likewise, structured chaos into culture. Thereafter music prophesied: the ordered music of eighteenth-century Europe prefigured the industrial economies of the nineteenth century. Then, thanks to the technologies of reproduction, any idea of authentic performance disappeared into the grooves of the gramophone record, leaving only the conformist pleasures of *repetition*. Yet, Attali foretold, technology will usher in an era of 'composition', in which all can become composers.

The 'history' here may be too structuralist for Anglo-Saxon tastes, but *Noise* is a crucial reference point for anyone thinking about music's future. Written in the 1970s, but a guidebook to the music of the 1980s – the ZTT label and the Art of Noise, or minimalists such as Michael Nyman – *and* to the electronica of the 1990s, *Noise* remains fiercely prophetic.

If *Noise* does anything, it liberates us from a constricting sense of musical 'history', figured as an endless succession of Important Events, and all too easily configured around the lives and works of the Great. Music's development involves trial and error, conditional success and failure; it involves theft, suppression and censorship. Its recent developments have been at the heart of the changing relationship between technology and capital. The very term 'music' has ceased to identify one or more of a set of fixed, quantifiable and assignable objects (the score, the performance, the recording), signalling instead the fluid and elliptical, never finished and never owned mobility of the mix. It's time to unhook the history of music from any notion of unilinearity and progress, and to think of subsequence and consequence, retrospection and introspection, and, as Attali insists, of prophecy. That way we might even come to know how we got to here.

Sounds and airs

Consider one brief musical moment, heard only by its five participants. April 1988, an isolated holiday cottage somewhere in England. Four musicians and a sound engineer embark on a week of group improvisation. Liberated by technology from the constraints routinely imposed by their keyboard, wind and percussion instruments, and the *reactive* mixing desk, all five participants cross-dress, swapping licks and sound processes whose provenance can't be tied to any particular sound producer or processor. The mixing desk, controlling levels and effects in both real and immediate-past time, becomes an acute part of the collective process, especially of continuity, storing and reproducing sounds while others program sequences or load samples from disk. Drum machine patterns chatter across each other, deep bass grumbles like the dragon Fafner newly awoken, samples and synthesiser patches holding the middle-ground sound now like a wolf-pack, now a fairground organ, and in the upper register reverb-perverted hi-hats and delay-distorted flutes chase each other into the stratosphere. Voices, sampled or real-time, interrupt to comment or narrate, sometimes to break into song. There's blues, dub, easy listening, minimalism, free jazz, in fact most of the commercial and experimental musics of the twentieth century, in the mix. At the start of the British 'second summer of love', we're in the jungle – or at least, in a place from which the language of jungle could have emerged.

Of course, it didn't. This moment of prophecy was actually part of the death throes of the band I played in, Man Jumping, which was trying through this experimental holiday to force a new musical language into being, to reinvent itself. Whatever the band's success in that endeavour, those outside weren't willing to continue to invest in it after two albums with modest sales, and by the end of the year the individual members had gone in different directions. Failure represents noise above all else, in a commercial musical world that can only consider success; yet while the band was failing, it prophesied.

But how *did* we get here? Look back to the early 1980s. Margaret Thatcher and Ronald Reagan are in the pomp of their dangerous double act, moving their countries sharply Right – and as part of this package, making no concession whatever to youth culture or liberal politics. Punk is already part of the burden of history, while the likeable new pop of Culture Club or Duran Duran seems as unlikely to last as other waves of pop. Elsewhere in popular music, disco's high time has passed, and guitar-based stadium rock is already out of its time (though obstinately unconvinced of that fact). There are innovations: early hip-hop has twisted the drum machine beyond its makers' nightmares, and Prince is beginning to put his own spin on the world's sense of rhythm. Synthesisers – analogue only, so far – are ubiquitous, but sampling and computerised sequencing are in their infancy – expensive and inflexible. Meanwhile, jazz is in the doldrums, caught between cool-bland fusion and a 'freedom' whose gestural lexicon has been obsolete for a generation; much the same could

be said of classical music, whose leading composers employ the atonal gestures of the 1950s and 1960s modernist establishment – even in, say, Oliver Knussen's *Where the Wild Things Are*, an opera written for children. 'Noise', here, in both 'free' jazz and classical music, has been reduced to the status of heritage culture, the acerbic effects of atonality stripped of any sense of intervention or assertion.

In this world, this moment, the trance-inducing, monotonal, repetitive aesthetic of musical minimalism can still be seen and performed as radical – as *noise* in a world holding to other sonic values – much as it had been when La Monte Young, Steve Reich, Philip Glass, Terry Riley and others experimented with tape loops and arpeggiated figures in the 1960s. Minimalist composer Michael Nyman is beginning to make a name for himself as a radical musician who has deliberately turned his back on modernism and set up his own band, using amplified instruments and repetitive rhythms. He launches his career via small-label recordings, and Peter Greenaway's films such as *The Draughtsman's Contract* (1982). At this moment a few young keyboard players based in London perform pieces by Reich, Glass and Riley, at the opening of an art gallery.

A few more gigs followed for this *ad hoc* group. The players began to write for the ensemble, then to invite more friends along to play in it. Now they'd formed a band, which expanded exponentially with voices, strings, winds, tuned percussion, drum kit and finally bass guitar added to the half-dozen keyboardists, making the world's first post-minimalist big band, the Lost Jockey – named after the surrealist Magritte's series of paintings,.

Musically, the Lost Jockey was on the button, working inside a living, evolving history – going from Reich to rock. Repetitive keyboard riffs weren't enough for players and audiences (its following was young, sharp and Islingtonian) who had been to rock gigs and wanted their propulsion percussive, and most of all loud. Small-label records were produced by Gareth Jones (who went on to engineer much of Depeche Mode's output) and John Leckie (who has produced outstanding pop for 20 years, including recently the work of Radiohead).[1] There were dozens of gigs in London, and the Arts Council weighed in with help for a brief national tour; there was a bit of TV work, and one performance on BBC Radio Three; some enthusiastic journalists, notably John Gill, provided buoyant support. Seemingly on the cusp of Big Things, the Lost Jockey formed itself into a co-operative and hired an administrator.

But the take-off into self-sustained growth never happened. The band's internal politics were porously unfit for the times. A co-operative of twenty people, with a floating periphery of a dozen more performers and helpers, had a peculiarly defiant air in those recession-hit days of early Thatcherism; its *structure* was noise in the contemporary world, even as its rock-minimalism was noise in a world ordered by the conceptual hedgerows enclosing pop, jazz, rock and classical music. The band endlessly debated strategic goals – the proposed support gig for Simple Minds, the week at the Edinburgh Festival, the television

feature by Peter Greenaway – which remained frustratingly out of reach. Then
again the playing was too often lukewarm. A band of friends rather than a full-
time commitment, the Jockey was prone to under-rehearsed, sloppy ensemble.
Internal policy differences mounted, egos clashed, and the band began to
collapse under its own weight. (At the end of the decade, Icebreaker emerged
and began to perform rather similar music; with a tighter organisation, they
have so far lasted the course better than the now totally lost Jockey.)

Meanwhile, from the fragments emerged (among other things)[2] Man
Jumping, in which four of the Lost Jockey's keyboard players (Schaun Tozer,
Orlando Gough, Glyn Perrin and Charlie Seaward), its bass player (John Lunn)
and saxophonist (Andy Blake) combined with session percussion virtuoso
Martin Ditcham. Excellent players with a mix of skills and backgrounds,
including several university music graduates, but people who had lived through
pop. All of us had played, written and listened to popular music since our early
teens; we all loved it. We all knew pop's history and had favourite pop, rock,
soul, funk, reggae and hip-hop acts, ditto for jazz; and we had all listened
widely outside the Anglo-African-American mainstream: the 'world music'
jamboree of the mid-1980s fell on well-prepared ears down Man Jumping way.
But we came to it all with ears informed by our other musical experiences,
ideas, training. Nothing Man Jumping ever did was naïve.

Everything Man Jumping ever did was totally naïve. The Big Idea was to
develop a post-minimalist musical language further towards rock, funk and
dance music, but not to repeat the Lost Jockey's mistakes. To concentrate on
studio recording, rather than live performance; to play only when paid for, and
to attempt to work within the commercial world, not the twilight zone of Arts
Council funding; to give band members enough room for their other projects.
Oh, and to work without a lead vocalist or other front-person, and to make
music that was almost all composed or studio-made, without the cop-out indul-
gence of jazz improvisation. This agenda was assembled in a commercial world
that wanted stars and songs, and if you must have instrumental music, then star-
ring instrumentalists and cliché-improvised solos. Ambitious? Mad? At least. Yet
for three years it worked. Using overnight downtime at Eastcote Studios, with
their excellent engineer Philip Bagenal (whose credits range from Ian Dury and
the Blockheads to Kula Shaker), Man Jumping was nervous and musically polite
at first, but as the sessions grew into the early hours, became argumentative,
readier to experiment, finally coked into *noisiness*. Charts, which had been care-
fully rehearsed and accurately played, were overlaid with echoes and pitch-shifts;
amps were cranked into distortion. This process, actively produced by Mike
Hedges (whose more recent successes include the Manic Street Preachers album
Everything Must Go), made a three-track demo to die for. All three tracks were
on the first album, *Jumpcut*, released by Bill Nelson's label, Cocteau, early in
1985.[3] Reviews were almost embarrassingly positive.[4] For what it's worth, Man
Jumping is probably the only band to have been favourably reviewed, in the
same month, by *Jazz Journal International* and *Classical Music*.[5] There were

sounds and sweet airs to glory in – a lexicon of sound-processing trickery made the analogue instruments (plus one primitive sampler) rich and strange. Minimalist keyboard riffs mix with big drum machine patterns with wicked real-time percussion with ultratight, accordionesque overdubbed saxes with ecstatic wordless vocals. A 12" followed,[6] which with its single-side white-label 'Freefall' remix, did some serious business until the label's administrator pulled the pluggers. All done very anonymously – at one point I was told by a street-wise and enthusiastic young woman that our 12" was the latest from the New York dance scene.

The 12" reveals a great deal about the band's placing of its music within the members' shared histories and senses of history. 'Aerotropics', the A-side, remixed from the rather shorter album track, lets you in gently with a quiet opening sequence, reverberant synths cut around a trumpet sample; then the sound of a match being lit flows into what sounds like an impossibly tight fanfare for saxes and snare drum – in fact it's an ensemble constructed by Philip Bagenal, gate-connecting the two instruments from separately recorded passages – which gives way to an orthodox Linn drum pattern, four on the floor and big snare backbeat at 120 b.p.m. Subtler cross-rhythms set in as big Fender Rhodes piano chords chime against ultra-tight, interlocking acoustic piano patterns sitting, but sitting *hard*, on the fence between minimalism and funk. A sparse detuned bass guitar line snakes underneath all this excessive rhythmic exactitude, a wordless voice echoes in the distance, while the intro's rolling military snare writhes menacingly around each pattern in turn. Upfront delayed trumpet, and incisive saxes, lead towards a big key change, with the brass reinforced by synths, and the bass joined by a choppier, funkier bass guitar. You realise you have just heard verse and chorus, as the whole repeats with additional percussion, then moves to a breakdown section dominated by percussion highlights, reverberant harp-ish sounds, and echoes of the piano and trumpet patterns, before the funky bass leads to an ensemble with all manner of overlaid samples disturbing the equilibrium. All this comparative chaos reverts to the tightness of the verse and chorus just when you think it's safe to wait for the playout and fade. It happens, but only when you've given up on the idea.

Thence 'Into the Jungle', the B-side, a more radical remix from the album, in which our friend the Linn drum keeps order while a *mélange* of sampled, looped and real-time percussion, voice, trumpets and keyboards offer a series of grooves and chords but refuse to settle into any of them. Instead they chase each other through and across the patterns polyphonically and polychordally, with delays and reverbs constantly changing, adding to or subtracting from the confusion as the Linn goes marching on imperturbably. A ghost of a chorus is hinted at but not repeated; a barking baritone sax figure and another funky-minimalist piano pattern make their own attempts to restore order, without much success, before another set of big chords on the Rhodes piano unexpectedly settles the harmony, and the piece fades towards rest with a sampled string bass getting the digital fingers working. Given what happened after 1988, this is

a prophetic track well beyond its title, and prophecy was part of the band's intellectual stock in trade, as we shall see.

But prophecy is all too often without honour. Okay, so the reviews were great, but distribution was lousy, and after six months the album had not sold well – and neither did the 12" when the record company stopped paying pluggers to promote it, and therefore DJs and pirate radio stations stopped playing it. Demos were made for another album, but interest from Cocteau was non-existent, and enquiries from elsewhere were slackly polite, rather than enthusiastic. Without new product the band's profile dipped below the horizon. A TV performance, working alongside a dance company, persuaded doubters inside the band that given enough percussive drive, Man Jumping could work live. Technology weighed in on our side at this juncture. The arrival of the Yamaha DX7 digital synthesiser, and the first generation of cheap enough samplers (in our case a Mirage keyboard) made it easier to replicate the studio sound in live performance, with at least one keyboard tracking the sax to produce brass parts. Former Lost Jockey drummer/percussionist Simon Limbrick was recruited to replace Martin Ditcham, now committed to the Sade band's world-wide wanderings, percussionist Dawson Miller of world music quasi-parodists Three Mustaphas Three was hired for gigs, and by late 1985 Man Jumping was indeed making live appearances in London, to general enthusiasm.[7] These live gigs led to the deal for the second album, with Editions EG. *World Service* duly appeared in early 1987.

World Service entered a very different world. Music had changed since the Lost Jockey crashed into the music business hurdles, and indeed since the analogue, real-time playing of *Jumpcut*. Those digital keyboards, now aided and abetted by racks of samplers and effects units, were matched by increasingly sophisticated computerised recording techniques. All was based around the MIDI (Musical Instrument Digital Interface) communications protocol, which meant that computers could control keyboards and other devices, and a sequence of notes played into the computer's memory could then be replayed on any subsequent occasion. Line all this up with a conventional recording tape that can generate an electronic pulse to start the computer, and you have the hybrid recording technique used for the construction of *World Service* (and indeed most other popular music recorded in the subsequent decade). So far, so good – but though they needn't have, the new trickeries acted as a brake on the band's edge. There were no more unorthodox dance tracks, nothing from which a 12" could easily be made, and while the keyboard sounds, amalgams of synthesised and sampled, are good-to-awesome, they don't push at the senses in the way *Jumpcut*'s analogue chaos had. Too much of the mixing was conservative (vocal refrains of various sorts were often dropped at the last minute, and assertive bass lines or shrieking lead instruments were pulled back into the mix). There were plenty of over-tired/hyperactive/angry/ridiculous moments in the recording process, but you can't hear them. The result sounds nice, too nice: not enough noise.

Noises

Noise had been an important part of the band's original agenda. *Jumpcut*'s originary tracks were contemporaries of the first appearance in English translation of Jacques Attali's *Noise*.[8] This virtuosic tract made an immediate impact on music practitioners of a leftist disposition, bored and frustrated with the internalised myopia of musicology, yearning for the adult excitements of theoretical debate, and for that debate to push them in new musical directions. Film theory had opened new avenues for the discussion of cultural production (while typically ignoring the music that remains a crucial component of the medium).[9] Recent theoretical discussion of literature, including the 'crisis in English' that shook even Oxford and Cambridge Universities in the early 1980s, had begun to establish new paradigms for literary work. Music was routinely, but shockingly, absent from this ferment of discourse.[10]

Into the gap strode *Noise*, an extraordinary work that both figures musical prophecy, and is itself fiercely prophetic. As Susan McClary points out, in her afterword to the translation, *Noise* was written during the aftermath of punk's noisy, disordering denial of rock and its star system. Yet its prophetic authority was evident in 1984, and is doubly so 20 years after that post-punk genesis. What most appealed to us as practising musicians, in fact, was Attali's reading of the immediate future. The phonograph, he argued, had been developed to preserve sounds; it ended by replicating them. Repetition, and the ability to replicate sounds faultlessly even in live performance, became the ultimate musical value, the norm against which everything was judged. Meanwhile, the domestic hi-fi even removed music from any directly apparent social role. But music remained caught in networks of power, although they were new networks that broke the status definitions ascribed to people through concert music. And:

> repetition becomes pleasurable in the same way music becomes repetitive: by hypnotic effect. Today's youth is perhaps in the process of experiencing this fabulous and ultimate channelization of desires: in a society in which power is so abstract that it can no longer be seized, in which the worst threat people feel is solitude and not alienation, conforming to the norm becomes the pleasure of belonging, and the acceptance of powerlessness takes root in the comfort of repetition.[11]

In the end, power begins to float.[12] This almost Adornoesque vision of bleak conformity, which could (and perhaps should) be applied to the analysis of post-1988 dance cultures, seems to remove music from any interventionist role. Yet at the same time, Attali foresaw, music once more prefigures an exit from this increasingly meaningless world. Technology becomes a means of escape from repetition, ushering an era of 'composition', in which all of us can become composers. John Cage's work prefigures the reintroduction of the sounds of the

street; a generation later samplers routinise the incorporation of such noises into music's order. Indeed, the new instruments foreshadow a new epoch in the same way as the new instruments of the seventeenth century foreshadowed the industrial revolution. Composers as a differentiated function will disappear. People will create their own compositions, into which images are incorporated rather than the reverse, while in the new composition:

> Time no longer flows in a linear fashion; sometimes it crystallises in stable codes in which everyone's composition is compatible, sometimes in a multifaceted time in which rhythms, styles and codes change...and rules dissolve.[13]

And rules dissolve. As they did on much of *Jumpcut* and its 12 derivations, and on the best moments of *World Service*. And as they have done this last decade as the diaspora of Chicago house, mediated through German software and Japanese record decks and high-technology instruments, has taken us from the house, and the holiday camp, into the urban jungle; as people without traditional musical skills have indeed become composers.

There's not much to be gained in attacking the grand historical narrative on offer here, or even its detail; for Man Jumping's purposes, thinking about music and ways forward in the early 1980s, *Noise* was a crucial reference point. A guidebook to the real events of the time, and to our own minor part in them.

Artful noises

There were others. Remarking *The Art of Noises*, the manifesto of Italian futurist, artist and self-taught musician Luigi Russolo, Attali points out that it prefigured by half a century the collapse of aesthetic codes that has occurred since the Second World War. One British record label found direct inspiration in the antics of the Italian futurists. Taking its cue from another of Russolo's works (and doubtless also from Malcolm McLaren's self-aggrandising use of situationism in the punk years), the ZTT label (the initials standing for Russolo's onomatopoeic Zang Tumb Tuumb) was set up by journalist Paul Morley and producer Trevor Horn. It had its fifteen minutes in the early 1980s, principally through that metronomic success statement of gay hedonism, Frankie Goes to Hollywood's 'Relax', produced by Horn.[14] It also signed ex-Lost Jockey composer Andrew Poppy, released two of his albums and an interesting 12 single,[15] then sat on a third album. Meanwhile, of course, ZTT was the obvious home for a band calling itself the Art of Noise.

The Art of Noise was a collaboration between composer/keyboardist Anne Dudley and (in early recordings) keyboardist/engineer Gary Langan, and computer programmer J.J. Jeczalik, whose modest talents included relative mastery of the first popular and relatively portable sampling composition package, the Fairlight CMI (Computer Musical Instrument). The Art of Noise

was, like Man Jumping, essentially a studio band that used hi-tech instruments to produce among other things dance music that used street sounds, conversation and mechanical sounds, alongside routine keyboard and bass patterns, and computer-sequenced rhythm tracks. But there *were* other things: Dudley's more orthodox, classically trained compositional gifts were given increasing reign, and in the end Art of Noise albums were as likely to be the home of Nymanesque cod-baroque works for string orchestra as four on the floor three-chord tricks.[16] Whatever, their work was studio-based, its strategy the production of albums and singles, not live events. There were a few exceptions. As a trio of keyboard players, they did a session for Janice Long on BBC Radio One;[17] there were even a few public appearances, from 1986, with session musicians providing the Dudley haloes for the beatbox brutalities. But this was basically electronic, studio-produced dance music.

And often enough, with an edge to it. Take 'Close (To the Edit)', for example. This 12 single, released in 1984, was a mutated mix from an earlier 12.[18] In 'Beat Box (Diversion One)', a big drum machine sound plays a routine but often interrupted pattern, and a modified string bass sample (later augmented by a bell sound, a synthesiser–trumpet lead, and some car sounds) plays around an orthodox blues chord sequence, while the rest of the track's sonic matter deconstructs bits and pieces of musical cliché – a few sliced-up guitar chords, a Michael Jacksonian whoop. The B-side, '(Diversion Two)', features more car sounds, orchestral chords, and cut-up female speech, all of which are boiled down into more compact form in the final track, 'Close (To the Edit)', dedicated to J.G. Ballard and *Crash* (a novel whose filmed version, by David Cronenberg, annoyed the moral minority in Britain in 1996). Samples of cars starting and car engines running, processed by the Fairlight, simultaneously provide part of the rhythm, and of the harmonic pattern over which the drums and bass ride. Then orchestral hits interrupt, alternately, a vocalised lead line, a set of gloomy chords, and a flutey tune over sampled conga drums. Sampled and cut vocals intoning 'close to the edge' are mingled with car and car crash noises as the track fades. It's dance music, but it makes, and is supposed to make, uncomfortable listening for any member of the disco generation (not quite yet in its dotage: Chic's greatest successes had been in the late 1970s, but Nile Rogers had produced the massively influential *Let's Dance* album for David Bowie in 1983; Michael Jackson's moment of global hegemony, *Thriller*, dates from 1982). Edited across the existing norms of taste, smoothness and repetition, and reinventing itself radically with every mix, this track is in Attali's sense pure prophecy, signalling the way in which dance music was to go in the following dozen years: away from the purity and material reality of the originary, authentic, finished, owned and copyrighted product, towards the fluid and immaterial, the perpetually unfinished, always-to-be-remixed, the property of all who mix or can mix.

In the 1990s music moved from its high-bourgeois status as immutable, ownable material and towards a conceptual status that increasingly defies

copyright or any other fix.[19] *It has already done it* with the Art of Noise's work in the early 1980s. What we have had since is not a smooth linear progression away from copyrighted static objects, but a digitalised quantum leap towards certain forms of musical freedom, undermining the music industry's ability to control its own product, to the general anxiety of those in whose interests it has been, heretofore, controlled.[20] Order has not disappeared, but its networks of power have visibly spread beyond the major labels' ability to control it. In the success of a DJ-led white-label culture, which has among other things post-poned indefinitely the 'death of vinyl' that was so convenient to the music industry in the early 1980s, we can hear that the music of the Art of Noise was truly prophetic. (To underline the point: I write this just after listening to *Art of Noise. The State of the Art*, a 1997, three-disc set of ambient, techno and drum 'n' bass remixes of Art of Noise material, featuring the work of the Prodigy and the Orb among many others.)

Lines out

But this wasn't prophecy in the sense that the Art of Noise (or Man Jumping, for that matter) were lone voices crying in the wilderness. Vertical and hori-zontal connections abound. Starting in the shadows of the early, highly politicised work of German techno pioneers Kraftwerk, the anti-pop ensemble Cabaret Voltaire, for example, had seethed and boiled their neo-Dadaist way through the alternative gig circuit, using high-technology instruments when convenient, since before punk, producing a dozen or so albums along the way. By the mid-1980s they were using minimalist percussion, sampled vocals and sequenced synthesiser accompaniments as their musical stock-in-trade. Their most commercially successful album dates from this time: the 1985 *The Covenant, the Sword and the Arm of the Lord* (named after an American right-wing military group), uses this language simply and effectively, Richard Kirk's work juxtaposing sampled orchestral hits and cut-up vocals against minimalist synthesiser and drum machine patterns, whose relentlessness is interrupted only by the occasional nod in the direction of dub, while Stephen Mallinder's sinister vocal delivery forces the listener to reassess even the most clichéd melodies. Despite their simple outlines, the tracks are often mixed at the edge of the capa-bilities of their recording systems, forced into distortion in a way that foreshadows the work of 1990s noise engineers such as Autechre. Their 1987 album *Code*, made with a bigger budget (it was their first album for their new label, EMI Parlophone), has a more luxurious sonic architecture. Twisting itself around the emerging dance forms rather than simply reproducing them, *Code* features the innovative guitar of that consistently creative outsider, former leader of Bebop Deluxe (and early Man Jumping patron) Bill Nelson. Even now hard to characterise, their music lacks the careful complexity, the layered sonori-ties, of the Art of Noise; but like the Art's clever use of the Fairlight, Cabaret Voltaire's pioneering electronics proved important to the dance music revolu-

tion of the later 1980s, and it has been celebrated as such; 1990 saw the release of a Cabaret Voltaire house album, *Groovy, Laid Back and Nasty*, featuring the work of house pioneer Marshall Jefferson.

Cabaret Voltaire's electronic inspiration, Kraftwerk, had been developing, almost creating, the area since the early 1970s, and having toured with robot *doppelgängers* apparently quite capable of playing some of their tunes, continued to harness new machinery and drop conventional instruments until their music was purely, coldly electronic. An equally chilly, if less inventive, electronic British pop had emerged a decade later by way of Gary Numan, Depeche Mode, Ultravox, Heaven 17 and the like. But this electropop was arguably a safe, conservative response to the transformative stance taken by Kraftwerk, and even the punkish electro of Cabaret Voltaire offered irony rather than aggression. Far more disturbing to the commodified aurality that is pop was the electronic side of what has been labelled, inadequately, 'industrial' – the deliberate, indeed militant, organisation of everyday sound into music. This involved bands like the German outfit Einstürzende Neubauten, whose musical resources included their own close-miked bodies, as well as industrial drills, sheet metal and chainsaws (their more polite, if also relentlessly proletarian, British equivalent was Test Department). Meanwhile in Slovenia the faux-Stalinist Laibach emerged in the mid-1980s, layering so many taped, electronic and real-time sounds on top of each other that the result is an often consciousness-cancelling repetition, located at the heart of dance's negation of individual power and desire. Laibach, like Cabaret Voltaire and the Art of Noise, have had a post-career in dance music, producing music that is recognisably 'techno' (e.g. the 1992 album *Kapital*).

Slightly beyond the fringe of even this controlled avant-gardism, J.G. Thirlwell (in a number of pseudonymous projects under names such as Scraping Foetus off the Wheel, his rejection of a stable creative identity foreshadows the many-named work of 1990s dance musicians like Aphex Twin), recorded a series of albums taking a wholly deconstructive angle on industrial electronica – and everything else. *Hole* (1984), for instance, features an engaging mixture of juvenile erotic/horror/military imagery, delivered by a voice that tends to the angrily despairing, accompanied by film and television clichés and repetitive minimalist and jazzy/dancey musics that refute the lyrics' prevailing gloom. There is no better product of what Jeff Nuttall labelled *Bomb Culture*.[21] Apocalyptic cold-war visions are supported by thrash metal sounds and then denied by a series of impish softcore rock, pop and country grooves: total, universal destruction had never seemed so appealing. Here the noisy prophet anticipates not dance music, but the nostalgically melodic and simultaneously apocalyptic dreamworld of Suede's song 'The Beautiful Ones', or the Radiohead album *The Bends*.[22]

Indeed, prophetic noise was everywhere in the mid-1980s – if you looked hard enough. The (British) jazz big band Loose Tubes, deliberately challenging the order of a music that had over the previous twenty years received Arts

Council grants and matching hushed audiences, played their part in the creation of an aesthetic that was at the same time minimalist, repetitive-hypnotic, and aggressively, insultingly noisy. The band performed without due care and attention to any stylistic convention; their live gigs were riotously spontaneous. Even in classical music, the Steve Martland band, using a more aggressive minimalism than Michael Nyman's, and Mark-Anthony Turnage's irreverent orchestral pseudo-jazz (especially the mock-cockney-opera version of the Oedipus story, *Greek*), were providing noisy disruptions of the modernist order.

So 'Industrial' was only one of a number of innovative musical cultures, many of which anticipated the more general house revolution of repetition that began to achieve a more general recognition in Britain in the 'second summer of love' of 1988. Largely ignored by official radio (which until the late 1980s in Britain was a monopoly, run by the British Broadcasting Corporation), the uneasy rock and dance musics propagated by the 'experimental' bands discussed here formed part of a widespread dance and underground culture based around clubs and pirate radio stations – whose musical components also included other (mainly reggae-derived and hip-hop) forms with which mainstream radio, deeply complicit with the commercial music business, was uneasy. Indeed, partly because of pressure by the mainstream music business, pirate stations were the target of official persecution throughout the 1980s: their premises were routinely raided and equipment confiscated. Only the last knee-jerk processes of Thatcherism, eager to destroy monopolies such as the BBC, led to the grudging granting of a government licence to London pirate Kiss FM in 1990.

What, though, had been the target of this Home Office hatred? Though the various mainly big-city clubs and illegal pirate radio stations catered for a wide range of unofficial musical tastes, it should be stressed that most of them propagated dance cultures whose musics were, by the standards of Laibach, Foetus, or even Cabaret Voltaire, anodyne. Pirates, record importers and entrepreneurs, organised and supported northern soul, funk and jazz-funk events, many of them in the 'noisy' fringe-legal or illegal world of consumer capitalism's dark side of drugs and illegal parties. This created a model that the late 1980s house scene filled with alacrity. To repeat – this is not a unilinear story, and it is certainly not the tale of an authentic and coherent avant-garde gradually displacing the tired values of a hyper-commodified pop culture. Noise is not always ascribable to combinations of pitches, rhythms and harmonies. As I argued at the start of the essay, minimalism had been more 'noisy' than the more harmonically astringent modernism in the late 1960s. Similarly a set of musically orthodox but politically unaccceptable cultures based around soul and reggae gradually made space for itself against the official broadcasting culture, and in so doing, became part of a general emergent culture of hedonistic dance to hypnotically repetitive music.

And yet a more obviously noisy music *was* equally vital to that transformation. Those of us who used new technologies to produce new sonics were helping to reconfigure musical culture towards that moment. It was not individ-

uals, or even individual bands, but music itself in all its patterns of production and consumption, which was moving towards a new set of utterances and combinations. Through the noise of mid-1980s experimentalism, new and more chaotic relations of musical power were prefigured.

Notes

1 The Lost Jockey's recording career: *The Lost Jockey* LP, Les Disques du Crepuscule (Belgium) TWI 062, 1981; *The Lost Jockey* 10 EP, Operation Twilight OPT011, 1982, re-released as a 12 single and cassette on Battersea Records BATLM2/ZCBTM2; *The Lost Jockey* self-produced cassette, TLJ001, 1983.

2 Among those other things: the band Emil and the Detectives, which gigged a few times in 1993–5; the solo career of Andrew Poppy, whose first ZTT album *The Beating of Wings* (see note 12 below) used two pieces, 'The Object is a Hungry Wolf' and 'Cadenza', which also appear on the Jockey's *Crepuscule* album.

3 Man Jumping, *Jumpcut* album and cassette, Cocteau JC5, 1985.

4 Reviews of *Jumpcut*: by J. Gill, *Time Out* 15 November 1984; R. Denselow, the *Guardian* 30 November 1984; T. Mitchell, *Sounds* 29 December 1984; L. Barber, *Melody Maker* 26 January 1985; P. Clark, *HiFi News and Record Review* May 1985; S. Trask, *Electronic Music and Music Maker* May 1985. Richard Williams, writing in *The Times*, made it one of his top ten albums of 1984.

5 They even shared a metaphor. Simon Adams, in *Jazz Journal International* January 1986: 'sharp, witty and infectious'; Keith Potter, in *Classical Music* January 1986: 'Both on record and live, Man Jumping is razor-sharp in performance.'

6 Man Jumping, 'Aerotropics – Remix' 12" single and cassette, Cocteau COQ T 16, 1986.

7 For example, S. Trask, *Electronics and Music Maker* December 1985; D. Elliott, *Sounds* 12 November 1985; R. Williams, *The Times* 9 November 1995; R. Denselow, the *Guardian* 15 August 1986; M. Aston, *Music Week* 13 June 1986.

8 J. Attali (1985) *Noise. The Political Economy of Music*, trans. B. Massumi, Manchester: Manchester University Press.

9 This absence is discussed in A. Blake, 'Listen to Britain: music and the advertising message', in A. Blake, M. Nava, B. Richards and I. MacRury (eds) (1996) *Buy This Book. Advertising and Consumption since the 1950s*, London: Routledge .

10 There were a few exceptions, most notably in English. A. Durant (1985) *Conditions of Music*, London: Macmillan – which appeared in a series on discourse and society, not on music.

11 Attali *Noise*, p.125.

12 Attali *Noise*, p.132.

13 Attali *Noise*, p.147.

14 Aspects of this interesting musical relationship are explored in J. Gill (1995) *Queer Noises. Male and Female Homosexuality in Twentieth Century Music*, London: Cassell, pp.158–60.

15 Andrew Poppy's albums for ZTT: *The Beating of Wings*, ZTT 1Q5, 1985; *Alphabed (A Mystery Dance)*, ZTT ZCIDQ 9, 1997; the 12" single '32 frames', ZTIS 2000, 1986.

16 For example, the Art of Noise *In No Sense: Nonsense*, China Records/Polydor ZWOL 4, 1988. This hybridising was preparation for a different musical career: Anne Dudley was a 1998 Academy Award winner for her score for the film, *The Full Monty*.

17 18 April 1995; K. Garner (1993) *In Session Tonight*, London: BBC Books, p.212.

18 The two 12 singles I'm dealing with here are the Art of Noise, 'Beat Box Diversions One and Two', ZTIS 108, 1983 and 'Close-Up', 12ZTPS01, 1984.
19 The beginnings of a discussion of legal aspects of this very important issue can be found in S. Frith (ed.) (1993) *Music and Copyright*, Edinburgh: Edinburgh University Press, and S. Redhead (1995) *Unpopular Cultures. The Birth of Law and Popular Culture*, Manchester: Manchester University Press.
20 For example, the attempt by Oasis to assert copyright control over their music by trying to control information available on the World Wide Web: 'Official warning for Oasis fansites', *New Musical Express* 17 May 1997.
21 J. Nuttall (1968) *Bomb Culture*, London: MacGibbon & Kee.
22 I am grateful to Scarlett Thomas for this insight.

Part III

GETTING TO THE PRESENT

The third section's three chapters are concerned with the recovery and defence of authentic experience through history, and with identifying what the authors see as the inadequacy of existing academic work. Ben Watson, deploying his trademark polemic, tries to revive the cultural politics of Theodor Adorno (usually written off as an elitist who failed to engage with the meanings of popular culture, seeing only the industry that produced it). Taking as his object of attack the academic study of popular culture, Ben Watson argues for a committed defence of the *unpopular*, and in particular certain aspects of avant-garde jazz and the heavy metal end of rock.

Jazz is also the object of recovery in Imruh Bakari's survey of Black music in Britain. Bakari denies the Americacentrism implicit in many accounts of jazz, looking at its relation with all the music of the African diaspora, including in particular the Caribbean musics that have been imported into post-colonial Britain. He proposes that the music of drum 'n' bass performer Roni Size is as constituted through its jazz connection as is that of the more ostentatiously jazzy Courtney Pine.

For James Ingham, too, there is a necessary process of recovery if we are to assess the real meaning of the warehouse parties that dominated the early phase of the acid house movement in Britain, of which he was a participant. Tracing back the sounds and spatial relationships expressed in acid house, he examines their forebears in the clubs of Chicago and the dance-lawns of Jamaica, ending in an exploration of the most overtly spatialised of all twentieth-century music, the dub produced by King Tubby and others in Jamaica's recording studios.

5

DECODING SOCIETY VERSUS THE POPSICLE ACADEMY

On the value of being unpopular

Ben Watson

Thought and the musical object

The romantics held that music, by opening a door on the sublime, bypasses rational thought. In the world of 'serious' music, critics are still to be found who denounce modernism as a rationalist incursion, a cerebral trespass on the preserve of pure feeling.[1] Not that popular music is superior to such romanticism. From the 'authentic' inarticulacy of Britpop to the new age hippie-speak of rave, competing brands of pop (and their critics) concur: music surpasses human understanding. A society that places every human activity before the tribunal of profitability finds it hard to explain the inner workings of music. A cut by Camden Council's education department is justified on the grounds that it 'merely' abolishes music lessons. In a climate of ignorance, it is easy to see why a mystical reverence should develop towards musical facts.

However, just because great music pushes us beyond our immediate verbal resource is no reason to deem it ineffable. Unlike religious experience, music is a specific movement of air molecules: objective, collective and recordable, a material event susceptible to scrutiny. Romanticism's ideology of transcendence is belied by its means of musical production. The symphony orchestra is a stunning example of the division of labour, a factory-like rationalisation unique in world music. Rather than simply unveiling a ready-made objectivity, technical innovations like recording answer social needs. Just as single-point perspective and *chiaroscuro* anticipated the photograph, so the rigorous determination of the score anticipated the aspect of recording that made it perfect for mass-production: repeatability. In this light, the 'unsayable sublime' of romanticism is simply a sentimentality invented to hide the fact that specialists can move our emotions – and then mass-produce the results.

Modernist composers offended romanticism by taking seriously its technical organisation of notes. The historical tendencies of nineteenth-century music were projected beyond audience requirements. Following Theodor Adorno,

79

Marxist aesthetes interpret the asocial screech of the avant-garde as the voice of truth imprisoned within capitalist social relations.[2] In reaction, post-modernism has been closely associated with minimalist music: an affirmative view of society embedded in less challenging tones.

Post-modernism also suggests avenues for musicology. By opening up composition to world and pop musics, minimalism claimed to 'break down the barriers' that separate composers from their audiences.[3] Musicology, too, is under siege from those who claim that the study of non-academic music will smash the division of labour that makes knowledge a badge for the elite. However, by extending its brief beyond the academy, the study of music quickly encounters the paradoxes of all 'scientific' attempts to quantify social experience.

Early 1970s social anthropology was plagued by instances of 'going native' (researchers adopting the language and culture of the 'object' society, even finding sexual partners and settling there). Rogue anthropologists lost their commitment to the original project: they could no longer return to the podium and report back. Those who really begin to understand another culture can no longer communicate in terms approved by the original discipline. In his subversive classic *Rubbish Theory*, anthropologist Michael Thompson pointed out that this raises some difficult questions:

> In consequence, theory can only be built up from the second-rate – from sadly incomplete insights into other realities – and this gives rise to a formidable problem, which is: how do we make allowance for this incompleteness? Do we adopt a crude positivism and assume that what we have gained access to is all there is – that, if we can't get it, it doesn't exist? Or do we accept that our insights are incomplete, that we have no way of knowing how incomplete they are and that, in consequence, we might as well abandon the whole enterprise?[4]

Far from abolishing 'elitism', replacing musicology with social anthropology (Georgina Born)[5] or sociology (Sarah Thornton)[6] actually drives thought and its object still further apart. The problem is Kantian: an inability to reach a materialist and historical understanding of an object – society – which includes the understanding subject. A metaphysical distinction between mind and matter prevents researchers examining their own mental categories. In the same moment that it claims to 'break down cultural barriers', the sociological turn reproduces a class division between the analytical academic and the musical culture 'out there'.

Appeals to the 'popular' promise to solve the 'elitism' of classical music, but actually reproduce it.[7] Confusingly, the opposite of the 'popular' is concealed – because it is the very discourse employed by the analyst. Analysts may declare that they 'really like' the music under consideration – Abba's 'Fernando' or the Adverts' 'One Chord Wonders'[8] – but they also speak a meta-language that

stands above pop music and its audience. The guilt of intellectual privilege is not to be wished away by changing the object of scrutiny. A split between intellect and object of study is built into the empirical method itself. This was pointed out by Hegel. Marx explained why: undialectical application of science to society reproduces the hierarchies of class.

A dialectical musicology requires a critique of careerism

What would a dialectical musicology look like? It would need to bring the historical nature of its concepts to consciousness – to subject the mental categories of the researcher to the same scrutiny as applied to the music. The reason that the academic study of pop produces such poor results – mocked by musicologists and listeners alike – is because it proceeds in the Kantian manner. It attempts to sort out its categories *prior* to engaging with the material.[9] Examination of the genesis of popular studies reveals that its categories are not the immutable conceptions of pure reason Kant argued were the preconditions for science. On the contrary, they are all too historical. Embarrassing as it is to its claims to 'objectivity' and 'science', they reek of politics.

The modernist high-culture 'elitism' of the bad old days is a demon-of-convenience for upwardly mobile intellectuals. Downgrading the value of a materialist analysis of genuine elitism (one that might lead, say, to union solidarity in the face of education cuts), post-modernism favours the competitive individualism of style warfare. In an intellectual version of Nigel Kennedy's 'roughened' accent, careerists wave their knowledge of the Beatles and Madonna in the face of the fuddie-duddies whose professorial positions they crave. Theodor Adorno, one of the prime exhibits in the post-modern hall of infamy, was actually a thorn in the flesh of the establishment. His proposals for a socially cognisant musicology, one that sprang from a vision of the social whole, was rejected by British academic departments committed to Leavisite 'practical criticism' (literature) and Schenkerian 'analysis' (music). In the writings of post-modern cultural theory, however, Adorno's holistic approach is damned as 'totalitarian' and 'elitist' – the cause of all our ills.

Before the political and cultural turmoil of the 1960s, mass culture was not the occasion for these claims and counter-claims. It was the birth of the *counter-culture* that gave pop music its intellectual standing. It is impossible to understand why academic departments were set up to study 'popular culture' without appreciating the political and artistic seriousness brought into the charts by Marvin Gaye and the Beatles, Bob Dylan and Jimi Hendrix. These developments were a spiritual expression of the fact that insurgent populations stopped a major war waged by an imperialist nation against a Third-World country (Vietnam) and briefly seized power in a major capital (Paris '68). These political facts were omitted by those with designs on academic respectability. Simon Frith and Dick Hebdige concealed the anti-establishment inspiration of their love for Black music in studies of 'fan culture' and 'youth identity formation'.[10]

The political and artistic relevance of rock 'n' roll also created unheard-of opportunities for commerce. When radio DJs wax nostalgic about the 1960s, it is because the institutions they now occupy were created in that decade. 'Popular music' is not the permanent adjunct of an eternal capitalism: it is a specific historical product nuanced by developments at different times and in different countries (for example, differing histories of imperialism explain the influence of Angolan music in Portugal, reggae in Britain and rai in France). Pop as we know it was created in the 1960s: it was not simply a 'peak in record sales' that would recur in the future. The Great Disco Collapse of 1979[11] was the result of commercial speculation about a fad that was expected to be a rerun of the Rock Boom. The belief that history – a specific conjuncture of determinants – may be fitted into eternally recurring, abstract patterns obscures actuality from Stock Exchange speculators and sociologists alike.

Pop is not a musical form

The academic study of 'pop music' cannot produce results because its founding concept is tendentious and ideological. Unlike blues or ballad form, computer music or guitar music, 'pop' does not describe anything concrete. 'Pop' merely tells us *what commercial interests believe will sell*. It is not a musical description, but a speculative category. Like all concepts, pop depends on its binary opposite – *unpopular* music, or the avant-garde. Empirical 'research' into pop music is rendered banal to the point of imbecility by the exclusion of this conceptual opposite. A materialist study of music, one that looks at the actual problems facing people engaged in music-making, immediately discovers conflicts over ideological compromise, musical standardisation and audience miscomprehension. It finds antagonism and avant-garde postures at every level. Only by exclusive focus on the 'consumer' – a putative concept with no ground in social class and no material relationship to the means of production – can popular studies evade the dialectical role of the *unpopular* in the genesis of pop.

Sociology turns avant-garde and 'popular' into watertight classifications, as if they describe particular styles. This obscures the fact that music, like all productive labour, is historical and concrete, a material process in which abstract antinomies are in continual interpenetration and transformation. Britain's forays into Black American music – Ronnie Scott working his way over to New York to hear Charlie Parker, Alexis Korner playing blues in Richmond, Big Bill Broonzy sleeping on Val Wilmer's mother's kitchen floor, Chas Chandler flying Jimi Hendrix into London to play the Scotch of St James, Lol Coxhill touring with Rufus Thomas – were all experienced as avant-gardes. Rock's subsequent commercial success has made every move legendary; but at the time, these people were operating in opposition to an entertainment scene they considered moribund and superficial – they *were* the avant-garde.

English middle-class aversion to the avant-garde has roots in history. The first nation to industrialise, England was also the first country to accommodate

the bourgeoisie to the landed interest and restore a monarchy. Victorian England produced Lord Alfred Tennyson; revolutionary France produced Charles Baudelaire. In the twentieth century, British vorticism was isolated and one-dimensional compared to the fertile interactions of cubism, expressionism, Dada, De Stijl and constructivism in Europe and Russia. T.S. Eliot's conversion to Anglo-Catholicism reneged on the anti-establishment resonance of his literary modernism, while F.R. Leavis quarantined English letters against the taint of continental surrealism and its 'over-intellectual' obsession with Marx and Freud. This historical aversion to the avant-garde remains a block to its becoming a dynamic category in the study of pop.

By understanding avant-garde and 'popular' as a distinction between 'high' and 'low' art, sociology places music on the shelves of an unshakeable class system. Post-modernism then arrives breathless with the discovery that availability of culture on the mass market mixes up and subverts 'high' and 'low' – pretty stale news to the Shakespeare scholars who interpret his every play as a miscegenation of court and barnyard.[12] If, following V.N. Volosinov, we see material culture as a pivot for class struggle, rather than something 'belonging' to a particular class layer, music's antithetical nature should be no cause for surprise. It is the very ambivalence of signs that allows them to be used in dialogue.[13] Instead of marvelling at this fact – even taking it to mean, contrary to all the economic evidence, that the end of class society is at hand – what we need to do is to *understand* the social tendency of various struggles around musical form. In doing so, we can commit ourselves to principled judgements.

A dialectical musicology should not only bring the historical provenance of the category 'pop' to consciousness. It must recognise that we can learn more from testing ideas in practice than from the theoretical 'systems' of those who assume – along with Kant – that the purest thought is contemplative and impractical. It is the contention of this essay that more light is shed on the mass culture industry by an 'unpopular' recording artist like Ronald Shannon Jackson than the vapid generalisations of what could be characterised as the Popsicle Academy.[14]

Simon Frith's *Performing Rites*

If the Godfather of Soul is James Brown, then the Godfather of the Popsicle Academy – since the mid-1970s, the most hardworking man in the business – must be Simon Frith. After two decades spent dressing up his musical tastes as 'sociology', Frith has become a Professor of English – and has finally turned his attention to aesthetics: his recent book *Performing Rites* is subtitled *On the Value of Popular Music*.[15] Those who insist, with Adorno, that absence of judgement makes the sociological approach to culture meaningless, might be expected to cheer.[16] Indeed, the final words of Frith's opening chapter – entitled 'The Value Problem in Cultural Studies' – offer hope for those looking for critique:

This is where my own tastes will inform everything that follows, my own tastes, that is, for the *unpopular popular*, my own belief that the 'difficult' appeals through the traces it carries of another world in which it would be 'easy'. The utopian impulse, the *negation* of everyday life, the aesthetic impulse that Adorno recognised in high art, must be part of low art too.[17]

This promises an aesthetic to be cherished: an articulation of the critical aspects of commercial music Adorno was born too late to grasp. However, the man who presents the Mercury Award to winners complicit with the British Music Industry has not relinquished his role as proselytiser for an affirmative culture. Indeed, Frith's aesthetic turns out to be no more 'Utopian' than an urbane way of chatting about all 'our' mysterious predilections: it is therefore unfit to deal with the explosive intensities of mass-produced music, which so often disrupts such 'reasonableness'. Frith misses the spleen and scorn that rages within the music.

Frith would have us believe that he can appreciate punk, rap and riot grrl alongside Meatloaf and Handel. He hopes to 'remain enough of a Marxist to be wary of answers...which are static, undialectical, which suggest that the way things are is the way they have to be'.[18] However, a mild sense that all is not right with the world does not constitute a critique of the role of capital in musical culture. Indeed, it is precisely Frith's inability to escape 'static, undialectical' sociological categories that explains his failure to arrive at a convincing aesthetics.

Youth studies: last refuge of a scoundrel

Frith's book registers an implicit retreat from 1960s militancy. His academic project no longer defines itself as a Sociology of Rock. Instead, it has become the musical wing of the general study of 'popular culture' that now includes sport and fashion.[19] However, the seeds of such banalisation were there from the start. 'Rock is the music of youth' were the words that opened his first book.[20] Responses to Black American musical forms were initially phrased in adult language – Hermann Hesse's *Steppenwolf*,[21] the jazz poetry of the Beats,[22] Eric Hobsbawm's Marxist jazz criticism.[23] The English bourgeoisie deem it an indication of immaturity to take either socialism or pop seriously: these are delusions peddled to the readers of *New Musical Express*, not the cultural accoutrements of the mature. Frith's reduction of non-classical music to a soundtrack for immaturity conceded everything to conservative cultural values from the start.

Frith still includes 'youth' in the brain-numbing mantra of 'gender, race, class, religion, nation, sexual-orientation, disability, etc., etc.' that certifies cultural studies discourse,[24] but it is no longer his central term. It has been replaced by the equally unhistorical and undialectical concept of the 'popular'.

For all his demurs about ideology and essentialism, Frith cannot see through the patronising, top-down concept of the 'popular audience' to the contested realities that shape our culture. As a person who 'loves rave music' but has never been to a rave – and who expresses amazement that a rock band should abominate the priorities of the sound-mixer[25] – Frith is remarkably ignorant of the mediations of the art form he has made his 'speciality'.

Frith rarely contradicts other writers (at one point, uniquely, he registers that a certain opinion makes him 'bristle').[26] However, for anyone who is not in on the racket of 'popular studies', this politeness comes across as a collusive exercise in mutual citation – of observations whose banality is frequently breath-taking. At least the academic study of Roman law or glaciers or Romantic poets keeps alive knowledge that cannot be found elsewhere; so much of this, on the other hand, is otiose: 'Behavioural rules apply to audiences as well: an audience for the Cocteau Twins behaves differently from an audience for Nirvana.'[27] Grunge audiences are different from those for indie pop: now, whoever would have guessed that!

A negative

Frith's normative sociology applauds the mere act of description. As each new aspect of 'popular culture' is duplicated in the literature, it is hailed by Frith as a 'nice observation' (and receives the all-important footnote). Yet because this is study of 'the popular' (not the avant-garde, or the eccentric or the downright asocial), we are only ever told things that have been done to death in the media already – usually with more wit. Frith pours the results of all such 'findings' into a dilute soup of 'what we now know' (the material social basis of this 'we' remains unexamined). *Performing Rites* is a patchwork of unopposed points of view: every contribution is a plus. The aim of this essay, on the contrary, is to provide a *negative*: something that might break with Frith's collusion and trigger genuine debate.

Descriptive sociology is an insult to the people it describes: it performs the condescension of generalising specific experience, of treating human beings as an object of study rather than subjects of address. Sociology and market research are designed to give those in charge of production information about potential customers. Frith's attempt to provide a 'left' or 'progressive' sociology can only be an eclectic compromise in which pious wishes (an *'unpopular popular'*[28] here, a 'disruptive'[29] there) are added without upsetting the basic assumption, which is that of a stable and equitable society whose division into class layers is inevitable and natural.

In so far as Frith claims to be a 'popular consumer' himself, he is immediately compromised by the ecumenical blandness of his tastes. In *Performing Rites* he declares his aesthetic 'values'. These prove to be what you'd expect from a mainstream pop reviewer who finds redeeming features in whatever reaches the top of the charts: Meatloaf, the Pet Shop Boys, Portishead. In an

extraordinary confession of faith in official culture and lack of curiosity (not to mention access to an exceptional wealth of listening materials) Frith declares that he never played his B-sides![30]

In his review in *The Times Literary Supplement*,[31] Richard Coles focused on the most speculative part of Frith's book, which argues that music – like sex – allows us to 'live in the present tense'.[32] However, this Utopian vision lacks critical focus. Walter Benjamin used 'jetztzeit' – 'now time' – to criticise the ossified experience of commodity capitalism.[33] For Frith, on the contrary, pop is a *complement* to the alienation of work. His exhortations to consume (plaudits for the latest release) are in effect calls to earn money: to *work harder*. Since only Marxists envisage the social totality (and hence the net effect of 'harmless' activities like pop reviews in national newspapers), such criticisms exceed Frith's liberal brief. Without an understanding of how the profit system impacts on musical experience – how, for example, the catharsis of gospel or free jazz is branded as eccentric to pop normality because such music does not create biddable 'star' personalities and saleable commodities – Frith's account of music as 'the utopian impulse' and the '*negation* of everyday life'[34] is really no more than calling it 'nice'.

Like the smile of the electoral candidate, the urbane pluralism of Frith's taste conceals less savoury ambitions. He hopes his bland recital of other people's opinions will flatter enough positions on non-academic music to allow him to continue to chair the debate. But liberalism only gains a free space for 'dialogue' by suppressing the conflicts that spring from social inequality. The very terms – the study of the 'popular' – exclude the one observation that could provide the basis for a materialist musicology: that the 'popular' is constructed by an industry based on exploitation.

In a capitalist society, as soon as any music occurs that has an emotional resonance for society as a whole, it is harnessed to a system geared towards profit. Actual communication is replaced by mechanisms to accelerate the extraction of surplus value. Some artists manage to use these mechanisms to achieve wonderful things, but only because they are informed by concepts of resistance (variously described as morals, hipness, roots, no-sell-out, hardcore, the avant-garde) that Frith's focus on the 'popular' and the 'consumer' fail to articulate. Nat Cole's dignity, Elvis's sincerity, Tammy Wynette's moral core, George Clinton's scatological subversion, the KLF's pranks, Alabama 3's prison-inmate defiance, Sinead O'Connor's politics, Sonic Youth's noisecore raids on rock business-as-usual – all of these spring from an antagonistic aesthetic Frith is unable to descry.

In his introduction, Frith cites his love for the Pet Shop Boys as if this revelation of 'common' taste will earn our affection. Actually, as a former editor of *Smash Hits*, Neil Tennant has the same background in press privilege and behind-the-scenes elitism as Frith the pop journalist. Pet Shop Boys records are knowing, littered with references to post-modernist consumer theory and media studies. However, they convert such awareness into the *irony* that Richard

Rorty made central to his defence of right liberalism.[35] Frith finds the Pet Shop Boys sublime because their combination of smugness and success reflects his own. It has no room for the cry of those excluded from the game. However, this cry remains the 'value' Frith is attempting to locate: the visceral tremor of his adolescent exposure to blues and soul. Although he has now hidden his Sociology of Rock in a mandarin discursus on pop, Black American music – as for everyone initiated by the Beatles and the Rolling Stones[36] – remains the hidden foundation for Frith's conviction that non-academic music is worth taking seriously.

For all his urbanity, Frith's judgements are inconsistent. This is because his aspiration to respectable authority entails repressing the social provenance of his ideas. His tolerant universalism repeatedly gives up on heavy metal, which he calls 'male bonding in futility'.[37] This derives from an early-1980s liberal current that proposed turning Rock Against Racism into Rock Against Sexism and castigated guitar music as proletarian 'backwardness'. These prejudices have kept him uninformed about developments in metal that brought in punk attitudes and politics (Motörhead, Bad Brains, Napalm Death, Suicidal Supermarket Trolleys, Rattus) and made connections with both the avant-garde (John Zorn, Ascension) and feminism (Lunachicks, L7, riot grrl). Because Frith removes the political roots of his reasoning, his views are categorical judgements on inert objects rather than dialectical challenges to living subjects.

In tokenistic surrender to Black Nationalist brickbats – launched by a Black middle class who wish to sever connection with demotic excesses – Frith hides that rock 'n' roll is a 'burlesque' of Black music, 'endemic' with racism.[38] This poisons any progressive aesthetics of pop at source, completely misconstruing the camp release that is Funk.[39] Frith subscribes to the liberal high-mindedness that removes from rock 'n' roll miscegenation its trump card: desire.[40] Frith repeats Bernard Gendron's slander that in playing up a caricature of Blackness to a White market, Chuck Berry and Ray Charles abandoned the 'sedate' and 'dignified' blues of yore (the idea of male blues as anything but reprehensible, alcoholic and low-down is quite simply a rewrite of history).[41] Borne aloft on this tide of middle-class moralism, insulated from the inspirational electricity of Black music's wild transgressions (from Little Richard's pompadour to Jimi Hendrix's guitarlingus and Snoop Doggy Dogg's boasts about testicular pre-eminence), Frith ends up denouncing the Red Hot Chili Peppers! It seems their antiracist politics is anathema.

A critical musicology would use categories that articulate historical processes immanent to the music. These can be found in the names that designate musical styles: ragtime, jazz, swing, bebop, blues, race, rock, improv, punk, rap, rave, drum 'n' bass, process, lo-fi, etc. As the music of the past is bought up by corporate capital, its expressive charge – its negative, critical, lived moment – is emptied of social content and marketed as a pure plus. Only a materialist musicology that raised the hard facts of capital investment, surplus value, musician failure and fan disappointment could generate real information about the

industry that provides Frith with his review 'product'. The paradoxical fact is that only failed critics – those who support bands who are ignored by the major labels, who rile editors by supporting labels that never buy advertising space, who grumble on about the stupidity of 'the mass' – truly reflect the experience of the 'mass'. This is because, unlike the spectacle of success presented by the charts, the mass (those without access to capital) are not in fact 'on top'.

Ronald Shannon Jackson's Decoding Society

Consideration of the travails of an 'unpopular' artist can tell us more about how the industry hurts music than all the fanbase 'research' of the Popsicle Academy. Ronald Shannon Jackson is a drummer who, in the current phrase, 'defies categories'. He shows that genuine defiance of categories raises problems undreamed-of by the glib copywriters of arts brochures. The experience *hurts*. Shannon's current band was put together in order to emphasise gospel roots. Each musician, in common with most working-class Black Americans, has had some experience of a sanctified church. Guitarist Jef Lee Johnson uses a Marshall stack and plays loud. This has led some jazz critics to denounce Shannon Jackson for 'selling out' with attempts to 'popularise jazz'. This fails to understand what motivates the music. Jazz may be marketed to a class society as an 'elite' article of consumption, and rock as a 'mass' phenomenon, but that doesn't explain how either come into being.

The current rash of studies of 'consumption' is the last gasp of a movement that began in the Euro-communist magazine, *Marxism Today*: a critique of Marxism for being 'production-oriented'. It has allowed battalions of ex-left intellectuals to make peace with government and commercial social-research bodies. It forgets a crucial fact: the 'consumer' is not a reality, but a way of looking at people from the point of view of those who bring goods to market. It is actually people seen from the point of view of the *manufacturer*. The category of 'consumer' reneges on the universal humanism proposed by the bourgeoisie in its heroic phase, and is very precisely *production oriented*. To say that Marxism ignores issues of 'consumption' is to pretend that Marxists never deal with either hunger or aesthetics, both of which figure high on its list of priorities. Marx declared the world working class the inheritors of the bourgeois claim to stand for the interests of humanity as a whole. Rather than looking at people from the point of view of the productive sector – as 'consumers' – Marxism looks at economic systems from the point of view of the mass of people, the exploited. Marxism is therefore more intimately concerned with the facts of actual consumption than any surveys for whom 'consumer base' is a euphemism for calculating economic *solvency* and potential *sales*.

A recent letter to *Time Out* reads:

> I'm a student in Bristol on a media degree and am making a radio documentary about fans. If you've got posters all over your wall of Boyzone,

if you dribble 'n' drool over Peter Andre, if you really wanna meet the
Spice Girls, or if you idolise Elvis, then I'd like to speak to you.[42]

If the Bristol student were directed to look at the music and marketing of
Boyzone – and allowed to admit to subjective ('aesthetic') responses – one
might find out something about pop entrepreneurship and commodified sexu-
ality. Frith's sociological approach makes sure that 'research' merely perpetuates
commercial categories

If, instead of attempting to interview people already designated as
'consumers' of various mass-marketed stars, our Bristol student had been encour-
aged to look at the formal musical basis of Boyzone and the Spice Girls, he would
have found them reliant on early-1980s Black pop and its use of multi-tracking to
separate out the polyrhythms of disco for audibility on transistor radios. The
gradual rediscovery of African polyrhythm is a well-known story in histories of
jazz, but rarely features in considerations of pop. However, 'jazz' itself is a
construction – one that separates off acoustic music and improvisation as marks
of a 'high' and 'inaccessible' culture. Exposure to Ronald Shannon Jackson's
music and motivations would do much to alter our Bristol student's starting cate-
gories. Shannon could demonstrate the source of the Spice Girls' drum patterns
in Prince and Shalamar, and how their beats relate to James Brown's recasting
of Texas blues. Shannon could explain the role of gospel in music, from the
Allman Brothers to Crystal Waters, and explicate the revolutionary politics of
free jazz.[43] It is true that such heady ideas might put our student's 'career in
pop radio' at risk, but Bristol has a long history of funky subversion – the Pop
Group, Rip Rig and Panic, Pigbag, Armagideon, Black Roots, Dub Crusaders,
Red & Blue: this new knowledge of rhythm and politics might enable the
student to contribute to Bristol's burgeoning pirate-radio scene.

There is something absurd about raising a discussion of radical Black jazz –
John Coltrane and Ornette Coleman and Albert Ayler – in the midst of the
'sociology of pop'. However, as the Dadaists understood, all real challenges look
'absurd' to those in power: the charge of absurdity is a means of policing a
normality conceived as adequate. However, the absurdity is not only on our side.
Professor Frith is hardly a household name within 'popular culture' either, yet
there is no embarrassment at quoting *his* name when researchers propose a non-
classical musicology. The Popsicle Academy hide the eccentricity of what *they* do
behind a screen, whilst the music on the radio is made to appear as natural and
inevitable as the wind and sky. My contention is that consideration of avant-
garde music – taken in conjuncture with awareness of the mass market as a
whole – tells us more about pop than the 'theorists' who profess to advise us.

Shannon Jackson was born in Fort Worth, Texas in 1940. He played R 'n' B
with musicians associated with Ray Charles before moving to New York, where
he made a splash by drumming for Albert Ayler, one of the revolutionary
players that arrived in the wake of John Coltrane. Ayler's reception in New York
in the mid-1960s is a textbook example of the manner in which a class society

travesties anti-commercial populism. Ayler was deemed unlistenably violent, but his playing was actually what you can hear at the ecstatic peaks of a gospel service. When you listen to the drum patterns Shannon Jackson is playing behind his sax lines on the one recording they made,[44] it is the same kind of dramatic, pushy, improvised dancing funk that Shannon plays with his guitar-heavy 'metal' Decoding Society today.[45]

Shannon drummed on *Dancing In Your Head*, Ornette Coleman's inaugural electric album.[46] At a loss to describe how it could simultaneously sound so aggressively avant-garde and populist all at once, critics called it 'punkjazz'. It was taken up in New York and called 'No Wave' – a musician's answer to new wave's rediscovery of 1950s pop. Performing a rhetorical Einstein on the fundamental parameters of the European academy, Ornette christened his music 'harmolodics'. It was the first new step taken by jazz since freedom in the 1960s, but it has faced the problem of marketability. It's too dissonant for the radio, yet too raunchy for the concert hall. In an interview, Shannon pointed out that the music was not really designed to be 'avant-garde' at all.

> When I was a small kid, there was a very strong grapevine, not from the newspapers, but every morning at 5 o'clock my uncle would get up to prepare breakfast, you'd hear about what happened, somebody got shot, somebody was leaving town, someone was going to California. Lots of churches, churches and bars, and all-night places that played music. The black community was doing all right, but the white community had gobs of money. We had a strip on Jacksboro Highway that was very famous for years and years, because regardless of the law you could gamble all night, there were burlesque houses, striptease joints, all the things that were necessary for the kind of music we call jazz to survive and to develop in. My mother was someone who loved to dance. In the summer – it's a very warm climate also – there was a place called Greenway Park and my mother used to go there to dance. The musicians would go around 5 or 6 in the morning after playing on Jacksboro, out in the park where no-one could hear it, and the musicians would just jam all night and the music that you hear as 'harmolodic', man, I was hearing at the time I was two years old! My grandmother refused to be a babysitter, she made my mother take me, so my mother would have me in the back of the car, and I remember as a kid, raising up and looking over the back seat of this car, listening to all this music. It was musical joy, music of pleasure, because the musicians had made their money, and they would come just to have jam sessions at 7, 8 o'clock in the morning. People would be dancing.[47]

When Shannon says 'no-one could hear it', he refers to the police, but also the night-club owners who don't want music that might upset the dining habits of their paying customers. Far from being a 'non-evaluative'[48] indulgence,

music outside the academy is a struggle to achieve community and truth. Commerce can indeed turn it into something ordered, predictable and miserable – but to judge the producer by the product is to accept commodity production and exploitation.

Frequently, focus on art as a haven from commercial degradation itself becomes an excuse for elitism – and hence an ideological acceptance of class society. It is because Adorno emphasised this fact that his writings are deemed 'incomprehensible' and 'paradoxical' by those who want uncontradictory positive value in art. However, as Frith shows, abandoning the artist in favour of the putative 'consumer' is no solution either; the result is an affirmative sociology that cannot home in on the critical aspects of mass culture. Convincing aesthetic theories arrive from writers whose involvement with music goes beyond either the daydreams of the fan or the narcissism of the connoisseur (though often assumed to be opposites, both stances reflect the alienation and powerlessness of consumption).

Musicology outside the academic playpen: Wilmer, Vincent, Carducci

Writer Val Wilmer has become increasingly marginalised in the 'jazz' press as the free jazz she supports has been downplayed by a fashion-driven music industry determined to recycle 1970s disco and bossa nova as 'new' movements (acid jazz, trip-hop, etc.). Adherence to the point of view of the musician means that her writings open up a window on the turmoil of the 1960s that is denied to those who simply rearrange their Beach Boys and Van Morrison albums in order of preference. This adherence naturally sways her towards Black nationalism and art ideology – both of which inculcate pessimism about mass music – but she nevertheless provides an account of the actuality of musical production. Wilmer is an essential corrective to the way Frith's method restricts students to the safe imaginary of finished product. As might be expected for such a champion, when Wilmer launched her classic book on free jazz – *As Serious As Your Life*[49] – Ronald Shannon Jackson offered to play at her launch.[50]

Rickey Vincent is a DJ with a funk-music broadcast in the Bay Area of San Francisco. His book is a passionate exposition of the virtues of Funk from James Brown and George Clinton through to Gangsta Rap and Afrika Bombaataa.[51] Free of the liberal relativism that makes Frith so hesitant about judgement, Vincent speaks with authority. His treatments of disco, Prince and Michael Jackson are nuanced and insightful because he understands that the glory of Black music stems from group collectivity and action from beneath. He understands the manner in which a commercial system encourages the creation of individual 'stars' and how this saps the multicultural and multisexual ideals of funk. He criticises the buttoned-up aesthetic of the new Black middle class and salutes the White bands who extend funk tradition (including the Red Hot Chili Peppers).[52]

Although hampered by the domination of American politics by race, Vincent is aware of the potential for political consciousness in working-class musical collectivity and how this is impacted by the profit system. The dilemma between 'artistic' and 'political' judgements in so much pop criticism is unmasked as a product of reified consciousness, an alienation from the social actuality of musical production. For Vincent, good music turns you on. Sexual pleasure, stoned silliness and historical knowledge are all aspects of The Funk. He also has praise for Shannon Jackson and his Decoding Society, removing him suddenly from the category of 'élite jazz' to that of 'nastay swanging fonk'.[53]

As with Wilmer and Vincent, Joe Carducci's thesis on rock and pop has been ignored by the Popsicle Academy.[54] Like them, he does not obey the back-scratch niceties of footnote and citation, but like them too his knowledge of the music is immense and theoretically innovative. True, it is possible to dismiss Carducci's writings as the illiterate ramblings of a boorish, redneck rock album collector. Because in a way they are. But *Rock and the Pop Narcotic* also contains an aesthetic that draws astonishing parallels to Vincent's. In a detailed survey of rock from the 1960s to the present day, Carducci pillories the hypocrisies of *Rolling Stone*-style liberalism: the critics who need Bruce Springsteen as a super-star in order to fulfil their fantasies of a political correctness rewarded by mainstream success. Carducci concentrates on an admirably simple aesthetic premise – does the music *rock*? – and reaches a conclusion of Adornian heights.

For Carducci, rock proposes a proletarian mode of collective, improvised, industrial music-making continually at loggerheads with the bourgeois individu-alism of music-publishing copyrights, studio technology and the star system. This class analysis allows us to appreciate what Shannon Jackson is trying to do: play great modern proletarian music and shrug off the categories imposed by marketeers and sociologists (Black/White, rock/jazz). Though Carducci's brief does not stretch to avant-garde jazz, Shannon Jackson's Decoding Society duly makes an appearance (and in heavy type, signifying 'real rock' – an accolade denied Bruce Springsteen!).[55]

Carducci's thesis receives independent confirmation by Johnny Rotten's words on the group ethos.

> I'm writing this book because so much rubbish has been written about us that it might be interesting for someone to get the correct perspec-tive on it and see it for what it really was, rather than what the fantasists of the world would have you believe. There's so much exag-geration and intellectualizing going on about what was basically real human beings trying to come to grips with each other and somehow or another actually writing songs that mean something. It's such an intense process, being in a band, but some of the books out there never understood that. These writers have never been in bands, and they have never really committed themselves to other people in such close quarters. They're more like solo performers, and there ain't no

such thing as that in any band. You should never leave any single
member in a band up to their own devices. I don't care how big
headed the lead singer is, it all comes down to the fact that he must eat
shit in a rehearsal room. The histrionics of the lead guitar, the excesses
of the drummer and the stupidity of the bass player have to mix on
equal footing.[56]

For Carducci and Rotten, proletarian music-making is a Utopian anticipation
of a new way of doing things: it *is* 'sensuous human activity'.[57] It is not
evidenced by record sales or recordings designed to fit radio formats. Carducci
shows how Bruce Springsteen betrays his blue-collar aesthetic by recording to
radio-friendly click-tracks. This attack on standardisation is a devastating coup
for critical intelligence: direct, intimate infusion of aural sensitivity with the
orientation of the expert.[58]

Carducci is prepared to talk about the *use value* of music, prepared to make a
judgement, and able to trace the moment at which exchange value impacts the
form: the spoilage of music by the interests of capital. Although Carducci's poli-
tics are skewed by indignation with the hypocrisies of liberalism (his
redneckism), he has developed a magnificent argument for a political, class-
defined aesthetics of non-academic music. Symbolic of his refusal to
countenance the use of rock music as a condescending tool of 'moral improve-
ment' for the working class is his concentration on the bottom of the music. He
begins by explaining how a band *rocks*: 'It's the purposeful imprecision of the
drummer in response to the purposeful imprecision of the bassist and guitarist
as the three of them chase down a song-ritual's particular spirit incarnation that
excites the listener.'[59] This live materialism is directly pitched against the bour-
geois obsession with finished product. Like Rotten, Carducci is making a social
criticism of the ways of life justified by different critical perspectives.

> *Pop* criticism requires nothing more than a radio and records. And if
> you get your records free by mail from the labels you need never leave
> your apartment (other than to check out that new restaurant that
> everyone says is so hot). With just a little sleight of mind, this pop
> circus gets presented as if it were the rock world.[60]

Carducci's aesthetic is not only illuminating about live music: it provides an
explanation of what makes certain records classics. Listeners find themselves
returning year after year to records which put Carducci's 'purposeful impreci-
sion' at the centre of the mix. This is the reason records by Marvin Gaye, the
Stones, Hendrix, Little Feat, Zappa, Iggy Pop, the Pistols, the Cramps, the
Specials, the Only Ones, Pinski Zoo, Metallica, the Decoding Society – and
whole genres like Studio One dub, Stax and Memphis soul, Gangsta Rap –
sound so 'good'. They are played by ensembles who have spent time working
collectively at their 'purposeful imprecision'. Far from causing deafness to new

developments (such as the defence of 'real rock' by *Mojo* magazine), the idea
that purposeful imprecision, collective interplay and explicit usage of industrial
technology are crucial can explain why free improvisation, *musique concrète* and
lo-fi have become oases of aesthetic quality in a desert of pop fraudulence.

Carducci has discerned an essential starting place for any materialist criticism
of art: the artwork is a product of real social activity and does not 'mean' simply
in relation to already-existing signifiers. When Frith talks about the Pet Shop
Boys, he lists the references their 'craftiness'[61] conjures, their skill at communi-
cating within a closed system. In contrast, Carducci is concerned with musical
productivity. Despite his bad manners, this makes his aesthetic similar to those
of Wilmer and Vincent. If writers on rock, jazz and funk can all agree so much,
it seems that Frith's liberal relativism is not the only ground on which commit-
ment to different genres can meet. Instead of a merely personal statement about
how a record fits into a pre-existing set of social signifiers, aesthetic judgement
becomes a way of discerning the social means of the music's production.

Conclusion

Combine Wilmer, Vincent and Carducci and you have the makings of a *critical*,
interventionist aesthetic of pop, one that bypasses the sterile paradoxes of
Frith's pseudo-universalism. A musicology of non-classical music – materialist
and universal – is possible, but it is not to be achieved by empirical sociology or
structural anthropology, disciplines that reflect back the bureaucratic, inert cate-
gories of class society. Critical musicology will only be achieved by establishing a
dialogue between awareness of the social antagonisms within mass-produced
music and Adornian attention to the materials of mediation. Only those who
really care about the material they're talking about – and hence have tried to
change things at the point of musical production[62] – can make a contribution.

In the 1980s, Joe Carducci worked for the West Coast label SST. Founded
by the punk band Black Flag, SST issued a slew of records that trashed the
genres by which commercialism duplicates the divisions of the working class.
The label kick-started the career of Joe Baiza, who issued punk records under
the name of Saccharine Trust. His band Universal Congress Of later played a
tune – in this context, the aptly named 'Small World' – written by Ronald
Shannon Jackson.[63] The Popsicle Academics believe that they can find in chart
music a redemptive 'togetherness' that will resolve the conflicts of the world.
This absurd daydream of a functioning capitalism only makes sense to its benefi-
ciaries. However, in a different way, those rejected and destroyed by the system
can also find a unifying force.

For bourgeois historians and social scientists, all 'sensuous human activity' is
tainted by a lack of objectivity. In the Popsicle Academy, expression of musical
preference is deemed to make a musicologist partial and hence unscientific. In
fact, the reverse is true. Frith, Born[64] and Thornton, mired in the paradoxes of
Kantian social science, are actually incapable of making objective musical judge-

ments – while Black funkateer Vincent, White lesbian Black Nationalist Wilmer and redneck Carducci, all militantly committed to their chosen 'genres', can unite in appreciation of Ronald Shannon Jackson. This is because his Decoding Society plays objectively great music, and this material fact transcends ideological posturing and the illusion that 'consumer choice' is a political or existential act. Far from being divisive and destructive, social and musical engagement allows writers to tell it like it is.

Notes

1 For example, Ivan Hewitt's attack on the composer Richard Barrett, 'Fail Worse, Fail Better', in *Musical Times* March 1994.

2 The most succinct statement of this argument is to be found in the T. Adorno (1941) 'Schoenberg and Progress', in *The Philosophy of Modern Music*, trans. A. Mitchell and W. Blomster (1973), London: Sheed & Ward.

3 Usually accompanied by exhortations to 'destroy elitism'. Since such phrases invariably appear in concert programmes – middle-class explanatory devices absent in other musics – the rhetoric is fabulously paradoxical.

4 M. Thompson (1979) *Rubbish Theory*, Oxford: Oxford University Press, p.6.

5 A recent attempt to deal with contemporary music using anthropology is G. Born (1995) *Rationalizing Culture, IRCAM, Boulez and the Institutionalization of the Musical Avant-Garde*, Berkeley: University of California Press.

6 A recent example of the sociological approach – and one that has caused much indignation among the 'natives' – is S. Thornton (1995) *Club Cultures, Music, Media and Subcultural Capital*, Cambridge: Polity.

7 Born, *Rationalizing Culture*, p.280, proposes a concept of the 'popular' to go beyond both modernist elitism and post-modernist eclecticism. The category derives from Pierre Bourdieu.

8 Examples from a talk by Georgina Born at 'Popular Music Talks Back', Conference of Critical Musicology, King's College, London, 19 April 1996.

9 A point forcibly made by Gillian Rose (1981) against sociology in general, *Hegel Contra Sociology*, London: Athlone, pp.45–6.

10 Stuart Hall, on the other hand, was so patrician he had no low tastes to hide.

11 See F. Dannen (1990) *Hit Men, Power Brokers and Fast Money inside the Music Business*, London: Muller, p.155.

12 The short-memory idiocy of much post-modernist excitement about 'high' and 'low' in-mixing may be gauged by a glance at William Empson's 1935 essay, 'They that Have Power, Twist of Heroic-Pastoral Ideas in Shakespeare into an Ironical Acceptance of Aristocracy', *Some Version of Pastoral*, London: Peregrine/Penguin, 1965, pp.77–96.

13 'If ...a certain sound complex had only one single, inert, and invariable meaning, then such a complex would not be a word, not a sign but only a signal.' See V.N. Volosinov (1929) 'Multiplicity of meanings is the constitutive feature of a word', *Marxism and the Philosophy of Language*, trans. L. Matejka and I.R. Titunik (1986), Cambridge, Mass.: Harvard University Press, p.101.

14 A reference to both pop sociology's lightweight theoretical armature and its musical predilections.

15 S. Frith (1996) *Performing Rites, On the Value of Popular Music*, Oxford: Oxford University Press.

16 Adorno's dialectical approach, which answers empirical sociology's claims to objectivity by interpreting the absence of a voiced subject-position as *repression*, is summed

up in the aphorism, 'We can no more understand without judging than we can judge without understanding.' See T. Adorno (1966) *Negative Dialectics*, trans. E.B. Ashton (1973), Frankfurt: Suhrkamp, London: Routledge & Kegan Paul, p.197.

17 Frith *Performing Rites*, p.20.
18 Frith *Performing Rites*, p.19.
19 Frith *Performing Rites*, p.273.
20 S. Frith (1978) *The Sociology of Rock*, London: Constable, p.19.
21 H. Hesse (1927) *Steppenwolf*, Frankfurt: Suhrkamp.
22 *Passim*, though the most famous and eloquent example is F. O'Hara (1964) 'The Day Lady Died', in *Lunch Poems*, San Francisco: City Lights.
23 'Francis Newton' (1959) *The Jazz Scene*, London: Penguin; since republished under Hobsbawm's name.
24 For a sample of cultural studies categories on autodrive: 'The same issues are involved in the use of all other devices of socio-musical representation – representations of race and class, gender and nation…' Frith *Performing Rites*, p.121. In this neck of the woods, evidently, encounters between sewing machines and umbrellas are no longer a possibility.
25 Frith *Performing Rites*, pp.24–5.
26 Frith *Performing Rites*, pp.252–3.
27 Frith *Performing Rites*, p.92. This statement also provides a perfect example of the tautological nature of identity thinking, the 'rules' are a sociologist's observations made after the event, so of course they 'apply'. Indie pop and grunge are already defined as mutually exclusive categories, so of course such 'empirical' observation affirms them. Only by 'testing' these rules could a truly 'scientific' fact arise. In other words, if Professor Frith tried stage-diving at a Cocteau Twins gig, we might get somewhere.
28 Frith *Performing Rites*, p.20.
29 Frith *Performing Rites*, p.277.
30 Frith *Performing Rites*, p.336. Frith's lack of interest in the accidental and the underside speaks volumes to a Freudian.
31 *The Times Literary Supplement* no. 4894, 17 January 1997, p.11. Strange that Coles should endorse Frith's statement that *all* music lets us live 'in the present'. Surely this would cancel the need for such admirable critical voices as the Communards?
32 Frith *Performing Rites*, p.157
33 See W. Benjamin (1940) 'Theses on the Philosophy of History' XIV, in *Illuminations*, trans. H. Zohn (1992), London: Fontana, p.252–3.
34 Frith *Performing Rites*, p.20.
35 R. Rorty (1989) *Contingency, Irony and Solidarity*, Cambridge: Cambridge University Press.
36 The 'post-rock' attempt to rubbish this contention as 'modernist' (i.e. uncool, macho, proletarian, unsophisticated, dated, etc.) relies upon ignorance of the material musical origins of machine beats. Those who were exposed to Chicago house on northern pirate radio in the mid-1980s find the claim that London bed-sit boffins 'invented techno' in the 1988 'Summer of Love' ridiculous. This was transparent to Bill Drummond; see his words on Black innovation and copyright, in the Timelords (1988) *The Manual (How to have a Number One the Easy Way)*, London: KLF Communications, pp.31–2. Duke Ellington – via Adonis and Tyree – is the True Godfather of Rave.
37 Frith *Performing Rites*, p.224.
38 Frith *Performing Rites*, p.131.
39 This generic term has been capitalised in honour of Rickey Vincent's book *Funk* (see below).

40 I am indebted to Erika Laredo's work on South American literature and race relations for this argument.

41 Frith *Performing Rites*, p.131.

42 Gareth Jones, letter to *Time Out* no. 1378, 15–22 January 1997, p.170.

43 The classic statements of the tradition Shannon adheres to are LeRoi Jones (1963) *Blues People*, New York: Morrow Quill, and Frank Kofsky (1970) *Black Nationalism and the Revolution in Music*, New York: Pathfinder.

44 Albert Ayler Quintet *Truth Is Marching In*, 1 May 1966, Magic Music 10003; Albert Ayler Quintet *Black Revolt*, 1 May 1966, Magic Music 10004.

45 Shannon Jackson (1995) *What Spirit Say*, DIW895.

46 Ornette Coleman (1976) *Dancing In Your Head*, A & M/Horizon SP722.

47 Interview with the author, Plaza on Hyde Park, Lancaster Gate, London, 16 March 1996; the interview appeared in *The Wire* no. 147, May 1996 (though without RSJ's words quoted above).

48 Following Pierre Bourdieu, Georgina Born's characterisation of the 'populist' aesthetic, *Rationalizing Culture*, p.280.

49 V. Wilmer (1977) *As Serious as Your Life: The Story of the New Jazz*, London: Allison & Busby.

50 V. Wilmer (1989) *Mama Said There's Be Days Like This, My Life in the Jazz World*, London: The Women's Press, p.310.

51 R. Vincent (1996) *Funk, the Music, the People, and the Rhythm of the One*, New York: St Martin's Griffin.

52 Vincent *Funk, the Music, the People, and the Rhythm of the One*, p.299. In an admirable display of musical over racial principles, Vincent also salutes the Average White Band, Primus and even Grand Funk Railroad (for their 'charming, stinky working-class irreverence', p.189).

53 Vincent *Funk, the Music, the People, and the Rhythm of the One*, p.147.

54 J. Carducci (1990) *Rock and the Pop Narcotic, Testament for the Electric Church*, second revised edition (1994), Los Angeles: 2.13.61.

55 J. Carducci *Rock and the Pop Narcotic*, p.363.

56 J. Lydon with K. Zimmerman (1993) *Rotten, No Irish, No Blacks, No Dogs*, London: Hodder & Stoughton, pp.159–60.

57 The quotation is from K. Marx (1845) 'Theses on Feuerbach', I, in *Early Writings*, trans. R. Livingstone and G. Benton (1975), London: Penguin, p.421. The phrase describes what materialism ignores if reality is not grasped 'subjectively'.

58 This paraphrases W. Benjamin (1973) 'The Work of Art in the Age of Mechanical Reproduction', XII, in *Illuminations*, ed. H. Arendt, London: Fontana., p.227.

59 Carducci *Rock and the Pop Narcotic*, p.17.

60 Carducci *Rock and the Pop Narcotic*, p.52.

61 Frith *Performing Rites*, p.7.

62 Examples would run from music-making, promotion, journalism to 'fan' acts like passing a cassette to a musician or DJs and/or heckling/wearing a tea-cosy at a gig. In some areas, simple audience attendance has a direct effect on the musical form.

63 Universal Congress Of (1990) *The Sad and Tragic Demise of Big Fine Hot Salty Black Wind*, Enemy EMCD117.

64 As cellist in Henry Cow, Georgina Born made both musical and political interventions; unfortunately none of her experience of surrealist/communist rock show up in her 'anthropology'.

6

EXPLODING SILENCE

African-Caribbean and African-American music in British culture towards 2000[1]

Imruh Bakari

Mapping the jungle

During the last twenty years there has been a growing awareness of the impact that the expressive cultures of peoples from the Caribbean and Africa have had on British culture, and of the distinction between these and the 'American' influences that have also made their presence felt in the shaping of British popular culture since 1945.[2] This focus has been framed within a notion of 'post-modernity' that not only renders the 'margin/centre' dichotomy redundant, but addresses the contemporary cultural hybridity and syncretism that are as much characteristic of 'British' as of any 'Other' culture.[3] Particular attention has been given to music as a signifier of the African-Caribbean presence in British cities during the latter part of the century. As with the music of the African diaspora in general, African-Caribbean music has come to be regarded as both the repository and the medium of the most profound expressions of the African experience in modernity.

The Souls Of Black Folk, a volume of essays by the African-American scholar W.E.B. DuBois, was first published in 1903. This publication was pivotal in setting the precedent for a tradition of cultural sociology that includes current critical studies in popular culture. Coming as it did in the wake of the Pan-African Congress (1900) and Booker T. Washington's *Up From Slavery* (1901), Dubois's book set the agenda for a radical Black cultural activism that set the critical agenda for the expressive cultures of the African diaspora in the twentieth century.

Significantly, DuBois pursued the interrogation of this African diaspora experience through the discourse of music.[4] Rooted in the seminal moment of modernity, the Atlantic Slave Trade, DuBois's 'sorrow songs' symbolised the transmutation of that moment into meaningful neo-African discourse. Dubois elevates the 'cry of the slave'[5] to the level of the profound articulation of the human condition. *The Souls of Black Folk* in its broadest perspective sought to engage the Black presence in modernity around the question of 'how does it

feel to be a problem...', posed at the beginning of the book. On another level the 'subaltern experience' is expressed through the insistence of the 'hewers of wood and drawers of water' on having their own voices, place and role.

At the end of the century in 1997, two celebratory but poignant events in music coincided: Wynton Marsalis's 'jazz' album, *Blood on the Fields*, won a 1997 Pulitzer Prize, while the 1997 Mercury Music Award (for music made in Ireland and Britain) was won by the 'jungle music' album, *New Forms*, by Roni Size and Reprazent. The significance of these two albums is directly related to the shifts and movements in African diaspora cultures, and the ways in which music has continued to be regarded as the iconic expression of the African encounter with modernity.

In mapping this encounter it should be recognised that early in the century the terms 'jazz' and 'jungle music' were synonymous. Both served to locate Black music and fix it within the hierarchy of modern and civilised taste. Jazz for the 'civilised' Euro-American epitomised all that modernity sought to distinguish itself from and to erase. For others, the appeal of its primitivism resided in the exotic and transgressive pleasures that the music seemed to offer. As such, Black music and its derivative styles came to be regarded for the manner in which their deviant and subversive tendencies could be deployed as a counter-discourse in the hegemonic struggles taking place within modern society. Black music however, signifies much more than a 'protest': it represents a presence, and an engagement. Thus, the emergence of a new genre of 'jungle music' in the late twentieth century seems to point directly to the paradox of the Black presence in modernity, and specifically in Britain.

While Roni Size's *New Forms* could be considered a voice from the underground in Britain, Marsalis's *Blood On The Fields* quite deliberately positions the Black presence within the dominant American twentieth-century culture. This epic work unmistakably revisits the narrative of slavery in America with a sense of the contemporary, a strategy similar to that of Duke Ellington, whose *Black, Brown, and Beige* suite premiered in 1943. In their respective contexts Duke Ellington, Roni Size and Wynton Marsalis testify to an insistence on being active modern subjects in very much the same way that DuBois (1903) wrote of an American context in which 'we have woven ourselves with the very warp and woof of this nation'.[6] The differences in these works, however, are a reflection of the way in which the 'jazz' aesthetic has been expanded, deepened and simultaneously institutionalised over the years. More significantly, Roni Size, together with an African-Caribbean-British jazz musician like Courtney Pine (whose album, *Modern Day Jazz Stories*, was a nomination for the 1996 Mercury Music Award), indicate the ways in which the African-Caribbean community has not just existed in, but helped to define the 'warp and woof' of Britain since 1945.

Joe Harriott and the jazz intrusion

In his seminal 1959 novel, *Absolute Beginners*, Colin MacInnes articulated the impact of jazz on the urban British youth of the time[7] Almost a decade later, Jeff Nuttall in *Bomb Culture* re-emphasised the importance of jazz in post-war British culture.[8] This music, and indeed the entire spectrum of Black music, became a metaphor for notions of freedom and influenced many of the trends that emerged in popular culture. Fuelled by iconoclastic narratives of sexual exploits and drug usage, Black music, African-American in particular, was established in the popular consciousness with a certain attractive deviancy. Yet for the musicians themselves, and Black people in general, the perspective on this music and its associated behaviour was much more sophisticated than the stereotyped image implied.

The dichotomy between 'Black' and 'White' perceptions of jazz reflected a deeper schism separating the standpoints from which White society and Black communities viewed the world. From the White perspective, an underlying speculative approach to the nature of Black humans and their expressions was involved. This set a tradition of jazz criticism in motion that would be concerned with defining jazz and rationalising its meaning in terms of the Euro-American experience, and in particular of ranking jazz against the values of the European tradition of 'classical' concert music – in which music was claimed to have been abstracted from any sense of use, value or political content. The dominant impulse among established jazz critics therefore became one of stripping the music of its 'social and cultural intent' and seeking 'to define jazz as an art (or folk art) that has come out of no intelligent body of socio-cultural philosophy'.[9]

It also seemed to have come from America. Referring to the 1930s, Jim Godbolt audaciously asserts that 'the black contribution to British jazz was slight', beyond a small 'coterie of black musicians working in the warren of one-room drinking clubs in London's West End, notably the red-light district of Soho'.[10] Godbolt's dismissive and cynical account lacks any awareness that jazz is a component of a global African diasporic experience, and that Britain and the British experience are both implicated in and influenced by its process. His attitude is part of a pervasive response that not only devalues and erases the Black presence from British soil, but seeks to place it firmly beyond the orbit of Britishness.[11]

In the 1920s and 1930s there was in fact a significant Black cultural and political presence in Britain. Outstanding jazz musicians were part of the urban scene, among them Jamaican trumpeter Leslie 'Jiver' Hutchinson (1907–59), Louis Stephenson (1907–94) and the Guyanese showman and bandleader Ken 'Snakehips' Johnson. In a rare autobiography by a musician of that period, Jamaican trumpeter Leslie Thompson (1901–87) gives a particular insight.[12] In 1936 Thompson was co-leading a Black swing band, the Emperors of Jazz, with Johnson. They parted company in 1937 and Johnson went on to establish

the band as a major attraction at the Cafe de Paris in London's West End. In spite of their earlier differences Thompson fondly recalls Ken Johnson coming to Martini's Restaurant where he (Thompson) was playing an early session and having 'a nice bottle of Spanish wine with his dinner' before going off to the Cafe de Paris 'in his lovely white suit'. It was here that the band was literally 'wiped out' when a German bomb came through the roof and into the dance hall on that night, in March 1941.

This tragic occurrence in the midst of war seemed to erase all traces of the inter-war presence of African-Caribbean musicians in Britain. In subsequent years their role, apart from general club work across Europe, was principally to supply music to the West African and Commonwealth market for the major record labels like Decca. On these recordings many of the jazz musicians who had survived the war could be heard playing the now 'commercial' calypso and highlife tunes, often alongside White English musicians like the Etonian Humphrey Lyttelton and Wally Fawkes.

The real significance of African-Caribbean musicians on British culture from the 1930s to early 1960s cannot therefore be accurately assessed by way of a catalogue of definitive recordings.[13] The suggestion here is that there is a need to look elsewhere, both at the testimonies of musicians themselves, and at the popular trends in music at the time. For example, as far as live music is concerned there is evidence of the prominent role of a significant number of African and Caribbean musicians, many of whom were band leaders. Among these were Leslie 'Jiver' Hutchinson, Nigerian Ambrose Campbell and Ray Ellington (who provided musical interludes for BBC Radio's Goon Show). Arguably the most successful was the Trinidadian Edmundo Ros who publicised himself as a 'Latin American', and was at the forefront of a popular trend in Latin American dance music.[14] His band became a regular feature on BBC broadcasts.

Yet, within the popular memory of post-war Britain, it seemed easy to forget the Black presence in British jazz in much the same way that the wider sentiments of an inclusive Britishness which had galvanised the war effort in the former colonies had been forgotten. African-Caribbean musicians like Shake Keane, Coleridge Goode, Dizzy Reece, Harold McNair and Bogey Gaynair were therefore generally regarded as at best a minor diversion from the 'real' jazz. Joe Harriott (1928–1973), however, remains a seminal figure in both British and European jazz. He arrived in Britain from Jamaica in 1951 at the age of twenty-three, already an accomplished musician with both classical (European) training and a wide knowledge of the jazz tradition. During 1960–3 he produced three definitive albums: *Free Form* (1960), *Abstract* (1961) and *Movement* (1963). He called the music of this moment 'abstract music' and with his quintet he established himself as an innovative and controversial musician. The quintet included Shake Keane (from St Vincent) on trumpet and flugelhorn, Pat Smythe (Scotland) on piano, Coleridge Goode (Jamaica) on bass and Bobby Orr or Phil Seaman from England on drums. Saxophonist

101

Harriott understood that jazz did not have to be 'American', which has a quite different implication to a disregard for the 'tradition'. As such it was legitimate (as has now come to be accepted under the rubric of 'world jazz') to explore within the music a Caribbean response to modernity. Harriott's music is distinct by virtue of the ways in which he evoked and utilised the traditions of the British 'West Indies', drawing on various folk, ceremonial and devotional forms.

During the late 1960s Joe Harriott moved on to explore 'Indo-jazz fusions'. In this period the three albums, *Indo-Jazz Suite* (1965), *Indo-Jazz Fusions* (1966) and *Indo-Jazz Fusions 2* (1967), were recorded in collaboration with Indian classical musician John Mayer. Here, as with the earlier abstract ensemble, Harriott was extending the idea that the jazz aesthetic could be explored in any cultural context. This was not lost on musicians who were to become identified with avant-garde and modern jazz in Britain. As Ian Carr has written, Joe Harriott, as well as being 'an important innovator' is also 'the father of European free jazz as opposed to the American kind, and one of the first jazz musicians to revitalise this by integrating it with elements from ethnic music'.[15] Throughout his life in Britain, Harriott fought against the subliminal idea that good or innovative jazz could emanate from no other place than the USA.

Harriott importantly epitomised a wider cultural movement among African-Caribbean writers and artists in Britain that aimed to establish an independent and assertive global presence. The Caribbean Artists Movement (1966–72) was established by major writers and artists, Kamau Brathwaite, Andrew Salkey, John LaRose, Wilson Harris, Aubrey Williams, among them. These individuals recognised the need to establish an African-Caribbean identity that was not read through the prism of the African-American experience, but in terms of its specific British colonial and post-colonial experience.[16] There is no direct evidence that Joe Harriott was a 'member' of the Caribbean Artists Movement (CAM), but his collaborator Shake Keane, also a noted poet, was actively involved in CAM programmes. Importantly these programmes extended to theoretical and critical debates about African-Caribbean cultural expression. Most relevant here is Kamau Brathwaite's seminal essay, 'Jazz and the West Indian Novel' written between 1967 and 1968, in which he expressed the general view that the jazz aesthetic was central to the Caribbean experience, and as such 'these jazz elements constitute the direction of a West Indian aesthetic'.[17] Harriott's music reflected this approach which, with hindsight, moved towards contemporary notions of fusion and 'world jazz'.

This trend in British jazz was significantly enhanced by the presence of a number of South African musicians who arrived in Britain during the 1960s. In 1961, the 'All African Jazz Opera', *King Kong*, arrived in London's West End. This musical was written by Todd Matshikiza, and is based on the life of a legendary South African heavyweight boxing champion, Ezekiel 'King Kong' Dhlamini. The cast that arrived in London were among the first South African exiles from the apartheid regime. There were many others. In 1965, having

made a début in Europe that established them among the leading avant-garde players, the Blue Notes arrived in Britain. This band: Dudu Pukwana (1939–90), alto sax; Chris McGregor (1936–90), piano; Johnny Dyani (1945–86), bass; Mongezi Feza (1945–75), trumpet; and Louis Moholo (b. 1940), drums; was a formative influence on a new generation of British jazz players who emerged during the 1970s and 1980s.

Renaissance dread: warriors on the rampage

On the August Bank Holiday of 1965 about 500 people ventured on to the streets of Notting Hill revelling behind a steel band. This marked the first attempt by 'West Indians' to establish in Britain the tradition of a Caribbean carnival that involved the occupation of the streets. In so doing the issue of how leisure was spent and culture expressed became one focus of their political encounter with British society. As such the 'blues dance', the 'shebeen' and the 'sound system' assumed the significance of frontier outposts to be defended and mobilised against State control, regulation, and surveillance.[18] In addition certain pubs and cafes took on a comparable significance as venues of Black cultural expression. One such pub was the Coleherne in Earl's Court, London, where a regular Sunday jam session known as the 'Sunday school' took place. Here various musicians would turn up to jam around jazz and calypso standards. Rus Henderson, who played dinner jazz piano during the week at exclusive venues, was one of the leaders of this session.[19] He was also an accomplished steel pan player, and one of those who led the group of revellers back to the streets of Notting Hill in 1965 in what was to become a yearly occurrence, maturing into a fully organised street event by the mid-1970s. By this point carnival in Notting Hill had become a major event involving a new generation of British-born Black youth. In 1975 250,000 people turned out on the streets to the shock and dismay of the police, local authorities and the Government, which reacted by attempting to remove carnival from the streets. Carnival was firmly established in the official British mind as a law and order issue. Nothing to do with culture or artistry, it was regarded in terms of the quintessential image of the Black presence in British society: a threat to public order and decorum that had to be controlled and legislated against.

As August 1976 approached the battle lines were being rapidly drawn. Tension was fuelled by the notorious 'Sus' law, the 1824 Vagrancy Act, which was mobilised to arrest and charge hundreds of Black youth with being 'suspected' persons; a Black activism gained momentum in opposition to this regime of surveillance and criminalisation. Carnival that year was indeed spectacular, producing some of the most violent scenes witnessed in the UK outside Northern Ireland. It set in motion a tradition of press reporting, still followed currently, which interprets the carnival and its success principally in terms of crime figures. The debates that were precipitated by these events highlighted the central concern about what was to be the acceptable form and expression of

Black culture in Britain. In this reggae music, the emergent Jamaican urban music, and the sound systems were together demonised as part of the unacceptable face of carnival.

Reggae music, with its anti-establishment ('Babylon') rhetoric and nationalist sentiment, had found resonance in urban Britain where incarnations of the 'Natty Dread' archetype were literally willed into existence. 'Jamaican music embodies the historical experience of the Jamaican masses – it reflects, and in reflecting, reveals the contemporary situation of the nation', wrote Linton Kwesi Johnson in 1976. He continued:

> the popular music of Jamaica, the music of the people, is an essentially experiential music, not merely in the sense that people experience the music, but also in the sense that the music is the true historical experience of the people, that the music reflects the historical experience....In making music, the musicians themselves enter a common stream of consciousness, and what they create is an invitation to the listeners to be entered into that consciousness – which is also the consciousness of their people.[20]

Johnson is fully aware of the significance that this music and its exponents had acquired among the African-Caribbean community in Britain during the 1970s, and particularly the 'youth' who had entered the 'consciousness' of the music through the discourses of migration, struggle and redemption. In this sense Jamaican music expressed the pervasive Black political consciousness in Britain. This music has played a significant role in defining the carnival in terms of a British experience, and in determining its form. It is in this context that bands like Steel Pulse, Aswad and Misty In Roots began to emerge as distinctive 'Black British' youth voices.

Until that time, apart from jazz, the more radical and innovative music, at least aesthetically, came from a number of Black rock bands, the most successful being Cymande and Osibisa. Osibisa brought together a group of Eastern Caribbean and West African musicians, a reminder that while the Black presence in Britain is usually codified as being 'West Indian', a significant section of the Black community has always been made up of West Africans. Osibisa established itself among the internationally acclaimed big rock bands of the period. Cymande was a nine-piece band fusing soul, reggae and Rastafarian rhythms. In this group was alto saxophonist Mike 'Bami' Rose who went on to play with the South African drummer Julian Bahula in his band Jabula. Rose became a key player in the Jazz Warriors, an all-Black big band that introduced the 1980s generation of African-Caribbean jazz musicians (including Courtney Pine) to Britain.

Bridging the 1970s and the 1980s is the charismatic figure of Guyanese-born Eddie Grant. Back in the 1960s he had led the Equals, a multiracial pop group that, with hits like 'Baby Come Back' and 'Viva Bobby Joe', was

distinctly a 'boy band' in contrast to the more mature, and equally multiracial and popular Hot Chocolate. In 1972 Grant went out on his own to establish himself as a producer. He opened the first Black-owned recording studio in Europe, Coach House, in 1973, and in 1974 he set up his own Ice label. By 1980, with a number of hit singles and albums to his name, Eddie Grant had established himself in a unique position of independence. More than this, songs like 'Hello Africa', 'Walking on Sunshine' and 'Living on the Frontline' became international anthems of the African diaspora rooted in an African-Caribbean street style and sound. Grant's music fused many influences, and as with the music he produced for other London bands, covered a wide spectrum including calypso, highlife, soul and reggae.

These developments were all part of the global trends in African diaspora politics and culture. Events like CARIFESTA (Caribbean Festival of Creative Arts) first held in Guyana in 1972, and FESTAC (World Black and African Festival of Arts and Culture) held in Nigeria in 1977, are symbolic of the African diaspora's mood during this period. From the perspective of the African-Caribbean community in Britain the popular appeal of Rastafarian ideas and lifestyle was of great significance, and as with a band like Cymande, this influence was reflected in music as well as in literature and the visual arts. In Britain these trends within the African diaspora were understood and ratio-nalised through the historical and critical writings of Pan-Africanists like Frantz Fanon, Kwame Nkrumah, Amilcar Cabral, Walter Rodney and C.L.R. James, who explored the processes of de-colonisation and national identity.

By the mid-1970s, however, in much the same Pan-African mood, another 'jazz revolution' had already occurred in the USA. John Coltrane, Charlie Mingus and Max Roach, among others, had brought a new dimension to the jazz aesthetic in the form of a 'transcendent political nationalism'.[21] This new development had opened the way for a movement of jazz players willing to openly encourage and engage in Africanist, 'un-American'[22] activities. With Miles Davis's monumental album *Bitches Brew* (1969), the threshold was crossed with consequences across the whole spectrum of music. Importantly, both electronic instruments and primal rhythms were now part of the jazz idiom. The music had gone full circle to accentuate both improvisation and dance simultaneously as components of its process.

In Britain the South African musicians exiled here were well placed within this new mood. Considering their background in 'township jazz', the South African urban music rooted in the modalities of improvisation and dance, Chris McGregor's Brotherhood of Breath quickly gained a unique appeal. As one of the few big bands in Britain playing contemporary music, the Brotherhood with its fifteen-piece line-up established a unique British jazz sound that was to span two generations from Harry Beckett, Evan Parker and Mike Osborne, to Dave Defries, Annie Whitehead, Claude Deppa and Steve Williamson.

Developments in Britain during the 1980s were indicative of a renaissance in Black music, as a new generation, drawn to jazz by the 1970s music of

musicians like Miles Davis, Herbie Hancock, Wayne Shorter, Joe Zawinul and Sonny Rollins, finally shattered the silence imposed upon the Black presence in British jazz for decades. In 1986, almost overnight names like Steve Williamson and Courtney Pine (with his quartet which included Joe Bashorun, piano; Gary Crosby, bass; and Mark Mondesir, drums) became prominent features in British jazz. With his debut album, *Journey To The Urge Within* (1986), Pine was hailed as the leading figure of this resurgence.

Two years earlier in 1984, The Abibi Jazz Arts (TAJA) had been formed with Pine among its founding members. It was one of a number of organisations of Black musicians set up in the early 1980s to deal with 'discrimination within the industry' as the Black Music Association (BMA) put it in their 1986 brochure, *The Black Music and Record Industry in London*. TAJA was primarily concerned with jazz 'as a specifically black art form' and '[to] encourage young people to play, perform, and understand' the music. The Jazz Warriors, a twenty-piece big band set up by TAJA, was therefore regarded as a showcase for Black musicians designed to provide a context for developing, performing, composing and arranging skills. The band's only album, *Out of Many, One People* was released in 1987. A year later they were on a national tour, 'Homage to Joe Harriott'. Since then, many of the Jazz Warriors have established themselves as leaders in British jazz, encompassing a wide spectrum of styles and influences that have become a recognised and influential part of British contemporary music.

These developments during the 1980s were part of a mood of openness and fusion that had been heralded by the cross-cultural and international success of reggae, foregrounded by that of Bob Marley and the Wailers. In Britain, in addition to jazz, the music of Soul II Soul, with its R 'n' B/reggae orientation, is arguably the most important example of this new mood as reflected in Black street culture and style. The prime mover in this unit was Jazzie B, who had grown up playing with sound systems in North London. Sound systems in Britain, like the legendary Jah Shaka, have over the years taken on a cultural and, as mentioned in relation to the Notting Hill carnival, a political significance. At first principally associated with the culture of reggae music, sound systems soon reflected the mixed taste of both reggae and American soul/funk among London's Black youth. This gave rise to a fusion of style and fashion in the shape of the 'funky dreads'. Complementing this development was the rise of rap and hip-hop from urban New York, equally influenced by a new Caribbean cultural presence in the USA.

All these diaspora influences were reconstituted to express the African-Caribbean experience in Britain of the 1980s – Soul II Soul's work is comparable to Eddie Grant's in the 1970s. With Jazzie B, the Caribbean musical heritage, particularly the influence of reggae, and the organisational structure of the sound system were mobilised to establish an independent space within the British music industry and British popular culture. He told influential style journal *The Face*, 'We totally related to being a sound system before

anything else, and the knowledge of business came from that foundation, of running and operating a sound....'[23]

The acknowledged influence of the sound system tradition is more than cursory. Like the legendary Jamaican innovators, among them King Tubby, Coxone Dodd and Lee 'Scratch' Perry, Jazzie B played no instrument. Soul II Soul's music and the band's persona however, was built around him and bore his authorial stamp. As 'Scratch' Perry's career illustrates, the phenomenon of the producer as front-man, as showman, as alchemist perhaps, has its own attraction and is the radical and central characteristic of dub. In this the 'producer' is not resigned to anonymity while the work assumes the brand names of various artists. There has long been a tendency among reggae producers to claim authorship, sometimes to the detriment of the musicians. On another level, however, as typified by 'Scratch' Perry, this approach could take on an aesthetic significance and a politicised posture in relation to the music industry. The characteristic significance of this role within the sound system was in fact the formative influence on Soul II Soul, and a few years later in the drum 'n' bass/jungle trends of 1990s Britain.

New forms: return of the junglists

At the root of the 1990s sound is the modality of dub (literally foregrounding drum 'n' bass) in which, however, the 'jazz' aesthetic is the central organising characteristic. Roni Size understands jazz as 'a progression',[24] indicating an approach to music making that involves a notion of improvisation and continuous change. As is evident in the archetypal 'sorrow songs', gospel songs at their most profound, the jazz aesthetic involves a process not only of reclaiming authorship, but profoundly a reclaiming of the body from reification. Within Black expressive cultures this process becomes a strategy for resisting colonisation, oppression and surveillance, and is central to African diaspora discourse.[25]

The music of Roni Size and his collaborators (under the name of Reprazent) typifies an articulation of the African-Caribbean diasporic experience from the perspective of the urban British city. It is symbolic of the way in which a notion of Black subjectivity is being negotiated, lived and represented through the resources of 'memory'. Here the 'premium placed on history'[26] and its evocation in Black music testifies to the importance given to the celebration of 'tradition', not as 'fetish' but as 'memory'. It is in this sense that the irreverent nods at tradition evident in jungle, rap and reggae signify a strategy towards sustaining the jazz aesthetic in the post-modern technoscape that is contemporary British popular culture.

A similar claim can be made for Courtney Pine. His album, *Modern Day Jazz Stories* (1996), also captures the diasporic essence of the urban Black presence in Britain. In Pine's music categories and boundaries lose their significance. Dub becomes jazz and jazz becomes dub. This may not free the music from the processes of capitalist exploitation, but it does sustain an important 'dialogism',

and signifies in the 'counterculture of modernity',[27] the irrepressible significance of being. This product, then, is indicative of the political economy of Black music in Western societies at the end of the twentieth century.

Dub in many respects is the subtext of all 'commercial' popular Black music in late twentieth-century Britain. In Jamaica, from the late 1950s on, the local record industry was incapable of meeting the demand for new records on a weekly basis. Sound systems, as the principal access point to popular music, responded by producing their own 'white labels' – tunes and mixes of tunes exclusive to the DJs. The idea of the 'version' or 'dub' in the vocabulary of popular music began here. In these instances the producer took over from the musicians as the principal creative artist, utilising his skills at mastering the available technology. The songs would be reconstructed around the rhythm section – the drum and bass – and reconstituted as a new product.

The link with current trends in Britain is however more directly related to the way in which these innovations travelled, not simply through the sound system, but through radio formats and broadcasting strategies evident in the rise of Black pirate radio stations that began broadcasting from around 1981. Dread Broadcasting Corporation (DBC) in Notting Hill, West London, was among the first. Among the issues brought to the fore by carnival riots, and other uprisings in areas of big cities with large Black populations, was the role of the media, and implicitly, the need for a more substantial Black media presence. The emergence of pirate radio stations was one response to this demand. The general focus was the need for more Black music to be played on the radio. In reality this meant going beyond the limits of the 'commercial' reggae and soul that could be rationalised within the regime of the play-list, as well as a recognition of the diversity of music styles appreciated within the African-Caribbean community. As DBC DJ Miss P related, 'Our format allowed us to play music that would otherwise never be heard publicly.'[28] The significance of Miss P's statement rests in a notion of music that would 'never be heard publicly' and the implicit importance of a 'format' that would facilitate a representative diversity of music and an appropriate approach to its presentation. Both are intrinsically linked, and are reflected in the modality of the sound system and dub/drum 'n' bass music.

The transmutation of this dub modality into a radio format was first established in the late 1970s in Jamaica by Mikey Dread, a radio DJ turned recording artist. Mikey Dread (Michael Campbell) hosted a radio show on the Jamaican national radio, JBC. His programme employed an eclectic mixture of techniques, some of which had been evolved through the sound system. On the radio, the programme became a continuous soundscape of popular tunes, remixes, jingles, chat and adverts linked by techniques of stopping and starting records, rewinding tapes, and added echo and reverb effects. In 1979, a simulation of this radio show was released as *African Anthem: The Mikey Dread Show Dubwise*. It indicates a seminal moment to which contemporary trends in jungle

music might be traced. On this album techniques of dub and sampling are in evidence, as well as the foregrounding of the 'producer' as artist.

Jamaica in the 1970s was a 'war zone'. Political violence was at its height fuelled by the contesting ideologies of Michael Manley's 'socialism' and Edward Seaga's pro-America rhetoric. Reggae musicians, steeped in Rastafarian idealism, generally abandoned partisan politics and claimed neutral territory. Mikey Dread opened up this third 'subaltern' space within the Jamaican national broadcasting institution in a dramatic way. It was not so much a question of 'Dread at the controls' as 'Dread in control'. This example was replicated in Britain through pirate radio with much the same cultural and political effect. I am suggesting that Jamaican music in general, and dub in particular, gave African-Caribbean music produced as a reflection of the British experience its most definitive characteristics. The modality of dub with its cultural and political discourse has determined the framework within which all other influences would be incorporated and syncretised. These defining characteristics have given African-Caribbean culture its specific identity in Britain and its location in popular culture.

Within the African diaspora paradigm as a whole, however, this separates the 'British' music of Size and Pine into a subaltern discourse, distinct from the hegemonic 'American' music of Marsalis. *Blood On The Fields* is constructed around a 'Porgy and Bess' narrative that charts the African diaspora experience from bondage in Africa to freedom in America. Here, Africa is a 'repressed' presence/absence 'apparently silenced beyond memory by the power of the experience of slavery';[29] while America is 'the sweet soil of our democracy', and slavery just 'a bitter taste to our national life'.[30] The music is confined within a linear, indeed operatic, mode that represses any notion which might obstruct the trajectory from the 'margins' to the 'mainstream'.

As part of the predicament of Dubois's 'double consciousness', it is in effect an attempt to overcome an assumed 'lack of identity'.[31] This is in contrast to Pine and Size, where the music affirms a legitimate identity within the 'margins', while at the same time insisting on not being marginal or marginalised.[32] The issue here concerns an approach to the British urban experience (and African diaspora politics) that resists attempts to domesticate the 'primitive' as a substitute for an acknowledgement through praxis, of the complexity of national identity and the contradictions of the 'nation state' as the acceptable paradigm of modernity.

The African-Caribbean experience, given its essential diaspora dimensions, cannot be adequately rationalised or legitimised within the nation state. Black political and cultural practices, as Gilroy says, do much more than this: they 'indicate a substantive "post-modern" vision where they have stepped outside the confines of modernity's most impressive achievement – the nation state'.[33] The deduction can be made therefore that African-Caribbean music in Britain is less concerned with 'being British' than it is with simply 'being'. This in turn

seems to raise a number of issues relating to the role that the Black presence, as a signifier of the 'primitive', plays within British culture.[34]

A characteristic of the rationalisation of this presence in Britain can be observed in the course taken by the Notting Hill carnival. Here the rigorous policing of pleasure is coupled with a calculated integration of the marketing of multinational companies as part of the carnival, undifferentiated from the costumed bands and masquerades. In this sense therefore 'being Black', while appealing to a certain legitimacy in terms of 'being British', works to erase the African-Caribbean or Black subject from the discourse of the carnival itself. Taken as being symbolic of the way in which hybridity and difference is managed in the political economy of the 1990s, the emergent 'jungle' music of this period is of significance in providing an indication of how the 'post-modern event' – as an aspect of British urban life – is being negotiated. In this Roni Size and Courtney Pine, in contrast to Wynton Marsalis, provide an indication of the tendencies that will continue to determine African diaspora cultures in Britain in the twenty-first century.

Notes

1 Dedicated to the memory of Shake Keane (1927–97), who died in Norway, November 1997, while this paper was being drafted; and to bassist Coleridge Goode (b. 1914), the only surviving member of the legendary Joe Harriott Quintet.

2 See D. Hebdige (1979) *Subculture: The Meaning of Style*, London: Routledge; D. Hebdige (1987) *Cut 'n' Mix*, London: Routledge; P. Gilroy (1987) *There Ain't no Black in the Union Jack*, London: Hutchinson.

3 See A. Brah (1996) *Cartographies of Diaspora*, London: Routledge.

4 See P. Gilroy (1993) *The Black Atlantic*, London: Verso.

5 W.E.B. DuBois (1903) *The Souls of Black Folk*, New York: Fawcett Publications Inc., 1953 edition, pp.181–2.

6 DuBois *The Souls of Black Folk*, p.190.

7 C. MacInnes (1959) *Absolute Beginners*, London: Allison & Busby.

8 J. Nuttall (1970) *Bomb Culture*, London: Paladin. See also V. Wilmer (1989) *Mama Said There Would Be Days Like This*, London: the Woman's Press, for another insightful account of the impact of jazz on post-war Britain, noting the role played by African-Caribbean people.

9 See for example L. Jones (1968) *Black Music*, New York: William Morrow & Co. Inc., p.14.

10 J. Godbolt (1984) *A History of Jazz in Britain*, London: Paladin, p.185.

11 See P. Fryer (1984) *Staying Power*, London: Pluto Press, for a history of Black people in Britain.

12 L. Thompson with J. P. Green (1985) *Leslie Thompson: an Autobiography*, Crawley: Rabbit Press.

13 See P. Oliver (1990) *Black Music in Britain*, Milton Keynes: Open University Press.

14 Oliver *Black Music in Britain*.

15 I. Carr, D. Fairweather and B. Priestley (1987) *Jazz: the Essential Companion*, London: Paladin Grafton Books.

16 See A. Walmsley (1992) *The Caribbean Artists Movement 1966–1972*, London: New Beacon Books, for an account of the movement, with contextual information about the Black cultural and intellectual presence in Britain from the 1930s.

17 Walmsley *The Caribbean Artists Movement 1966–1972*. An edited version of the essay 'Jazz and the West Indian Novel' appears in A. Donnell and S. Lawson Welsh (eds) (1996) *The Routledge Reader in Caribbean Literature*, London: Routledge.

18 See Gilroy *There Ain't no Black in the Union Jack* for a discussion on the 'oppositional implications' of this activity.

19 The saxophonist Andy Hamilton, born 1918 in Jamaica, a contemporary of Joe Harriott, has played a similar role in Birmingham. His first album, *Silvershine*, was released in 1991. Among the guest musicians are David Murray, Jean Toussaint and Steve Williamson.

20 Linton Kwesi Johnson (1976) 'Jamaican rebel music', *Race and Class* XVII (4).

21 See I. Kofsky (1970) *Black Nationalism and the Revolution in Music*, New York: Pathfinder Press Inc.

22 The term 'un-American' is used to indicate a wide spectrum of avant-garde, Afrocentric, and dance jazz that gained popularity in British clubs.

23 'Funki Like A Dred', *The Face* April 1989.

24 See P. Johnson (1996) *Straight Outa Bristol*, London: Hodder & Stoughton, p.188.

25 See Gilroy *The Black Atlantic* for his discussion around *The Souls of Black Folk*.

26 Gilroy *There Ain't no Black in the Union Jack*.

27 Gilroy *The Black Atlantic*.

28 See J. Hind and S. Mosco (1985) *Rebel Radio*, London: Pluto Press, pp.32–8.

29 For a discussion of the three 'presences' in the African diaspora identity, see S. Hall (1990) 'Cultural identity and diaspora', in J. Rutherford (ed.) *Identity*, London: Lawrence Wishart, pp.24–39.

30 Wynton Marsalis (1997) *Blood On The Fields*, 'IV: The Market Place', Columbia CXK 57694.

31 See T. Gabriel (1993) 'Ruin and the other: towards a language of memory', in H. Naficy and T.H. Gabriel (eds) *Otherness And The Media*, London: Harwood Academic Publishers, for a discussion on 'notions of Black and other minority identities' that posits identity as 'statues to be built' against the idea of a more dynamic 'cultural memory'.

32 Gabriel 'Ruin and the other', also B. Hooks (1990) *Yearnings: Races, Gender, and Cultural Politics*, New York: South End Press.

33 See Gilroy *There Ain't no Black in the Union Jack*, p.219. My ideas are developed from his conclusions.

34 See H. Foster (1985) *Recodings: Art, Spectacle, Cultural Politics*, Seattle: Bay Press, for a useful discussion on 'The "primitive" unconscious of modern art, or White skin Black mask'.

7

LISTENING BACK FROM BLACKBURN

Virtual sound worlds and the creation of temporary autonomy

James Ingham

This is a geographer's journey into sound – into the ways in which sound and space interact. Audio technology, combined with certain musical genres and arrangements of physical space, gives the experience of 'virtual sound worlds' – alternate worlds defined by sounds that are created by and only possible thanks to electronics. I shall demonstrate this by looking at the space where I became aware of this process, the Blackburn warehouse parties of the late 1980s. I shall then consider two of the forebears of this sonic/spatial arrangement, the moment of Chicago house, and the dub sound world initiated in Jamaica by King Tubby.

The Blackburn warehouse parties highlight the role of virtual sound worlds in the creation of a TAZ (Temporary Autonomous Zone), 'an uprising which does not engage directly with the State, a guerrilla operation which liberates an area (of land, of time, of imagination) [which] dissolves itself to reform elsewhere/elsewhen, before the State can crush it'.[1] The term TAZ, coined by anarchist Hakim Bey, is a useful analytical concept that allows us to acknowledge that virtual sound worlds can bring people together in fluid association driven by desire and imagination, worlds in which music can function 'to pump a desire into human bodies to move, to dance and let go'.[2] Bey's characterisation is a pretty exact description of the political situation of the illegal party scene of the last decade.

My experience of sound interacting with place got me thinking about how the TAZ developed. There was no existing historical narrative that could account for such an occurrence – it is now more than ever necessary to perceive history as including aural events, but histories so far written are incapable of encountering and dealing with the history of sound. I therefore tried to formulate a new history. All of the material directed me to Chicago and the DJ work of Frankie Knuckles and Ron Hardy. However, these investigations did not fully account for the creation of virtual sound worlds. It was necessary to go back

further, to the creation of dub. This led me to the conclusion that dub was perhaps the key moment in giving people an experience of the world in which new sound, constructed through music technology, created new space.

In their groundbreaking study, *The Sex Revolts*, Simon Reynolds and Joy Press have also linked house music with dub. They argue that both types of music create a feeling of 'oneness with the Cosmos'.[3] This results from surrounding and immersing the listener in sound, creating the preconditions for the 'letting go' that Hillegonda Rietveld has described as the desired effect of rave. However, this seems almost dangerously general: before we read off any sonic-to-psychic effect as somehow inevitable, it is necessary to place any music, and the events and technologies at and through which it is presented, in a more specific cultural context.

Blackburn warehouse parties and the creation of TAZs

Blackburn, situated in the Lancashire hills, is a cotton-weaving town that was once a centre of the industrial revolution. The economic history of the town means that there is even now a large number of warehouses. By the end of the 1980s, after several years of industrial decline, many of these warehouses were left empty. These industrial warehouses were transformed for 'acid house' parties. For a brief period of time, a night, void spaces became venues.

The Blackburn parties took place between 1 July 1989 and 1 March 1990 (see Table 7.1). There were two types of party in this moment. The first type, *Blast Off* and *Live the Dream*, were held outside in marquees. Admission cost around £15. The second type were held inside warehouses, admission to which cost £3–5. Although *Blast Off* and *Live the Dream* played similar music to the warehouse parties, they were different in the sense that they were well advertised (with flyers) and they were on land that the party-givers had been given permission to use. The police claimed that they were unable do anything to stop these two events because they were private parties on private farmland. It is more illuminating for our purposes to concentrate on the parties that took place in the warehouses – spaces that the owners had not given permission to use. The parties were also, if no less thoroughly planned, less capitalised (hence the lower admission charges), with no investment in equipment such as marquees. From the map (see Figure 7.1) it can be seen that the vast majority of the warehouse parties were held within the urban area of Blackburn; the organisers and many of the people who attended the events were local.[4]

The warehouse party, the layering of virtual sound worlds and the creation of the TAZ

The parties held in warehouses began with the meeting of a convoy of cars outside the *Sett End Pub/Red Parrot* night-club on Shadsworth Road, Blackburn at 2 a.m. on a Saturday night. The pub acted as a meeting point for

Table 7.1 Chronology of Blackburn warehouse parties

Key[1]	Date	Details of event
1	Saturday 1 July 1989	Approx. 800 attend party at an old cotton mill, Ciceley Lane, Blackburn. Stopped by police; four arrests for drug and public order offences
2	Saturday 29 July	Approx. 4,000 attend *Blast Off* at Balderstones, near Blackburn
3	Saturday 16 September	Approx. 4,000 attend *Live the Dream* at Tockholes, Blackburn
4	Saturday 23 September	Approx. 800 attend party in a disused slaughterhouse, Sumner Street, Blackburn. Music went on until 8 a.m., although by that time the numbers inside had dwindled to about forty. One person arrested for drugs offence
5	Saturday 30 September	Approx. 800 at Albion Mill, Albion Street, Blackburn
6	Saturday 7 October	Approx. 800 at Northrop factory, Moss Street, Blackburn. Ended shortly before 10 a.m. Sunday
7	Saturday 14 October	Approx. 500 at Pump Street, Blackburn. Ended shortly after 10 a.m. Sunday
8	Saturday 21 October	Approx. 500 at Glenfield Park, Blackburn
9	Saturday 28 October	Approx. 500 at Huncoat Industrial Estate, Hyndburn. Finished 10 a.m. Sunday
10	Saturday 4 November	Approx. 1,000 at Fort Street, Eanam, Blackburn. Eight arrests for drug and public order offences. Police broke up the party 7 a.m. Sunday
11	Saturday 11 November	Approx. 1,500 at GEC industrial complex, Clayton-le-Moors. No arrests. Finished 8 a.m. Sunday
12	Saturday 18 November	Approx. 1,500 at Waterside Industrial Estate, Grane Road, Haslingden. No arrests. Finished 10.30 a.m. Sunday
13	Saturday 2 December	Approx. 2,000 attend *Acid House Erupts* at Park Batteries site, Whitebirk Industrial Estate, Blackburn. Eight arrests; four officers injured
14	Saturday 9 December	Approx. 2,000–3,000 at Balmoral Mill, Chadwick Street, near Royal Infirmary, Blackburn. Relatively peaceful; ended about 9 a.m. Sunday
15	Saturday 16 December	Approx. 3,000 at Ewood Mills, Bolton Road, Blackburn. Six arrests
16	Christmas Eve	Approx. 3,000 at Whitebirk Industrial Estate. No arrests
17	Boxing Day	Approx. 2,000–3,000 at Whitebirk Industrial Estate. No arrests
18	Saturday 30 December	Approx. 5,000 at Lancashire Fires Ltd, Whitebirk. No arrests
19	New Year's Eve	Approx. 3,000 at Ewood Mills, Bolton Road, Blackburn. No arrests
20	Saturday 6 January 1990	Approx. 3,000 at Blackburn Cattle Market
21	Saturday 13 January	Approx. 5,000 at Gladstone Street, Blackburn
22	Saturday 20 January	Approx. 5,000 at proposed Royal Mail parcels warehouse. No arrests

Table 7.1 Chronology of Blackburn warehouse parties

Key[1]	Date	Details of event
23(a)	Saturday 27 January	Approx. 800 at an industrial unit, Ordance Street, Blackburn
23(b)	Saturday 27 January	Approx. 1,500 people at the former XL crisps factory, Waverledge Road, Great Harwood
24(a)	Saturday 3 February	Approx. 5,000 at Waterside industrial estate, Haslingden
24(b)	Saturday 3 February	Approx. 1,000 at Ford Street. East Lancashire Police Chief Bob Metcalfe warns that he wants an end to the parties within three months
25(a)	Saturday 10 February	Approx. 6,000 at empty industrial units owned by Hyndburn Council, Altham Industrial Estate. Forty arrests. For the first time the party-goers are prevented from gathering on the Shadsworth estate
25(b)	Saturday 10 February	Approx. 5,000 at Fogart Ltd, adjacent to Blackburn railway station. 2,500 people still present at 9.30 a.m. Sunday
26	Saturday 24 February	Between 7,000 and 10,000 at Lomeshaye Industrial Estate, Nelson. Police break up the party. Many arrests; all cells at Nelson, Colne and Burnley police stations were said to be full
	Saturday 3 March	Police roadblocks seal off Blackburn. Fourteen arrests
	Saturday 10 March	Police roadblocks seal off Blackburn. No party; twenty arrests; mini-riot in Blackburn
27	Saturday 17 March	Police roadblocks. Party attempted at Finnington Lane, between Chorley and Blackburn; twenty-one arrests
	Saturday 24 March	Police roadblocks. No party
28	Saturday 31 March	Police roadblocks to stop a party in a house on Mile End Row, Revidge, Blackburn

Source: Derived from *Lancashire Evening Telegraph*.

Notes:

[1] Key to map location of party (see Figure 7.1)

thousands of revellers who arrived from all over East Lancashire, and as word spread, from further afield. They came to this meeting point in order to find out the location of the illegal parties. Two local journalists, Richards and Slater, reported that 'the event of the week starts in the dark in more ways than one', because – largely in order to prevent police action – the exact venue was kept secret until the last minute.[5]

Once all the cars had met up, they set off (at around 3 a.m.) to the destination. This was probably a warehouse, an old mill or a disused factory. The quality of the buildings varied. Some were almost new, some old but in reasonable condition, while others were almost derelict. Before the convoy reached the warehouse, the organisers had already set up the music equipment,

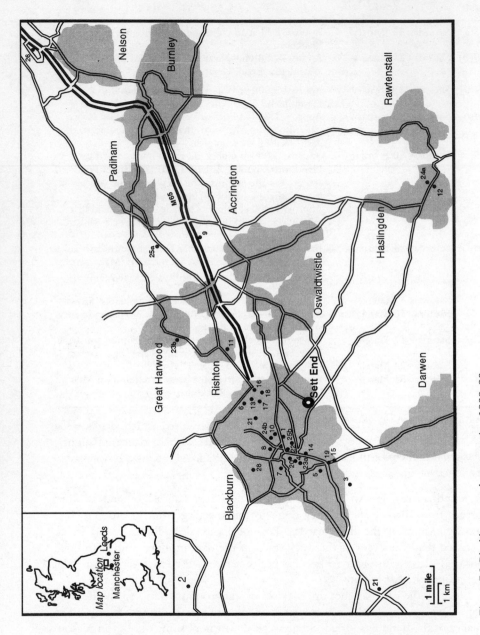

Figure 7.1 Blackburn warehouse parties, 1989–90

consisting of loudspeakers, amplifiers, two record decks, plus a generator and a refreshment van. In order to do this the organisers usually had to break into the premises.

On entering the building, often by a narrow door, one would be greeted by an 'onslaught of frenetic almost deafening house music',[6] which had been 'created' by the DJ for, according to Richards and Slater, 'wall to wall dancing'; being, they add, 'no place for socialising, though everybody seems to know dozens of other revellers'.[7] The entire space inside the building was a dance-floor for which record players, records, speakers and amplification were used to create the virtual sound worlds vital to the reconfiguration of the empty space. The music would last till 8 a.m., occasionally as late as 10 a.m. the next morning.

What was it like being inside this temporary sound-controlled space? My recollections of the experience include not knowing who was playing the records and what the records were called. Similar feelings were felt by those dancing around me; it has become common to ascribe this to a shared ecstatic state in which conventional memory is lost.[8] However, I also remember the sound of the crowd inside in the warehouse erupting when they heard, *and recognised*, a particular record. The DJ would play with the records to heighten this frenetic atmosphere in interaction with the crowd. As Sarah Thornton explains, 'DJs respond to the crowd through the choice and sequence, seek to direct their energies and build up the tension until the event climaxes.'[9]

So Rietveld's claim that everyone simply 'lets go' has to be qualified. The interaction involves a paradoxical situation of a 'suspended memory' that can still actively recognise musical patterns. To understand this process it is necessary to consider the combined experience of music, dance and drugs. Although the main attraction of these parties was the music, for a number of party-goers the music was enjoyed in association with drugs, in particular ecstasy or 'E'. Ecstasy produces hyperactive behaviour of a repetitive kind, which works well with repetitive dance music. As well as making users wish to dance all night, ecstasy makes the user more friendly to other people. Consequently, the sensory experience of the space was an outcome of both repetitive music and altered perceptions on E, often characterised as a suspended moment, a floating feeling. But again this is not, as is sometimes claimed, a transcendence of the possibilities of recognition – memory and pattern recognition still function.

When an understanding of these feelings is combined with an information theory of music, it is possible to explain how particular values are generated within the dancers. Information theory argues that the listeners' awareness of the patterns of musical tensions and resolutions is what gives music its significance. The listeners' knowledge of the musical style allows them to partake of the tensions and resolutions of the music.[10] The dancers listen/experience the sound and respond through their body actions. A *narrative* is created by the interaction between DJ and dancers. The music, the drugs, and the combined emotional behaviour of the participants powers the event. Writer Irvine Welsh

has claimed that there are few ways in which people can gather in a collective, since the demise of trade unions, churches and terraced football grounds. Consequently, events such as the Blackburn parties are one of the few places where a sense of communality and belonging to something can be created. One of Welsh's characters describes his feelings at such an event:

> The muscles in my body seemed in harmony with each other, the bodies' internal rhythms were pounding. I could hear them for the first time. They were saying, you're all right...you're all right. We're all right. People, strangers were coming up to me and hugging me, birds, nice looking lasses, guys...some of them...[I fought] in the past. I just wanted to hug them all, shake them by the hand, something special was happening and we were all in this together.[11]

Like Thornton, I believe that these experiences create particular 'subcultural ideologies', which she identifies as 'a means by which youth imagine their own and other social groups, assert their distinctive character and affirm that they are not anonymous members of an undifferentiated mass'.[12] However, Thornton does not explain how the experiences of the event *generate* the ideology. It is this experience of virtual sound spaces in conjunction with the drugs in a social setting that generates the value, the ideology of the TAZ, in the minds of the party-goers.

Clampdown on the TAZs

The TAZ itself, for all its spatial fluidity, was subject to the fairly predictable narrative of establishment, opposition and defeat. Police, residents, warehouse owners and politicians had a very different perspective on the warehouse parties from the party-goers. The local media had a key role in spreading the opinion of disgruntled residents who had been disturbed by the parties, and of warehouse owners who were upset about people breaking into their premises. This set an agenda for clampdown on the TAZs. The case demonstrates real conflicts of interest, and indeed of interpretation. Party-goers attended the events to experience the 'music'; the residents complained about the 'noise' disturbance associated with the parties.

In the beginning the police did not stop the parties, or even prevent them from going ahead. They lacked foreknowledge of the events taking place, and also believed that the parties did not pose a threat to the well-being of the community. The parties themselves tended to be well organised. There was little violence at the events (a lack usually attributed to the effects of the music in conjunction with the use of E). More specifically the police lacked powers to deal with the situation. Parties were held on private land, and court injunctions were useless.

Taking their lead from residents and the newspapers, the local MPs took

action against the warehouse parties. A deputation of residents from the Shadsworth estate met the local Labour MP, Jack Straw (who has since become Home Secretary), to complain about the noise disturbance. Straw was very much against the parties:

> Blackburn is not short of places for young people to enjoy themselves. To say there is nowhere to go is nonsense. It is just a foil by very greedy, very selfish criminals who disturb a neighbourhood and put the lives and safety of young people at risk in order to make money.[13]

The local residents' campaign, supported by Straw, persuaded the council to withdraw the licence from *The Sett End/Red Parrot* night-club, forcing the local Thwaites brewery to close the pub down. A similar opinion on parties was expressed by then local Ribble Valley MP David Waddington, who helped to draw up MP Graham Bright's Bill that became an Act on 9 March 1990, enabling such parties to be banned. The measures included a new licensing system in which stringent safety regulations were to be enforced by local councils and strict limits were imposed on noise levels. Organisers of acid house parties were required to inform the police of their intentions. Those who flouted the new rules faced massive fines – many times the previous maximum of £2,000 – and courts were given new powers to seize the property of party organisers.

These developments (unfavourable reactions from the local media, residents, politicians and warehouse owners) changed police opinion. The police decided it was time to end the parties. It was now possible for them to break up a party lawfully, secure prosecution of the organisers and punish them with hefty fines and prison sentences. Lancashire's police decided to stop the parties with an operation code-named *Alkaline*. First, roadblocks were used to disperse the convoys. It was also decided to stop the party on Saturday, 24 February 1990, when it was in full swing. This was done, not only to catch the organisers, but to warn party-goers not to attend future parties. The party in question, held at Nelson, was the biggest acid party ever to have been held in East Lancashire. Between 7,000 and 10,000 people attended the event. At one point forty police vehicles were lined up in the road outside Nelson police station, many of them carrying a dozen officers. Other police vehicles were spread out over a wide area.

After the events at Nelson, the police had the powers, and the knowledge, to stop the parties, and they did so – with powers, it should be noted, granted well before the passing of the 1994 Criminal Justice Act (one of whose targets was once again this type of party). No more warehouse parties have occurred in East Lancashire to date. Other parties did occur in parts of the North West in the summer of 1990, such as the *Revenge* parties named to signify their 'revenge' on the authorities and their stopping of the parties in Blackburn. These parties, based around Wigan and Warrington, were on a smaller scale than the

Blackburn parties. Even so they were often prevented from starting by police roadblocks. Since these events, there have been new dance nights, the opening of new night-clubs, and national legislation has permitted local extensions of the licensing laws. However, the new clubs have been mainly in the cities of Manchester and Liverpool. Blackburn itself has seen no new clubs and no extension of the licensing hours – despite the obvious demand. The new clubs do not offer the same experience: although playing the same music, the club does not provide an unexpected location each week. The club 'night' also tends to finish at 2 a.m., unlike the warehouse parties that went right through the night. There is also little conflict with local residents. Events are endorsed by local planning authorities. Overall there is less questioning of the local environment and people's daily routines. In this way the TAZ was suppressed (this police success is not necessarily contrary to Hakim Bey's optimistic figuration of an indestructible continuity: illegal parties have indeed continued 'elsewhere/elsewhen'). But what were the musical and spatial components that had helped the Blackburn TAZ into being?

Of course, dancing under the influence of psychoactive drugs has a long history.[14] The Blackburn warehouses reworked previous dance and drug experiences: at the parties specific musical/psychic 'power circuits'[15] were generated. Dancers (human body power), partly fuelled by psychoactive drugs or other stimulants, combined with the latest developments in production, distribution and sound dispersal technology. The dancers' energy and enthusiasm was fed back through the DJ to the makers of music and providers of technology, to form a feedback loop of production and consumption. But such power circuits are not built from nothing: the sounds, technologies and drugs arrived in Blackburn as part of a complex heritage of such relationships. The following cases explain the background to the power circuit.

The Chicago 'house' sound: the layering of virtual sound worlds in a social setting

The music for the warehouse parties was created using the techniques developed in Chicago house. This music took its name from the 'unique mix' played by Frankie Knuckles at the legendary Warehouse night-club between 1977 and 1985. The unique mix layered virtual sound worlds in a social setting, a process that was further developed by DJ Ron Hardy at the Music Box night-club. Hardy was responsive to the demands of his audience and at the same time willing to 'break new sounds'[16] such as 'acid house'.

The Warehouse

Frankie Knuckles's style involved, precisely, mixing – i.e. running one record into the next, often with the two playing simultaneously at the changeover point. He would mix genres, such as Philadelphia soul, New York club,

120

Eurodisco and sound effects such as a running train, to create a continuous sound-track for the entire night.[17] While the beat went on and on, the listener/dancer did not recognise that the record/sound world had changed. The mix at the Warehouse would often last up to fifteen hours (midnight Saturday until noon Sunday). The turntable became a musical instrument as he layered sound from one record over the beat from another. In this way, according to Knuckles himself, 'house music was born'.[18]

With powerful amplification, large loudspeakers and bass-oriented equalisation, these records conveyed loud kickdrum and deep bass sounds. The music emanating from surrounding speakers blended together the 'performer and audience'.[19] Loud low-frequency sounds leave the listener immersed, at the centre of the sound; he/she is massaged by it, flooded by it, part of it, his/her body moving like a negative of the loudspeaker diaphragm.

The Music Box: local involvement

By 1985 the night-club known as the Music Box, situated on the south-side, was starting to play a prominent role in the development of Chicago house. Where the Warehouse was 'more sophisticated...the Music Box was more hedonistic, messier, more intense'.[20] While Frankie Knuckles had laid the groundwork with his style of mixing records, it was DJ Ron Hardy who really created the environment for the house explosion. Hardy went for the rawest, wildest rhythm tracks he could find, and spun them in a way 'more linked to atmosphere than mixing technique, hyping up the crowd and pushing up the speed, playing tracks seven, eight, 12 times a night if need be'.[21] Both DJs mixed for the same mammoth time-span, about fifteen hours. But while Knuckles would never repeat a track in that time, Hardy would repeat tracks that had excited the audience. Frank Broughton describes Hardy's music being more about 'bombshells and surprises...an onslaught of sound reaching climax after...climax'.[22] This would have the effect of creating a more intense and frantic atmosphere than Knuckles at the Warehouse: and in the audience/DJ reaction we have a component of the power circuit.

The Music Box, was described in a visit by Tony Prince:

> Here was an underground, warehouse-atmosphere complete with a 100% black audience. Upstairs in the DJ booth, a hard-liner turned up the bass as aromatic, herbal extracts wafted their way skywards. We didn't feel this was the place to ask for a glass of white wine. It was the place to close your eyes and drift into the pulse of Chicago as you absorbed the very cellar of house music.[23]

Ron Hardy would play, predominantly, tracks that had been made locally in Chicago. Hardy's sound environment provided a local medium for local people's music, and they responded, in another line of the power circuit, by

making tracks for Hardy to spin.[24] K-Alexi Shelby who made tracks that were played at the Music Box said, 'when I make a record I think about the crowd – if I can see the crowd going wild, then I run it. It's a moment between me and the people.'[25]

Local involvement in the music process allowed varieties of house music such as acid house to develop at the Music Box. DJ Pierre took the first acid house recording to the club on cassette, which enabled Ron Hardy to make the sound of acid house popular in the space of the Music Box before it was available on record:

> The first time Ron Hardy played acid, people were like 'What in the world is this?'. Then he played it again and they kept on dancing and the third time they were like 'Oh man! This track is crazy!' And Ron played it four times that night and the fourth time they were jumping up and down and screaming![26]

This playing of the track four times in one night demonstrates the effect of a sequencing of virtual sound worlds on memory and behaviour. The first time the crowd heard DJ Pierre's 'Acid Trax' they were unsure of what was happening. By the fourth time, the track had entered their consciousness, and they engaged with the new musical direction. This interface of DJ with crowd heightened the energy level of the power circuit, generating a 'frenzied' atmosphere. Pierre recalls this atmosphere: 'You know how people get the Holy Spirit in gospel church? People were doing that with house music and that's why I say that house music is the only music besides gospel that can make you feel like that.'[27]

It should be recognised that drugs were associated with both clubs, and that this affected the ways in which the sound worlds were being experienced. Marshall Jefferson explains that at the *Warehouse* 'weed, cocaine and some acid circulated more subtly'.[28] However, at the Music Box 'anything went'. 'Acid. Angel Dust. [A popular high was "happy sticks": cannabis joints dipped in PCP (angel dust), providing manic energy for the user.] Spliffs. Coke. Everything. A drug haven. Ron Hardy was a heroin addict, sometimes living in the DJ booth at the Music Box, either DJing, working for days on re-edits, or getting high.'[29] (Hardy died in 1993 as a result of his drug addiction.)

King Tubby: the creation of 'virtual sound worlds'

The house sound has its roots in 1970s New York disco. These developments were transferred to Chicago mainly through the DJing of Frankie Knuckles. 'I used to go home to New York and bring records to Chicago. NY has its own unique mix. You see Chicago didn't have a style back then.'[30] One of the main influences on the production techniques of disco records (through record producers such as Francois Kevorkian) was dub.[31]

The invention of dub reggae transformed the aural environment. Dub can be defined as the creation of a virtual sound world via electronic studio techniques; routinely it is a form of electronically produced music that emphasises rhythmic drum and bass. The results from the studio are recorded on to acetate disc to create 'specials', which are then played on a sound system (consisting of record players, amplifiers and speakers). When the dubs are played in a social setting, the record player and records *become the musical instruments*. Dub here is used to describe both the process of making the 'specials' and the resulting musical recording. The point is not about length or even the type of music made; it's about studio-specific techniques and the resulting discs. I will explain why this production process is such a significant development within the aural environment.

Dub creates *virtual* sound worlds, alternate worlds defined by sound: dub is the 'engineering of space and time' by electronic means.[32] According to David Toop, dub creates 'new maps; sound sculptures, sacred sites', with a 'vast landscape of peaks and deep trenches, extending hooks and beats to vanishing point'.[33] Why should sound and landscape be associated in this way? Dub has altered fundamentally the way in which musicians/listeners perceive and experience sounds. The possibility of a 'decentered soundscape' is created through the use of amplifiers and loudspeakers.[34] Dub aims to create not just stereo but a three-dimensional effect. A sound is created with no visual point of reference – the listener does not watch a musical performance, or imagine one, but instead exists in an alternate world of spatially structured sound. This could be said to apply to all sound, if loud enough. However, dub specifically utilises sounds such as deep bass and echo to achieve this effect, and it does *not* refer to musical performances outside itself, as did most recording before the 1970s.

When dubs are recorded, the ideas and expression of composers/producers are preserved. But it is also the case that new versions of a dub can be created from the same basic recorded tracks. These are termed 'remixes' or 'versions' and it is possible to replicate, reinvent, or to make many versions. Once on record, sounds can be experienced again and again. When creating the dub, the producer has a number of individual sound possibilities (via electronics) at his/her disposal. There is a massive reduction in cost, which is no doubt relevant to the emergence of new record producers from relatively disadvantaged economic groups and regions.

The emergence of dub

Although a large number of people are credited with the development of dub, including producers Lee 'Scratch' Perry, Bunny Lee, Niney Holness and sound engineer Errol 'T' Thompson, it is sound engineer Osbourne 'King Tubby' Ruddock who had the pioneering impact. King Tubby was born in Kingston, Jamaica in 1941. In the late 1950s he had begun to experiment with sound system amplifiers, and by 1968 King Tubby was running his own sound system

called Tubby's Home Town Hi-Fi. In order to explain King Tubby's role in the creation of dub, it is necessary to provide some background on sound systems and recording studios in Jamaica.

Sound systems are mobile discotheques, 'travelling sound systems' that 'frequently play outdoors under the open sky'.[35] Competition and rivalry between sound systems has 'provided the underlying dynamic of Jamaican music for over three decades'.[36] Sound systems become popular 'by playing what another system cannot play'.[37] A competitive edge can be gained via the exclusivity of their music, thus 'idiosyncratic variations and recognisable trade-marks were literally enlisted in the struggle to achieve the *boss sound* on the island'.[38] In the beginning this 'boss sound' could be achieved by having the rarest records. However, as Imruh Bakari has pointed out, as well as using this means to stay popular, sound system owners began to make their own records, pressed in limited numbers.

The process of creating different versions of a particular record started at the end of the 1960s. At this time one of the biggest sound systems, which went under the characteristically imposing name of 'Ruddy's Supreme Ruler of Sound' was owned by Rudolph Redwood. Redwood acquired access to the entire recorded output of Coxsone's Studio each week. He would then cut this music on acetate discs that were played exclusively on his sound system.[39] In effect, Ruddy had discovered the remix, and in Jamaica it soon became known as the 'version'. These 'versions' allow an alteration and reinvention of the pre-recorded sounds. As Toop says, this means 'there is no such thing as an *original* mix, since music stored on multitrack tape can be considered to be "just a collection of bits"'.[40] As a result the *version*, an electronic *virtual* sound world, had been created with no referent to a live musical performance.

The creation of virtual sound worlds

Inspired by the example of Ruddy Redwood, King Tubby developed the techniques on his Home Town Hi-Fi, enabling him to establish his supremacy as the most popular and respected sound system.[41] King Tubby was at the time making records at Treasure Isle (Duke Reid's studio) and decided to utilise his access to recording equipment to make his own versions. King Tubby would take versions, the 'special dubplates', to play over his sound system, Home Town Hi-Fi.

Most of Tubby's dubs were mixed live at 18 Dromilly Avenue in the Kingston district called Waterhouse, using the Aggrovators session band, which included the musicians Sly Dunbar, Robbie Shakespeare and Carlton Barratt. As the music entered the mixing desk, Tubby would engineer the sound, using electronically transforming processes such as delay, echo and phasing. (Toop explains that echo is the fundamental device of dub, 'throwing words into caves' and 'repeating beats for an infinity'.[42]) With his background in electronics he was able to construct customised equipment, and Tubby showed an

aptitude for improvisation to achieve particular sounds. He would for example hit the spring reverb unit physically to create a thunderclap sound, or put a brief frequency test tone on deep echo, or use sound effects like sirens and gunshots.[43]

The echo effect in conjunction with the deep rubbery bass and the heavy drum sounds, creates what Toop calls the 'cavernous bottom' of the typical dub mix.[44] It should be remembered that these sounds are intended to be heard over a sound system with amplifiers outputting thousands of watts playing through a dozen or more wardrobe-sized loudspeakers, equalised to emphasise the bottom end of the frequency spectrum, and often slashed so as to distort the sound. It is no coincidence that the nearest approximation to dub is 'the sonar transmission pulses, reverberations and echoes of underwater ringing [which are] made by dolphins and whales'.[45] Indeed, oceanic metaphors abound in descriptions of a music that creates 'an ocean of sensation',[46] produced by 'swimming in a sea of reverb'.[47] This effect is further heightened by higher-pitched sounds, dentist's-drill hi-hat and pistol-crack snare, which are mixed with the instrumental 'voices', 'played with, brought forward or set back, dramatically underlined by ringing gusts of echo, made to drift in and out of phase',[48] and to drift up and down in volume.

Another aspect of dub is the amount of space between the sounds. An important technique of dub is to cut away, a subtracting rather than the adding which multi-track technologies seem to imply. For example the vocal can be removed or heavily treated: it becomes another virtual musical instrument – an attitude to the voice rare in pop before dub, but routine in acid house and its derivatives. It leaves spaces in the music, inviting the listener or dancer in, to 'fall back on their imagination'.[49] It is no coincidence that dub is associated with the use of marijuana. Simon Reynolds and Joy Press describe how the dub/marijuana process of 'de-activation' works:

> Dub with its echo-drenched spatiality, is designed to be enhanced by marijuana…by decreasing the sense of distance between source and listener; it encourages synaesthesia (so that the listener 'sees' the music); it diminishes both memory and future-focused anxiety, so that the listener can be absorbed by the present moment, become lost in music.[50]

The result on spatial perceptions may well be one of the reasons why so many of the above commentaries use geographic terms to describe the effects of dub music.

Working in the studio, Tubby was able to make a vast number of versions: a complete dub listing would run into hundreds of titles. Bunny Lee (King Tubby's boss) had evolved a production method in which everybody (artists, musicians, engineers) 'performed at full stretch with studio costs kept to minimum'.[51] As a result, a vast number of records were available to be played

over the sound system, with the popularity of different records changing week by week. Producers like Bunny Lee, Winston Riley, Roy Cousins, Leonard Chin, Vivian Jackson and Carlton Patterson left their tapes with Tubby to be versioned. Twenty-five years later this mutually-mixing behaviour is routine within British dance music.

King Tubby was murdered by a gunman on 6 February 1989 outside his home. To most of the Western 'musical world' his death went completely unnoticed. He has yet to receive full credit for his innovations in dub, which have had a far-reaching impact on dance music throughout the world.

Conclusion

Developments in dub created the 'power circuit' that led to the Chicago house experience and Blackburn warehouse parties. Although dopey dub and speedy house may seem to be different types of music, both rely on the same highly complex technological-physical interface: the mix, the DJ, the drugs, the body and the crowd, without which there would have been no TAZ in Blackburn. This interface (studio-recorded music remixed by a DJ and played over a large sound system to an enthusiastic crowd) is now used by the many subgenres of dance music. The musical interface creates a narrative for both the individual and the social gathering, an ever-changing narrative that is charged from the 'emotional tension' caused by anticipation and experience playing off each another. It was this narrative that drew people to the warehouse parties and generated the value of a TAZ in their participants.

These case studies only hint at the possibilities gained from thinking about sounds in a geographical way. My experiences at the warehouse parties enabled me to deliberate on the way technology has altered the production and dispersal of sounds over particular spaces. They also enabled me to draw links between Blackburn, Chicago, New York and Jamaica. At the same time the cases demonstrate that King Tubby's music and Chicago house did not develop in vacuums. There is a history here, a sequence of musical, technological and pharmacological developments. Taking these case studies as a groundwork, future research on the relationship between 'music' spaces, and the relationship between 'music' and other sensory experiences would be worthwhile. Not only would this approach impart invaluable material, but it would also provide a necessary groundwork for a more thorough study of music and space, a vital component of any future cultural geography. We need to journey further into sound.[52]

Notes

1 H. Bey (1991) *The Temporary Autonomous Zone: Ontological Anarchy, Poetic Terrorism*, New York: Autonomedia, p.101.
2 H. Rietveld (1993) 'Living the dream', in S. Redhead (ed.) *Rave Off. Politics and Deviance in Contemporary Youth Culture*, Aldershot: Avebury Press, pp.2–3.

3 S. Reynolds and J. Press (1995) *The Sex Revolts. Gender, Rebellion and Rock 'n' Roll*, London: Serpent's Tail, p.176.
4 The catchment area for the Blackburn parties included Manchester: see J. Savage (ed.) (1992) *The Haçienda Must be Built*, Manchester: International Music Publications, p.66.
5 J. Richards and R. Slater 'House music finds a market', *Lancashire Evening Telegraph* 12 January 1990: p.21; also P. Hall '800 foiled at "acid" mill fling', *Lancashire Evening Telegraph* 3 July 1989, p.1.
6 Richards and Slater 'House music finds a market', p.21.
7 Richards and Slater 'House music finds a market', p.21.
8 This is argued by several contributors in S. Redhead *Rave Off*. See, for example, A. Melechi 'The ecstasy of disappearance', and H. Rietveld 'Living the dream'.
9 S. Thornton (1995) *Club Cultures. Music, Media and Subcultural Capital*, Cambridge: Polity Press, p.65.
10 R. Aiello (1994) 'Music and language: parallels and contrasts', in R. Aiello and J. Sloboda (eds) *Musical Perceptions*, Oxford: Oxford University Press, p.59.
11 I. Welsh (1995) *Marabou Stork Nightmare*, London: Minerva , p.345.
12 Thornton *Club Cultures*, p.10.
13 D. Perry 'Acid laws in a rush', *Lancashire Evening Telegraph* 13 March 1990: p.1.
14 Some clues as to the length and depth of the place of drugs in human culture can be found in J. Goodman, P. Lovejoy and A. Sherratt (eds) (1995) *Consuming Habits. Drugs in Anthropology and History*, London: Routledge.
15 A. Blake (1992) *The Music Business*, London: B.T. Batsford, p.16.
16 DJ Pierre, quoted in K. Needs 'Windy city blow-out: interview with DJ Pierre', *Echoes* 27 February 1993, p.7.
17 S. Cosgrove (1996) *The History of the House Sound of Chicago*, BCM Records B.C. 70-2060-49.
18 Knuckles, quoted in D. Jones (ed.) *Equinox: Rave New World*, an edited transcript of a programme shown on British Channel 4 on 6 November 1994: p.14.
19 H. Gallagher 'Gimme two records and I'll make you a universe – DJ Spooky, the Subliminal Kid', *Wired* 2 August 1994: p.86.
20 D. Phillips (1994) 'This man started house music', *Mixmag* 2(41), p.48.
21 Phillips 'This Man', p.48.
22 F. Broughton 'Chicago: still rockin' down the house', *I-D* 139, April 1995, p.39.
23 T. Prince (1989) 'Mike Wilson's Chicago', *MixMag* 2(73), p.19.
24 S. Harvey and P. Bates 'Behind the Groove', originally from *Collusion* September 1983, reprinted in *DJ Magazine* supplement 11–24 March 1993, p.5.
25 F. Tope (1995) 'Music is power. I love it', *MixMag* 2(44), p.70.
26 DJ Pierre quoted in M. Fitzgerald 'The Master Blaster', *DJ* 76, 12–25 November 1992, p.12.
27 DJ Pierre quoted in Phillips 'This Man', p.48.
28 Quoted in Phillips 'This Man', p.48.
29 Phillips 'This Man', p.48.
30 Quoted in P. Ablett 'Frankie Knuckles – only the strong survive', *Soul Underground* 20 May 1989, p.22.
31 Other influences on the disco records include the realisation of what people like Norman Whitfield, producer/writer for the Temptations, had done on album for several years – make long grooves that were impossible on singles before the 45 r.p.m. 12"; Sarah Thornton argues that the idea of the 12" disco record 'came from American DJs who had been mixing seven-inch copies of the same record for prolonged play' (*Club Cultures*, p.59). The point is that it is not the length of

records that is important but the production techniques, which were first developed in production of dub.

32 V. Goldman 'Dubwise', *Straight no chaser* 11, Spring 1991, p.17.
33 D. Toop 'Dub', *MixMag* 2(19), December 1992, p.32.
34 Reynolds and Press *Sex Revolts*, p.178.
35 I. Chambers (1985) *Urban Rhythms. Pop Music and Popular Culture*, London: Macmillan, p.154.
36 S. Barrow (1995) 'The Dawn of Dub', *The Wire* 132: p.29.
37 I. Bakari (1989) 'Calypso and Reggae', in R. Samuel (ed.) *Patriotism – the Making and Unmaking of British Identity vol. III: National Fictions*, London: Routledge, p.101.
38 Chambers *Urban Rhythms*, p.154.
39 Examples can be found on S. Barrow (1994) *Dub Gone Crazy – the Evolution of Dub at King Tubby's 1975–1979*, Blood and Fire Records BAFCD 002; and Barrow (1994) *If Deejay was your trade – the Dreads at King Tubby's 1974–1977*, Blood and Fire Records Fire CD 001.
40 Toop 'Dub', p.32.
41 Barrow *Dub Gone Crazy*.
42 D. Toop, 'A-Z of Dub', *The Wire* May 1994, p.20.
43 Barrow *Dub Gone Crazy*.
44 Toop 'Dub', p.33.
45 Toop 'Dub', p.33.
46 Toop 'Dub', p.32.
47 Goldman 'Dubwise', p.17.
48 Chambers *Urban Rhythms*, p.173.
49 Goldman 'Dubwise', p.17.
50 Reynolds and Press *Sex Revolts*, p.178.
51 Barrow *If Deejay was Your Trade*.
52 A recent pioneering work in the area is A. Leyshon, D. Matless and G. Revill (eds) (1998) *The Place of Music*, London: Guilford Press.

Part IV

LIVING THROUGH
CONTEMPORARY POP

This final section offers fresh perspectives on the music of the very recent past. Rupa Huq examines the French musical world, tracing various lines through cultural history. While noting the presence of the State in the propagation of popular culture, she explores the tensions in this relationship, through an examination of the phenomenon of French rap. Rap is an aspect of an emerging France that is poor, suburban and multi-cultural, and while official culture and the political Right are hostile, it is the best-selling musical form among French youth.

Rap is at least connectable with official French culture through its concentration on language. Alexei Monroe deals with a set of extreme musical genres that, in their divorce from orthodox linguistic meaning, are at the edge of popular music's engagement with the routinely 'real', going beyond pop's concern with the politics and erotics of everyday life and towards a delirious engagement with the potentialities of mass movement and consciousness. Alexei Monroe charts some of the developments among these proliferating genres, while refusing any notion that his account can, or should, be authoritative.

For Jude Davies, on the other hand, the object is clear. Reversing the opening account of music made before its author's birth, the book closes with an articulate and theoretically aware account by a man in his thirties of the first year of the Spice Girls, young women whose music was aimed at young teenagers. Their success stopped the more serious, masculine and overtly nostalgic Britpop in its tracks, and reinvigorated our sense that we have all, since the 1950s, lived through pop.

8

LIVING IN FRANCE

The parallel universe of Hexagonal pop

Rupa Huq

An open-air pop concert on a warm autumnal evening in 1997. The onstage band belt out the stuff that has made them the most popular group in the country. Scenes of frenzied audience adulation follow. Stewards carry off someone who has fainted while all around people punch the air and sing along. But who are the combo topping the bill? Oasis? The Spice Girls? Wrong. Wrong again. The popsters in question are none other than Noir Desir. We are in Strasbourg, France. Welcome to the parallel universe.

Arriving in France in 1996, I was keen to discover the contemporary musical scene. Books on French culture had provided either unsatisfactory answers ('French musical life is above all marked by symphonic concerts and by recitals; obviously Paris offers the music-lover the biggest choice of musical spectacles')[1] or none at all – one recent survey deals with every aspect of French society except music.[2] From magazines, radio, television and gigs themselves it soon became evident that a buoyant pop scene has long existed in the Hexagon, as France is fondly known to its inhabitants. To the British observer of pop, such geometric niceties identify musically unknown territory: France is practically a parallel universe. This chapter surveys that universe, focusing on one of its more unlikely success stories, the French rap scene.

Pop in contemporary France

Studies of French youth, as those of English and American, emphasise the importance of pop. Mayol claims that music is the first of the 'seven pillars of youth culture'.[3] In Adrac's study of the musical practices of 10- to 25-year-olds, respondents' claims include: 'Without music I'd die', and 'Music is refuge, company, consolation.'[4] The popularity of pop music in France is seen in the consumption of CDs and in spin-off media. The pop-oriented television channel M6 is the most watched by youth. Radio stations playing pop (NRJ, Europe 2) command an overwhelming majority of the national audience. News-stand pop publications abound.

And yet there is a problem; indeed, the need to accommodate what is clearly

derived from Anglo-America has generated an identity crisis. Recent French books on pop almost all concentrate on Anglo-Americans.[5] The 1983 *Encylopedie Illustré du Rock* is a translation of an English volume, with 'Rock Français' tacked on as an afterthought by a publisher whose introduction runs, 'In this second section we have slipped some French groups which our English friends do not consider as of international value. These eight small pages will inflate the faith and pride of our little French hearts.'[6]

However, popular music (if not pop as such) is more structurally important in French culture than such disavowals indicate. France has long had a Ministry of Culture, and official structures at central and local government have long promoted popular music, and *la chanson Française* (French song) in particular. Among the creations of former culture minister Jack Lang was the Consultative Commission for Rock and Varieties. The televised annual *Victoires de la Musique* awards celebrate France's national popular music output. The yearly *Fête de la Musique* (National Music Day) is one of the more popular legacies of Mitterrand's presidency – and an event that the unlikely duo of John Major and Mick Jagger copied for the UK. Going beyond the day, a week – *la semaine de la chanson Française* – is celebrated by television channels, while everyone is encouraged to join, as participant or observer, in thousands of events that occur throughout the country.

Souvenirs, souvenirs

The beginnings of bona fide French pop itself are contested. Leproux claims that 1963 was the year of the 'investiture of French rock', and that its market that year was 7 million youth consumers via records, radio and the 17,000 jukeboxes in existence.[7] Dister puts French pop's debut at 1961, the year of riots at the Palais de Sports in Paris following rock concerts.[8] Whatever, the French are aware of their position as a poor cousin in the pop stakes, often to the point of the touching self-deprecation noted above, whether about the long career of the 'French Elvis', (Belgian) Johnny Halliday, or a comparatively successful band such as Les Negresses Verts. Bigot pours scorn on French rock, putting the term in inverted commas.[9] He describes what passes for French rock as trapped in variety, while Leproux, responding, merely claims defensively that 'France and rock aren't as far removed from each other as that'.[10]

Just as retrograde tendencies have gripped pop in the UK in recent years, France has its own healthy popular music retro-culture. A radio station named 'Nostalgie FM' (re)issues records in conjunction with its output. The unrelentingly nostalgic television programme, *Salut Les Chou Chous* (Hi Darlings), broadcast in the prime Saturday night slot on the commercial channel TF1, is a journey down *la chanson Française*'s memory lane – the title itself reworks that of a 1960s show, *Salut Les Copains* (Hi Pals). Studio guests share memories (their first-purchased record, teenage faves, etc.) before a studio audience and the presenter, ageing 1970s rocker, 'Dave'. Classic archive clips are unearthed: 1950s

folk idol George Brassens strumming away plaintively and eternal flame Serge Gainsbourg drunkenly slurring out songs at the piano. The set is a glittery recreation of an old juke-box; everyone speaks into old-style radio microphones.

France is a recurring theme in past and present pop songs, though not always in celebration. Dister claims that the consciousness-raising of the student movement in May 1968 galvanised French music from its earlier apathy: 'Authoritarian Gaullism was weighing too heavily on youth keen to act and think freely.'[11] The singer/songwriter Jacques Dutronc treated the fifth republic with sarcasm in two tracks, 'Restons Français, Soyons Gallois' (1970) and 'La France Défigurée' (1973). His ode to 'my disfigured France' paints a bleak picture of HLMs (council estates), the CRS (riot police) and destroyed forests, with the singer wishing that 'you become again as before'. The opening scenes of Noir Desir's video for the track 'Un Homme Pressé' of 1997 depicts youths throwing petrol bombs, with a close-up of one wearing a leather jacket with the complex Franglais pun 'fuck keuf' studded on its back. 'Keuf' is the '*verlun*' slang term for policeman, inverting the more common slang '*flic*'; verlun (*la langue a l'envers*, backslang) is a youth language formed by reversing letter orders and changing round syllables in words – typical cryptic slang. The video thus connects Noir Desir's routine pop with the harsher musical worlds of rai and of French rap, which I discuss below.

A more positive view was Marc Lavoine's 1996 hit 'C'est ça la France', described as a '*chanson d'amour*'. Its lyrics and video include images of Malraux, Brassens, Mitterrand, De Gaulle, Marseille and Camembert cheese, while the TGV represents modernity, and the North African dish *couscous poulet* (symbolically equivalent to curry in Britain) demonstrates not the desperate divisiveness depicted by Noir Desir's director, but that French culture is not a fixed concept and is positively open to immigrant influences.

Parallel pop: inside and out

For the British, the abiding image of European pop is of the annual ritual of the Eurovision song contest. There are a (very) few exceptions to this rule. The Norwegian trio A-ha were briefly the UK nation's favourite pop heart-throbs in 1986. In the 1970s, Eurovision winners Abba became Sweden's biggest export after Volvo. However, the fact that both sang in English is deeply significant (likewise, most of the hits of iconic German tanzmeisters Kraftwerk had lyrics in English). Among French-singing artists Celine Dion has achieved international success. Here, though, the parallel universe operates to produce parallel careers. The Dion MOR balladry that has struck a chord with her British public (e.g. 'On My Own') has not been the same that has made her a success in France (e.g. 'Il S'Appelle Ziggy'). A Francophone Canadian background has allowed Dion to conquer the French- *and* English-speaking pop audiences of the world in songs tailored to their linguistic needs (though a similar attempt to conquer Japan, with a single that saw Dion sing in phonetic Japanese, fell flat). Thus Dion is classified

with '*la chanson Française*' in record shops and among her recordings are *The French Album* and *Live à Paris*, only obtainable on import elsewhere.

Within the French pop scene there are internal parallels, one also with its own language. The product of French/Algerian post-coloniality, rai music is hugely popular amongst France's *beur* population (*beurs* are second-generation French-Arab youth; the word '*beur*' itself is 'Arab' in *verlun*). For all its cultural specificity, rai is increasingly seen as mainstream, in parallel with the UK's Bhangra scene.[12] Cheb Khaled, who scored a number one in 1992 with the song 'Didi', sung in Arabic, is probably the music's leading purveyor. In 1997 he was awarded the song of the year prize at the *Victoires de la Musique* for the best-selling hit 'Aiicha'. However, this was in French and written by John Jacques Goldman, which may explain the song's acceptance. The collaboration between Khaled, a Muslim Algerian, and Goldman, a Jew of Polish-German parentage, was seen as highly significant.

Jean Jacques Goldman once claimed:

> The traditional chanson Française is the only one [song style] in the whole world that one listens to sat down. Everywhere else song is linked to a spectacle where one moves or dances. Only in France do you get academic song where the music doesn't bother the text too much. These could be published in a collection of 'today's poets' – the texts without the music.[13]

These observations apply to the classics that he cites – Brassens, Piaf and Leo Ferrer; but French pop (including rai) has gone well beyond this staid style, whatever the connections thereto.

Indeed, 1997–8 seemed to be time to think the unthinkable – a French dancefloor revolution was underway, with genuine appeal in the UK. Notching up the most favourable mentions in UK music press were technomeisters Daft Punk, of whom style journal *The Face* waxed lyrical: 'Mere words cannot convey the disco-electro surreality and punk-funk splendour of the French duo's debut album.'[14] The band headlined Glastonbury's dance stage to a rapturous reception. Also on the Glastonbury bill were Dimitri from Paris, playing easy listening morphed with dancebeats, and Stereolab, a London indie group who have been known to sing in French. Dance publication *Muzik* described Etienne De Crecy, a product of the fashionable label Super Discount, as 'the master of cool Gallic grooves and all things groovily French'.[15] Yet back in France, the most successful of all these parallel Gallic grooves is rap.

Rap: a French institution

> This noisy musical genre, atonal and vituperative, doesn't serve anything else except a vast enterprise of destabilisation of the

moral, police and family values of the France of Vercingetorix, of
Joan of Arc and Michael Sardou.

(Telérama, 27 November 1996)

This is how goes today's gaullisto-chiraco-raplapla France.

(Libération, 16 November 1996)

Back to Strasbourg, in the summer of 1996; in the middle of the heatwave
something is stirring in the town railway station. A bunch of youths in hip-hop
gear are giving a policeman some grief. 'Your place isn't here', says a *beur*.
'Dégage!' (get lost), he insists menacingly, his body shaking with anger, his
voice booming across the concourse. The *flic* is outnumbered, powerless to do
anything except smile weakly, and...profess a liking for reggae. This isn't a case
of youth on police violence – it's one of the debates of the '*Université du Hip
Hop*', a summer activity put on by the socialist local government of the town.

Strasbourg, on the eastern edge of France, has a cosmopolitan and deeply
bourgeois image. Site of the Council of Europe and European Parliament, its
publicity calls it the 'capital of Europe'. Nonetheless some of the *banlieue
quartiers* (outlying neighbourhoods) of the city were the scene of urban
violence in 1995. *Université du Hip Hop* served a definite purpose for the
organisers of *Été Jeune*, the municipality's youth arts and cultural service. The
event's 'control' function was to channel youthful exuberance into an officially
sponsored framework to avoid any risk of repeated riotous behaviour. Here was
something so institutionally programmed that an entire HLM (municipal
housing estate) in the *banlieue* of Illkirch, and a local transport authority-
donated bus, were declared graffiti-permitted zones for the week – gestures that
both contradict the 'provocation' function of graffiti,[16] and suggest that hip-
hop is to be confined to the *banlieusard* ghettos, out of sight and out of mind
of 'straight' society.

Both central and local government have effected initiatives using rap's poten-
tial. Jack Lang supported the music with several grants from his departmental
budget during the period 1988–93. The municipality of Saint Denis, north of
Paris, labelled 'geographic cradle of rap in France'[17] was running hip-hop
events some five years before Strasbourg, backed by a Ministry of Culture initia-
tive FAIR – *Fonds d'Action et d'Initiative pour le Rock*. *Université du Hip Hop*
was a lavish seven-day happening celebrating hip-hop culture in all its expressive
forms – musical, graphic and bodily – via rap, graffiti and breakdance, all over
the city. A morning debate with conference speakers in the station began daily
proceedings (the hapless policeman spoke at one on 'hip-hop and institutions')
followed by afternoon workshops (on graffiti, rap and fanzine writing), with a
nightly free concert held in a different neighbourhood to round off.

This official top-down organisation of youth culture is one important point
where the parallel universe is not organised on parallel lines: it's totally contrary
to the UK valorisation of a free market in pop music, without subsidy. Yet

French hip-hop is no mere tool of the State; indeed it has its own internal concept of 'underground'. Mr E, a 23-year-old graffiti writer and DJ highlighted participants' suspicion towards *Université du Hip Hop*, underlining the tensions at its heart:

> France is a police state. It's centralised, everything is controlled: the administration, the papers [i.e. identity cards], everything. Pirate radio gets very quickly fucked up by the state for example. Hip Hop's been on the French scene since the early eighties. The media didn't believe it or push it [at first]. Regular people couldn't get to it. In 1996 it's getting popular, so they want everything under control.[18]

Leo, an experienced hip-hop promoter, is based in Strasbourg. Brought in to help the organising team, she also expressed an unease with the relationship between the event and its paymasters:

> The point was to show that hip hop is a movement with a spirit behind it. In terms of bringing people together, it has been a very good initiative. I've met some hyper interesting people....The town is run by the socialists. They've done a lot for social provision. It's not bad but there's a whole policy of 'assistata' [spoon-feeding], it's pretty bad for helping youth stand on their own two feet. There's a lot of problems in the quartiers here – fights, racism. The powers that be just throw money at it.[19]

French rap and chart penetration

Été Jeune's choice of hip-hip to anchor Strasbourg's summer *divertissement* is explained by the fact that France is rap's second largest world-wide market, in which Warren G, Wu Tang Clan and the Fugees all sold well during 1996–7. However, the French generally buy more of their own music than that from abroad,[20] and this includes home-grown rap, which has established itself as an aspect of mainstream popular culture during the 1990s. Lapassade distinguishes 1983–90 when the French rap scene was underground in Paris as a 'festive' live art, and the years following 1990 that saw its move overground.[21] Into this sequence Bazin's bifurcated model can be inserted. He names the two limbs of French rap as 'hardcore', which has a highly politicised and aggressive edge (e.g. IAM, NTM) and the more relaxed pacifist 'cool' rap (e.g. MC Solaar, Alliance Ethnique).[22] Both tendencies are what Toop (1990)[23] calls 'message rap'. The approaches are illustrated in the content and promotion of the two major albums from two of French rap's biggest sellers: *Paradisiaque* by MC Solaar (Dakar-born, Paris-raised rapper Claude M'Barali) and *L'école du Micro d'Argent* by IAM (a mixed-race seven piece from southern France with a name

variously interpreted as signifying Imperial Asiatic Men, Independentistes Autonome Marseillaise and 'I am').[24]

The claim that MC Solaar's aim is to win over people who don't like rap[25] seems to be supported by the media coverage of *Paradisiaque*, his first album in three years. The title track offers a satirical insight into urban life to the strains of Diana Ross's 'Sweetest Melody': 'Come to the *quartiers*, take a look at the paradise where angels live on the dole….My tower's better than Babel. Each to their own definition of paradise.' Solaar told *Le Monde*, however, that he had deliberately steered away from autobiographical negativism: 'I prefer to transmit good vibrations.'[26] He has named this style 'radicool' (on the 1994 album *Prose Combat*). The closest to a mission statement comes in 'Dakota': 'I like loads of rappers but the one I like best is MC Solaar.' Solaar's promotional videos ('Gangster Moderne', 'Les Temps Changent') were colourful and 'fun', reflecting the meliflous tone of the music. Those of IAM by contrast ('Le Côte Obscur', 'La Saga') featured epic/science fiction-derived cinematographic imagery.

It's easy to over-emphasise the differences between Solaar and IAM by resorting to Bazin's model (Solaar = apolitical, commercial, soft on the ear; IAM = militant Muslim, anti-fascist activists, pugnacious, darkly brooding musical atmospheres, etc.). Many points unite the two, not least their relation to French musical, literary and intellectual traditions. In Spring 1997 Akhenaton traced French rap from *la chanson Française* – making contact with the legitimising processes of the national musical past in the same way as the Goldman–Khaled combination identified above: 'The French artists, Jacques Brel, Jean Ferat, Charles Aznavour and Francis Cabrel – who have all known how to write – have influenced us. If we talk of a French rap scene, it defines itself by a certain quality of its texts…the freshness and the quality in a music in perpetual movement.'[27] Meanwhile, philosophy graduate Solaar has been seen as symbolising continuity with the French literary tradition. Asked by rock weekly *Les Inrockuptibles* if he found the label 'the intellectual of rap' a cross to bear he answered, 'That was excessive. With hindsight I think that the *intello* image must have been part of the marketing plan aimed at youth. I'm just a normal guy.'[28] This frank appraisal of the commodification of pop signals the cultural, economic and social forces that have produced this 'normal guy' and his ability to function as the first mainstream representative of a music produced by the excluded.

Ghetto blasting: *la banlieue* and the (sub)urban dimension

US rap has been seen as an equivalent to punk, shorthand for 'product of inner-city youth alienation'. French rap equally has post-war urban planning blight at its core. However, once again the parallel universe operates according to rather different rules. The UK/US urban model of suburbia as the leafy preserve of the middle class, and the inner city as the resort of the poor and dangerous, operates in reverse. The *centre ville* (city centre) is inhabited by the rich, while

the underclass are pushed out to the *banlieues* – suburbs, with high levels of immigrants, social housing and unemployment. Rap's theorists tirelessly claim that it is the soundtrack to contemporary (sub)urban street existence.[29] According to Cathus even in the *banlieues* the street may be for the respectable during the daytime, but by night it takes on dimensions of danger, survival culture and the 'law of the jungle'.[30] He sees the immediate *quartier* as an extension of the personal space of the perpetrators of street culture. Shusterman claims that the experience of art rests not in the objects of art but in the dynamic and development of active experience through which they are created and perceived;[31] for Cathus it is precisely the power of street experience that gives hip-hop its aesthetic power.[32] Chill of IAM concurs, making the correlation between 'street' and 'authentic': 'Hip hop isn't yet sold to the extent that it has become a banal sound. Hip hop is street music. The street isn't a particularly cool place. So the sound must be more forceful.'[33]

If the street is rap's stage it can be worked into a cartography of social relations. *Banlieue* mythology resonates in French rap mythology, following in the tradition of pop history's many tales of working-class boys made good. The word itself, pejorative in the eyes of the respectable, is worn as a badge of street credibility by others. Humble beginnings are a factor to be proud of; rather than 'making good', though, remaining in touch with roots is ostentatiously promoted. The group Ministère AMER (the doubtless contrived acronym spells 'bitter') produced an album called *95 200* after the postal code of Sarcelles, their tough north-Parisien *banlieue* of origin. NTM's name (see below) has one signification in 'Le Nord Transmet le Message', evoking the group's similar origins.[34] Just as IAM were fiercely proud of being from Marseille, Joey Starr of NTM has claimed to be unspoilt by success. 'We could have been like Solaar and not gone back [to the banlieue] but we can't do that', he told *Les Inrockuptibles*. 'We're asked why we still bother writing things like "Police" or "Plus Jamais Ça" (Never Again) but that's because we live it, we know....We're not quitting the banlieue.'[35] But the sound has spread well beyond these insalubrious districts: by the end of 1996 there could have been no one left in France who had not heard of rappers NTM. *Université du Hip Hop* was not the sole example of rap's institutional restraint in France.

The control of rap: the NTM affair and legal restraint

In November 1996 NTM (the title stands for Nique Ta Mere, fuck your mother) were all over the national media. The occasion was their sentencing to six months in prison (three custodial), a fine of 50,000 FF (£6,000) and a six-month ban on all French performances for 'outrages through words'. The censure was a familiar moral panic regarding youth culture, enacted against a backdrop of puritanical morality, supported by the extreme Right's view of cultural policy, and in turn intersected by the activities and attitudes of *banlieue* youth and liberal views of the supposed sanctity of artistic creation. The

sentence was pronounced by the local judiciary in Front National (FN)-run Toulon, southern France, for incidental comments made by the group's two rappers, Kool Shen (Bruno Lopez) and Joey Starr (Didier Morville), at a concert in July 1995.[36]

The FN's dislike of rap has extended to the removal of articles on it from library copies of magazines in FN-governed towns. The immigrant origins of the two rappers (Portuguese and Antillaise Caribbean respectively) were ceaselessly pointed out by the media. Overnight they became insurgent heroes of a generation, and predictably NTM re-entered the album chart as young people tapped into this outlawed underworld. Joey Starr commented, 'Our lyrics are thirty years behind. France has to accept that the problem of the *banlieue* has at its source the history of this country dating back to colonisation. It has to be realised that errors were made.'[37]

FN leader Jean Marie Le Pen, in his inverted way, agreed wholeheartedly, commenting at the party's Summer School: 'Rap and tag are passing fads of pathogenic outgrowths.'[38] Meanwhile, Catherine Megret, newly elected FN mayor of the town Vitrolles, told the German newspaper *Berliner Zeitung*, 'We're going to put a bit of order in cultural matters because rap and tag, that's not our cup of tea. That's just debilitating.'[39] France prides itself on being the home of *la liberté de l'expression*; however, NTM's interview with *Les Inrockuptibles* contained a recognition that this in practice had limits: 'We are privileged in that we have a chance to use the media, a framework, a means of expression.' Kool Shen added: 'At least we have the chance to talk about it. There are loads of young people who don't even have that chance, who don't have a microphone and find themselves in jail without having been able to explain themselves publicly.'[40]

The French liberal-Left media, fearing a *retour à l'ordre moral* (unleashing of reactionary moralism), commented that this whole incident was a *première* in France. *Télérama* claimed that such severity far outstripped past controversies over songs from the now revered 'classic' artists Serge Gainsbourg and Georges Brassens.[41] France's journal of record *Le Monde* sided with the group in an editorial titled 'A dangerous judgement'[42] and published the lyrics to the controversial song 'Police',[43] as did *Libération* which denounced 'a judgement stupefying in severity'.[44] Another *Le Monde* article saw NTM as living proof that Chirac's presidential promise to reduce *la fracture social* had failed: 'Governments would be well advised to bend an ear towards what these rappers are saying. It's cheaper than an opinion poll survey and as instructive.'[45]

The episode brings to mind the UK's Criminal Justice and Public Order Act of 1994, which enacted legal restraints on a youth culture seen as a threat or corrupter of the young, and thereby united (non-parliamentary) UK oppositional forces in a common cause. The combining of forces from the broad Left encompassing pressure groups, trade unions, student organisations, pressure groups and former Culture Minister Jack Lang against the NTM decision was also impressive.[46] Kool Shen was unrepentant: 'This goes beyond NTM. The

verdict has assembled the youth of the banlieue behind us. Now you have to choose between the state and NTM. We know very well where the youth are going to go.'[47]

International relations

There is a common perception, in France itself as elsewhere, that French youth are subject to the secondary diffusion of cultural trends – that France takes up forms and styles after their initial appearance in the US and UK. A word that has often cropped up in my conversations with Strasbourg youth is '*décallage*' (time change). Many young Strasbourgeoise feel a sense of a backwardness firstly *vis-à-vis* Paris, and then more generally between Paris and Anglo-American popular cultural innovation and leadership. The cultural critics agree. Daoud names 1975 as the year in which rap was invented in the US and identifies the first French performers as emerging in the mid-1980s.[48] Bazin uses the word '*retard*' (lateness);[49] Rousselet chooses '*déphasage*' (out of phase/touch);[50] and Lapassade selects '*décallage*' itself.[51] Jungle, the UK club favourite that first came to public attention in 1994 and was virtually mainstream by 1997, was barely visible in Strasbourg during 1996–7. (However one cannot always explain such anomalies in terms of French provincial towns being 'late' to catch on. Some Anglo-Americanisms are simply not accepted. Oasis, despite the might of the Sony corporation behind their label Creation, have not had the same success in France as they have elsewhere.)

Whatever the time-scale involved, in the case of rap, something is changed in the translation. Rap may have originally come from the (US) street; French rap has emerged from a parallel street. According to Bazin, France has always had ambiguous rapport with the other side of the Atlantic.[52] DJ Rebel told me: 'For too long, it's been said that France only copies America. It's time to say that we're not in America. We rap in French, our maternal language. We have a vision of rap that's French not American'.[53] Leo of the *Université du Hip Hop* voiced fears about American influences: 'There's an aggressivity in our quartiers and if nothing constructive is done we'll end up as New York in ten years.'[54] Of course, France has historical reasons to hate the US, which ensured the global spread of Anglo-Saxon language and culture and the end of the French language as the global tongue of communication. Common perceptions of shallowness stem from the United States' relative newness and supposed resulting inability to compete cerebrally with the older-established civilisations. Yet, predictably, all the studies of French rap copiously acknowledge and reference US rap in discography and text.[55] The compliment is not returned in US endeavours.[56]

The NTM case does, however, highlight a number of predictable parallels with US rap. The band's name is a direct borrowing of the term 'motherfucker'. US Gangsta Rap shares anti-police sentiments. The police are ever-present in the urban landscape in both countries. Cross includes an

appendix of incidents of police harassment in his study of the US rap scene[57] and claims that 'the Los Angeles Police Department has since its inception been the front line in the suppression of people of colour'.[58] 'Fuck Da Police' was a hit for NWA (Niggaz With Attitude) and similarly Ice T released 'Cop Killer' to controversy. Random police-administered *controles d'identité* (identity card check-ups) are seen largely as a way of harassing Blacks and *beurs*. A youth in Marseilles interviewed in *Libération* called the NTM song 'Police': 'A hit with 15–18 year old banlieue youth despite its boycott from most radio channels. The hatred of police, that's what unites kids.'[59]

Lapassade notes 'noirceur' (Blackness) as critical to rap in general, and that this sense, too, is derived from representations of Black America,[60] but all commentators focus on the local specificities of rap in France and in Europe more generally. French academic theories of rap note its connections with immigrant youth culture but also see it as part and parcel of integration.[61] While one Swiss study looks up at its 'American and French big brothers',[62] much of the work on rap elsewhere in Europe (including Italy, Germany and Switzerland) agree that the form has become de-Americanised – it's a good example of the way in which 'global' forms can exist as expressive of local cultures. Tony Mitchell's study of rap in southern Italy examines the music's local histories and rivalries, its relation to forms such as Neapolitan folk song, and even seventeenth-century opera recitative – in the same way as others locate their raps as aspects of the French tradition.[63] Linda Boukkakiou of Été Jeune, meanwhile, claims that the rap scenes in Switzerland and Germany are healthier than that of France because they are less institutionalised.[64]

Rap in French: say it loud, I'm Francophone and I'm proud

One reason why rap has been both so successful and controversial in France is due to its emphasis on language – arguably a more important element of the whole in rap than in most Anglo-American pop. The French defence of their language is legendary. The legislative proposal of the '*loi Toubon*' of 1993 attempted to replace Anglicisms in the French language, even to invent French equivalents for new words – '*le balladeur*', for example, is the little-used word for what most French continue to call 'le Walkman'. Thoday's appendix of English words that have entered the French language and vice versa, reinforces the association of French as a cultured/cultivated language and English as a cultural pollutant.[65] Terms in the French-to-English category cover the arts and (high) culture while the reverse are more popular/youth culture oriented.

Lapassade's claim that, thanks to its grammatical strictness and comparative long-windedness, French is prima facie linguistically incompatible with rap has not stopped the progress of rap in French. Catherine Ringer of the group les Rita Mitsouko sees connections with the French literary tradition as its strength: 'What is super is that it's direct. During the epoch of Aristide Bruant poets

improvised jousts, games with rhythms. That's what rap has rediscovered....Musical roots in France are very varied. Rap is a creation without precedent, musical chatter that finds its place in a literary country like France.'[66] 'The children of James Brown and Public Enemy have had a pleasant surprise: the French language adapts itself rather well to the tempo of these musics', claimed France's leading record retailer the FNAC in Spring 1996, during their promotion of '*la chanson Française*'.[67] Most French rap is indeed performed in the French language.[68] On the face of it, then, though the lexicon of Francophone rap does include a few English words,[69] it becomes part of the defence of the French language in the face of creeping Anglicisation, as manifested in the *loi Toubon*'s provision to set a 40 per cent quota of Francophone output for radio stations. Even as Lapassade muses that French is prima facie linguistically unsuitable for rap,[70] he acknowledges its place in French popular culture, and like Catherine Ringer, he labels rap as '*la nouvelle poesie orale des metropoles*' (new urban oral poetry).

To some traditionalists, this very newness makes Francophone rap as much of a threat as perfidious English. French linguistic formalism accounts for the greater gulf (compared with English) between its written and spoken versions. The latter can be divided into established slang, baffling to the foreign speaker, and *français branche* (plugged-in language) that is spoken by youth, has a six-monthly turn-over and is equally baffling to the French parent – '*verlun*' is an important constituent component of this constant youth neologising. Pierre-Adolphe *et al.* explain that its African, Arab, gypsy, English and French roots allow social and cultural identification for excluded *banlieuesards*. They oppose it to the regular French 'language of school, of order'. They continue: 'Victims of their success, certain words have been ennobled by their appearance in the *Petit Larousse* [the standard dictionary of French, equivalent to the *Oxford English Dictionary*].'[71] In this way then, the language of the *banlieue* has the same function as dress style or music as a form of youth expression. As with the commercial recuperation of these other elements of youth culture, it is when these words have passed into everyday knowledge that they are dropped from the vocabulary of the originators and replaced by new forms. Bazin warns that a transgression of linguistic rules in rap lyrics presents the risk that the message's intelligibility will be lost.[72] However, this is part of the point – language such as this will self-select the ears that it reaches.[73]

Conclusion

Though acts such as Daft Punk and Air have put some unexpected pre-millenial curves in the space–time of the parallel universes on either side of the English channel, rap remains the success story of the 1990s in what *Le Nouvel Observateur* calls rap's 'second kingdom'.[74] To date MC Solaar has averaged sales of a million copies per album, while the single 'Je Danse la Mia' from

'hard' act IAM reached number one during a six-week stay in the top 50, weighing in at 550,000 sales in 1994. French rap's popularity can be accounted for in the multiple inspirational sources that collide to strike a chord with its audience, making it more than simply a time-warped imitation of America – as its identification with characteristics of the *chanson Française*, and its use by officialdom indicates. Indeed, despite the views of the FN, both the soft and hard tendencies of French rap have been officially recognised. The annual *Victoires de la Musique* award of 1995 named IAM best group of the year. The following year the title went to Alliance Ethnik.

Mister E recognised that well beyond such official initiatives, rap is a *connector* of people to a culture:

> When you study ethnology, books like Levi Strauss tell you that there's two types of society: the private-natural and structured society. In all natural societies wherever in the world, people dance, sing, paint, do music. Today nobody sings, or has musical experience because they think that they don't know how to. Hip hop gives this back to young people. It is like these cultures; a need for our balance. It's going back without knowing it because there are so many things disappointing in industrial society: it's a premeditated thing, part of a process to homogenise cultures, making bad cultures in the same process. Hip hop culture comes and adds its culture to your culture. You have a different logic. For me hip hop is a whole culture. It's something from the street. It has values, references, habits and ways of seeing the world. It is not just a youth culture. It's something that you build everyday when you belong to it. It's DJs, writers, MCs, b-boys, the kid who comes home from school in his military clothes to fill up his bags with whatever he can get his hands on to go graffitting with his friends, risking their lives for it. One day you get into it and will probably never grow out of it. It's your identity. It lives your life.[75]

French rappers, like their equivalents in the rest of the world, are living through pop.

Notes

1 P. Petit (1975) *Comment va la France?*, Paris: Magnard, p.13.
2 S. Perry (1997) *Aspects of Contemporary France*, London: Routledge.
3 P. Mayol (1997) 'Les sept pilliers de la culture des jeunes', in *Le Monde de l'Education de la Culture et de la Formation* 250, July–August, pp.35–9.
4 Mayol 'Les sept pilliers', p.39.
5 Y. Bigot (1995) *Au Nom du Rock*, Stock; H. Skorff-Torgue (1984) *Que Sais-Je?: La Pop-Musique*, Paris: Presses Universitaires de France; S. Koechlin (1996) *Le Rock: Qui, Quand, Quoi?*, Paris: Hachette.

6 J. Tobler (ed.) (1983) *Encyclopedie Illustrée du Rock*, avec Cahier Française ecrit par Jean-Bernard Habey, Paris: RTL edition.
7 H. Leproux (1982) *Le Temple du Rock*, Paris: Robert Laffont, p.102.
8 A. Dister (1992) *Le Rock*, Paris: Editions Decouvertes Gallimand, p.49.
9 Bigot *Au Nom du Rock*, p.20.
10 Leproux *Le Temple du Rock*, p.101.
11 Dister *Le Rock*, p.106.
12 See J. Hutnyk *et al.* (1996) *Dis-Orienting Rhythms*, London: Zed.
13 M. Schmitt (1990) 'Changer la Vie', interview with John Jacques Goldman in *L'Autre Journal* 3, July–August, p.63.
14 *The Face* February 1997.
15 *Muzik* September 1997.
16 Z. Daoud (1996) 'Le rap et le tag: une nouvelle culture?', in *Banlieues*, Paris: Hachette.
17 *Le Monde* 31 October 1991.
18 Personal interview, 9 August 1996.
19 Personal interview, 9 August 1996.
20 *Syndicat National de L'edition Phonographique* 27 September 1997.
21 G. Lapassade (1996) *Le Rap, ou la Fureur de Dire*, Paris: Louis Talmant, p.11.
22 H. Bazin (1995) *La Culture Hip-Hop*, Paris: Desclée de Brouer, p.214.
23 D. Toop (1990) *Rap Attack* (second edition).
24 Bazin *La Culture Hip-Hop*, p.253.
25 Bazin *La Culture Hip-Hop*, p.254.
26 *Le Monde* 11 June 1997.
27 Akhenaton (1997), quoted in *Parcours Nouvelles Scenes Française*, Paris: FNAC, p.9.
28 *Les Inrockuptibles* 4 June 1997.
29 O. Cathus (1994) 'La vibration de la rue', in J. Y. Barreyre and A. Vulbeau (eds) *La Jeunesse et la Rue*, Paris: EPI/DDB, p.204; B. Cross (1993) *It's Not About a Salary. Rap, Race and Resistance in Los Angeles*, London: Verso, p.64.
30 Cathus 'La vibration de la rue', p.201.
31 R. Shusterman (1992) 'L'art à l'état vif (la pensee paragmatiste et l'esthetique populaire)', in *Le Sens Commun*, Paris: Edites de Minuit, p.48.
32 Cathus 'La vibration de la rue', p.205.
33 *Blah Blah* March 1997.
34 Lapassade *Le Rap*, p.54.
35 *Les Inrockuptibles* 27 November 1997.
36 The offending remarks can be roughly translated as 'Wank and piss on the justice system. The police are the fascists. It's them who assassinate. The fascists aren't just in Toulon, they are in general in threes, dressed in blue in Renault 19s. They are dangerous for our liberties. Our enemies are the men in blue. They're not very far behind you at the entrance. They're waiting for it to go wrong for us to smash in our faces. We piss all over them.' Indeed, twenty-six police and 'guardians of the peace' were present. Joey Starr later told *Les Inrockuptibles* (27 November 1997),'At our concerts there are always cops everywhere, barrages, check-ups. We're not trusted although there have never been problems directly linked to us.'
37 *Les Inrockuptibles* 27 November 1997.
38 *Le Monde* 23–24 June 1996.
39 *Berliner Zeitung* 24 February 1997.
40 *Les Inrockuptibles* 27 November 1997.
41 *Telérama* 27 November 1996.
42 *Le Monde* 17 November 1996.

43 *Le Monde* 18 November 1996.
44 *Libération* 16 November 1996.
45 'Le rap décapé, la France dérapé', *Le Monde* 5 December 1996.
46 The 23rd of November saw a march in Paris from the Place Republique to the Place Nation. It was supported by groups including the CGT, FSU, SUD-PTT, UNEF, UNEF-ID, DEL, FASTI, MRAP, JC, MJS, PCF, LCR, AREV, CAP, MJS, SOS Racism, etc. Lang's words were that 'liberty had been thrown out of the window'.
47 *Les Inrockuptibles* 27 November 1996.
48 Z. Daoud 'Le rap et le tag', p.79.
49 H. Bazin, *La Culture Hip-Hop*, p.257.
50 P. Rouselet 'postface', in Lapassade *Le Rap*, p.121; H. Rouslet-Blanc (1994) *Les Fans: Les Dieux de nos Nouvelles Mythologies*, Paris: Editions JC Lattes.
51 Lapassade *Le Rap*, p.11.
52 Bazin *La Culture Hip-Hop*, p.10.
53 Personal interview, 9 August 1996.
54 Personal interview, 9 August 1996.
55 Lapassade *Le Rap*; Bazin *La Culture Hip-Hop*; and O. Cachin (1996) *L'Offensive Rap*, Paris: Decouvertes Gallimard, are all informed by this debt.
56 Cross *It's Not About a Salary*; T. Rose (1995) *Black Noise*, Hanover, New England: Wesleyan Press.
57 Cross *It's Not About a Salary*, pp.319–31.
58 Cross *It's Not About a Salary*, p.8.
59 *Libération* 17 November 1996.
60 Lapassade 1996:52–65.
61 Bazin *La Culture Hip-Hop*, p.273; Lapassade *Le Rap*, p.13.
62 Anon. (1992) 'Let's move, let's tag! ou la rage du spray', Geneva: Les Editions Institut d'Etudes Sociales, p.107.
63 T. Mitchell (1996), 'Italian posses and their social contexts', in *Popular Music and Local Identity*, Leicester: Leicester University Press, pp.144–68. Thanks to Russell White for the reference.
64 *Repères* (Strasbourg listings magazine)17 December 1996.
65 P. Thoday (1995) appendix to *Le Franglais*, London: Athlone.
66 *Le Nouvel Observateur* 13–19 March 1997.
67 Akhenaton *Parcours Nouvelle Scene Française* .
68 Bazin *La Culture Hip-Hop*, p.214.
69 P. Pierre-Adolphe *et al.* (1995) 'Le dico de la banlieue', Boulogne: La Sirène, pp.5–15.
70 Lapassade *Le Rap*, p.15.
71 Pierre-Adolphe *et al.* 1995, pp.3–4.
72 Bazin *La Culture Hip-Hop*, p.222.
73 Pierre-Adolphe 'Le dico de la banlieue', p.3.
74 *Le Nouvel Observateur* March 1997, pp.3–19.
75 Personal interview, 9 August 1996.

9

THINKING ABOUT MUTATION

Genres in 1990s electronica

Alexei Monroe

Every new order presupposes the existence of disorder and is already affected with an inherent virus of future disorder.

Laibach[1]

Late in 1990 the Belgian group Front 242, which epitomised the late 1980s 'EBM' (electronic body music) genre, released a new single, 'Tragedy for You'. One of the remixes was entitled 'Punish Your Machine', and this title and the new sound it sought to represent can now be seen as the onset of a hidden, warped trajectory in the development of 1990s electronica that disappeared only to resurface around 1994 as a new subgenre, discussed here as an example of genre mutation within electronic music. The single marked a change of direction in the development of 242, a group who throughout the 1980s came to embody a sleek, aggressive and streamlined electronic music that in its paramilitarised stridency mirrored the tone of some of the more bellicose Italian futurists.[2] By the standards of contemporary electronica there is nothing particularly punishing about the remix, which is still based on melodic hooks and a 1980s techno-pop sensibility. However, it also contains something other: while the sound remains linear and precise it is unexpectedly muddy, bass lines especially become dense slabs of sound with blunt edges that crumple into distortion even at low volume. Similarly the will-to-power mantras of previous 242 lyrics typical of tracks such as 'Headhunter' and 'Never Stop!' were disrupted and qualified. The shocked victim of the song's clichéd predatory female reporting, 'I clearly remain, a blank, a void' and speaking of disembowelling and disorientation; the 242 commando-archetype had met his match and been humbled. The rage was as fierce as ever but was now that of the abused victim and not the frenzied übermensch suggested by the earlier work. The album that followed at the start of 1991, 'Tyranny For You' developed this sufficiently to surprise and disillusion many of the band's fans. Tracks were slower, less dramatic and far more cluttered with 'grungey' sound debris than previously and subtle signs of the 'contamination' of their sound by guitar were

creeping in; their quasi-fascistic 'jackboot beats' were rarely allowed to emerge from the mix for long and the feeling was now more paranoiac than euphoric even on the fastest, most heavily sequenced tracks. Fear had crept in, replacing the previous Nietzschean volition with a more leaden gloom.[3] However, 242 had not become more primitive but moved from a martial-clinical futurist sensibility to a less clear-cut, more cacophonous, futurism in line with their Canadian contemporaries Skinny Puppy, acknowledging the sound experiments of Russolo and Pratella rather than their previously unqualified Marinettist faith in 'speed, electricity, violence and war'.[4] The 'punish your machine' motif and the subsequent metamorphosis of this and other groups into purveyors of 'industrial rock' at the start of the 1990s is significant not just as an example of how musicians often feel compelled to abandon the generic archetypes they help establish but also because they prefigure a similar process of genre deformation and reformation (or in Deleuzeist terms, 'deterritorialisation') that has from the outset helped constitute 1990s electronica.[5] Yet as both the Laibach quotation at the head of this chapter and Adorno's discussion of form in classical music emphasise, deviation from a paradigm is always already preinscribed within its own constitution. In discussing the construction of the elaborate rules governing the fugue (and it should not be imagined that the formal stylistic conventions governing electronic subgenres are any more flexible) Adorno stresses that 'The tendential loosening of the fugal schema, and even the eventual liberation from it, is therefore inscribed in advance within it.'[6] Such an inherent deviationalism is perhaps truer of electronic music than any other form due to the sheer velocity of technologico-creative development, even when, as in the case of some subgenres, this appears as a regressional dynamic. However, economic and non-musical forces also frequently play decisive roles in the fate of genres and these must also be dealt with.

Outside of the industrial ghettos of late 1980s electronic music, a wider shift of musical paradigms was taking place. Late 1980s alternative consensuses centred on self-righteous 'indie' attitudes or avant-gardist 'sonic architecture' were about to be superseded by a new and far more saleable sensibility: grunge. After the self-conscious puritanism of what it replaced, grunge acted as a Trojan Horse for melody. It still paid lip service to alternative dogmas in its lo-fi muddy productions and slacker tempos but actually served as a means of smuggling melody and conventional, if not antediluvian, song structures back into credibility. In this way grunge can be retroconstructed as the culpable 'vanishing mediator'[7] of the unapologetic melodic conventionalism of Britpop. Yet 'vanishing mediators' are not simply obscured historical agencies, they often return in a new guise after their suppression; the (musical) *Zeitgeist* will always claim its revenge. Grunge revalidated the role of the listener both by requiring less of her and by focussing upon mundane emotional concerns rather than more dramatic social or other themes. Yet, even as grunge became the hegemonic rock sound of the early 1990s and many 1980s electronic and industrial bands such as 242, Depeche Mode and Nitzer Ebb 'grunged out' to often

catastrophic effect, the torch of pure electronic innovation passed on to the emergent techno scene. In its most streamlined and glossy forms the type of Germanic 'über-trance' epitomised by Frankfurt's Harthouse Records and others became a dominant pan-European sound in competition with the almost exclusively Anglo-American grunge. Yet the history of all musical trends, at least since punk, reveals that even as they reach their most developed forms they are laying the ground for their own supersession.

Harder, faster, darker...

Any examination of the problematics of genre reveals that even the ownership and lineage of genre names are inevitably contested. To a rock listener 'techno' as a general term can often mean any electronic dance music from happy hardcore to nosebleed to ambient, although it is generally associated with the faster, harder styles by non-specialists. Therefore, some minimal definition and a brief account of the constitution of techno as a meta-genre is necessary in order to track its subsequent fragmentation. Techno originated in association with the futuristic Detroit response of the late 1980s to European EBM and techno-pop. Yet, by 1992 it had re-emerged as a supposedly new European sound distinct from its dance contemporaries, acid house and hardcore. Originally a default category embracing all the 'harder' yet still serious, purely instrumental electronic music it was always little more than an over-category, containing from the start numerous tendencies that within a couple of years would all be sufficiently well-delineated to emerge as categories-in-themselves. As early as 1993 techno was having to be prefixed as, for instance, 'intelligent', 'hardcore' or 'Euro' if only to reflect the differing marketing strategies necessary to service an exponentially diversifying market. By 1994 'techno' was already becoming an increasingly contentless term, but even between 1992–4 it always meant different things in different places.

What was originally known as techno in Britain followed a different dynamic and developed different subgenres to those emerging in the main continental centres, Germany and the Low Countries.[8] In Germany, for instance, the streamlined, linear trends in dancefloor techno crystallised into so-called 'über-trance', a variant particularly associated with the Frankfurt scene, which emphasised force and duration yet did not exclude extremely slick production and a surprising amount of melody, whilst the form of British trance, particularly in its 'Goan' variants adopted the (slightly) softer imagery and sounds of a supposedly chakra-based spirituality. In Rotterdam and then the rest of Holland, meanwhile, the most aggressive types of techno and hardcore mutated into the extremely White, funkless 'gabber' (still the fastest and most unapologetically brutal techno variant) while in Britain hardcore was either incorporated into the predominantly 'Black'-oriented sound of jungle or rejected its parent subgenre's harshness and mutated into 'ardkore/happy hardcore.[9]

It was some time around late 1993/early 1994 that the techno monolith

disintegrated as the tensions within it exploded. This was not just a question of regional specialisation but of wholesale departure from the basic (tonal) paradigms of techno and crystallisation into new stylistic constituencies. Similarly, the emergence of the more distant but to some more dynamic forms of jungle led many potential and previous techno artists to 'jump ship' either as a career move or creative development. Since then the 'techno scene', in as much as such an entity still exists, has refragmented every time one of its branches becomes either too dominant or so convention-bound as to inhibit further creative development. (Neo)-industrial techno, for instance, is an expression of the perceived need for more avant-garde forms to disrupt or at least slow the reification of techno-as-such. Since intelligent, trance and dance-floor techno were all attempting to monopolise marketing images of 'nowness', the only way forward for non-aligned, more experimentally oriented producers was through a retroactive assimilation of industrial values in a flight from sterile digital clinicism to the unexploited fertility of sonic dirt and disorder. Unlike the other subgenres that emerged from techno's implosion this neo-analoguism reconnected techno to the grunge side of the 1990s. Preschismatic techno[10] carried within its bowels a *Zeitgeist* infection: 'grunge', which broke out in the form of the raw, unpolished and muddy sounds of these industrialist artists. The perfection of ultra-bland digitalised techno actually facilitated the reirruption of noise and chaos within the body of electronica by provoking the dynamic of contra-distinctive reaction that produced industrial techno and further subgenres.

Just as corporate, ultra-sleek, anthemic (though still frequently innovative) techno achieved its pan-continental dominance, this new manifestation of 'grunge', perhaps the most recurrent motif of the 1990s, began to resurface at the extremities of what the German 'digital hardcore' maverick Alec Empire and other so-called techno insurrectionaries see as a Germanocentric 'techno Reich' in the form of an alienated, self-consciously introspective and experimental version of techno that often used primitive equipment. This form was the most visible evidence of techno's disintegration into numerous new forms and sects. From Finland came the Sahko Collective, from Antwerp their collaborators Starfish Pool and from Frankfurt, the heart of the corporate techno Reich of commercialised mega-raves and the perpetual deradicalisation of the techno archetype, came the Mille Plateaux/Force Inc. series of artists, complete with a robust Deleuzeist theoretical framework. The un- or even anti-clinical tones of such work and the abrasiveness of its sonic textures can be seen to demonstrate the influence of wider cultural atmospheres (grunge) even on genre developments in apparently unrelated fields.

Due to its very nature, it is only within electronic music that these fragmentary processes are seen at their most explicit. Any music where electronics are the central or predominant form of instrumentation is a mode of expression explicitly constituted by technological factors, even when, as in the case of some of the artists discussed here, the equipment used is deliberately antique or

corrupted. As such the simultaneous potentialities of both establishing and disintegrating new genres are infinitely greater than in other forms. For rock to remain rock it can change 'attitude' freely (though even this is still ultimately limited by instrumentation capacities) but *cannot* even have the choice of a full range of tempos let alone of instrumentation; keyboards and even purely electronic remixes are no longer forbidden but if electronics become the predominant instrumentation a music is no longer (allowed to be) seen as 'rock'.[11] Electronica (understood here as all popular/non-academic electronic music) and, until the mid-1990s, techno, are far more pragmatic definitions than rock/indie, being openly (rather than covertly) based on the inescapable facts of instrumentation. Rock and, to an extent, indie both present themselves as being, above all, an expression of certain 'attitudes' or sensibilities when they are in fact far more rigidly constricted by their orthodoxy of instrumentation (and the physical performance limits this entails) than electronic musics, or the family of subgenres within the overall category of electronic music. The choice of instrumentation does imply a certain attitude but beyond that the scope for new forms of both orthodoxy and heresy is infinitely greater; any tempo from one to thousands of beats per minute is permissible, and within that licence there are an infinite number of possibilities that when they reach a critical mass or appear frequently enough, crystallise into a new subgenre. It is not simply for linguistic convenience that rock's subgenres still retain their 'rock' tag;[12] even a group as experimental as Tortoise cannot escape being labelled ('post')-rock. The history of 1990s electronica suggests that the greater the technological possibilities the greater the number of potential subgenres. Neo-industrialist types of techno constitute themselves in opposition to what they see as the conformism of simply following and not seeking to disrupt the new technological paradigms but are still, in effect, structured by them. The later-1990s trends towards post-rock/electronica, drum 'n' bass/easy listening collaborations are examples of newer outward, inter-genre forms, but since the early 1990s the developmental (sometimes regressional) dynamic within electronica has been implosive rather than explosive. In fact fragmentation has been integral since the dance music explosion of 1988 but after four or five years of (relative) stability, the rate of increase not just of technological development and tempos but of the proliferation and self-cancellation of electronic genres became ever more rapid.

Given the vertiginous pace of change, it has for some time not been possible to speak with authority, with an inclusive knowledge, as the number of subgenres has all but erased the functionality of these terms save for outside commentators trying to corral a multiplicity of related styles into more assimilable categories. The subgenres and consequently the *counter*-subgenres are driven by a contra-distinctive dynamic. At this point an attempt to engage in some sort of 'pop teleology'[13] and to try to represent the lineage of the various genres visually (much as the changing line-up of groups is encoded into an option Deleuze and Guattari would surely categorise as an instance of 'arbori-

fied' logic: rock 'family trees') seems necessary.[14] The inappropriateness of this rigidly linear option is due to its ideologically loaded 'rockist' connotations and because it can only viably show one set of mutatory stages of a single subgenre; to depict the initial emergence of the subgenres from the over-genre (which always already contained them as potentialities) would require far more complex multidirectional representation and therefore only a rough visual analogue is possible.

Attempting to represent the mutational dynamic of just one subgenre does provide some clues as to how a (temporary) visual assemblage might represent the same dynamic across the field of all the subgenres (see Table 9.1). If we take the movement from the original 'gabber' subgenre to its own diluted sub-subgenre 'happy gabber' on to the third-level genre that reacts to that and seeks to return to the spirit of the original, a narrowing, arrow-head image presents itself. In order to establish its identity each of the successive sub-subgenres has to close off more and more stylistic possibilities and thus to over-emphasise the diminishing number still available to it. Negation sparks counter-negation until a furthest 'downward' point is reached and the only alternative to an endless recurrence of the same is to return back along the path to the starting point of the original subgenre (level 1) via a negation of the second level. However, in framing this return as some sort of return to the 'true' spirit of the original – as a focus of an always already 'lost' authenticity – *some* of the original characteristics are overemphasised. In a sub-subgenre like 'techstep' (ultra-dark techno-influenced jungle as a reaction to 'drum 'n' bass' dilutions of 'original' jungle) there is a kind of 'compulsive overidentification'[15] or over-conformity in relation to those aspects of the original paradigm it reprivileges.

Even ultra-fetishistic returns such as 'old school' elektro re-enactments (or retro-constructions) by 'contemporary' artists retroactively restructure (the perception of) the original genre as much as the most cynical dilutions (level 2

Table 9.1 Mutational subgenre dynamics

Genre level	Genre	Characteristics
Parent sub- or over-genre(s)	Hardcore/techno	
Subgenre (first stage)	Gabber	'Harder, darker, faster' intensification of hardcore and techno
Sub-subgenre (second stage)	Happy gabber	Retention of gabber tempos coupled with rejection of harshness in favour of re-emphasising melody and hedonism
Counter-sub-genre (third stage)	Speedcore	Over-compensatory re-emphasis on speed and darkness of gabber as constitutive negation of second-stage dilution

of the gabber dynamic). No genre or subgenre is safe from reconstruction or even usurpation by its bastard and other offspring, and the ultra-accelerated pace of these mutations within electronica means that the period in which a genre is simply itself (before any of the potential subgenres it bears within it emerge) diminishes ever more rapidly. This even comes to affect historical assessments of genre formation to the extent that the period in which techno was still (seen to be) techno-in-itself (when it still held together in some sort of fissile pre-schismatic unity), becomes ever shorter in retrospect.

Given the extent of recycling, cannibalisation and sampling involved in the production of new subgenres as well as the increasing use and abuse of pre-digital equipment it seems apparent that in addition to these narrowing and delineating subgenre dynamics there is also an active two-way temporal (though not unproblematically linear) flow facilitating genre proliferation. These processes have crystallised within one of the most active but unconceptualised sectors of 'techno'. Based upon its most prominent characteristics and in order to impose not order but at least a pause within which some sort of assessment can take place, I designate this industrial or neo-industrialist techno (although 'asceticist' or 'analoguist' would be equally apt labels for most of the artists included). This subgenre[16] is currently the most (retro)actively historical of all electronic subgenres due to its built-in historicism. Panasonic and Starfish Pool in particular derive their sounds largely or exclusively from the manipulation and combination of old analogue equipment and combine this with a privileging of the type of sonic abrasiveness and disruption rarely heard in electronic music since the original industrial music of the late 1970s and early 1980s. It is within such work that the early 1990s grunge ethic re-emerged as an unexpected rematerialisation of the 242 'punish your machine' motif of 1990. Therefore, rather than representing a repressed return to the genre that it emerged from as in the case of the gabber and jungle subgenres, industrial techno actually moves back to a previous genre via a hidden lineage. As it moves 'back' (in as much as it is possible to return to a point you did not (knowingly) depart from), the dynamic of this subgenre inverts and obliterates the traces of its origins.[17] For someone unaware of the actual (chronological) course of the development of electronic music it can easily (be made to) seem as if the process had run in reverse. As if from the previous industrialism a straight (but obscured) line of forward development ran from that period to the present resurfacing of industrialism and not, as it 'actually' does, backward from 1990s electronica to the 'new' start point of the 'original' industrial music. Industrialist techno has then emerged out of contemporary techno/electronica and is (at least chronologically) a subgenre of the same but has done so in such a way as to draw into question its own 'parentage' and profoundly subvert (whilst at the same time crystallising) the teleology of its own generic development.

152

Culture on speed

Inevitably, this analysis has been (allowed to be) heavily structured by the narrowing and retroactive dynamics discussed. This is mimetically illustrative but obviously if left at this stage the analysis would be open to the charge that it simply recapitulates the ever more esoteric types of closure that create (and annihilate) such subgenres. The remedy for this is not retraction but firstly an assimilation of this narrowing dynamic as a widening illustrative device that can cast light far beyond the individual subgenres. Having established and to an extent over-emphasised the existence of this dynamic it is then relatively straightforward to detect the presence of the same dynamics at the macro-level of cultural production (albeit in much more diffuse and less visible forms). This specialising or 'niche-ing' dynamic can be seen as an expression of the same forces that produce the audience and genre specialisation characteristic of structurally fragmented post-modern cultural markets. The same imperative to create, maintain and dissolve (often in the same moment) specialised niche markets along with their own mass-productional infrastructure is as much at work in electronica as in the most consciously pre-programmed, market-researched, 'mainstream' cultural products – although at far greater intensity in the latter.

Thus, the fate of electronic genres is determined by the interface of extremely rapid technologico-creative development (making it a sector of the cultural market that mutates too rapidly to be entirely 'colonisable') and the need of post-modern cultural production to ceaselessly invent and reinvent new niche markets to service. As fast as the mass market can assimilate and commodify 'underground' subgenres, these mutate and negate each other ensuring the brief creation of *pre*-commodified zones, constantly one step ahead of the pursuit.[18]

The inherent discipline used to ensure and enforce the over-production of such is what Ulrike Meinhof conceptualised as '*Konsumteror*' and Greil Marcus recodes as 'consumer-fan panic'.[19] The speed of technological development and the exponential search for new sounds cannot entirely explain the proliferation of electronic subgenres and the rapid production of commodified versions of them cannot be explained as mere aberrations. Metaphors of terror are particularly useful in explaining both the speed and the ferocity of the witch-hunting schismaticism that plays at least as large a part in constituting subgenres as do creative and technological innovation. It is by now apparent that the contra-distinctive dynamic of genre formation often has quasi-religious overtones; second-level counter-sub-subgenres emerge as a reformist, modernising project only to be denounced by the 'born again' advocates behind the subsequent third-level counter-subgenre(s). The tribal antipathies between say happy hard-core and speedcore fans and producers are the expression of an almost Stalinist dynamic of denunciation, banishment and contrition that is in turn animated and intensified by the ferocity of *Konsumteror* as cultural agency. Both

153

specialised and general presses (and even academic efforts such as this) simultaneously generate and are driven by the fear implicit within *Konsumteror*, that of failing to keep up with the times. Inserting Althusser into the context of a radically specialised and (apparently) deregulated culture industry, the immanent existence of a *de facto* repressive *market* apparatus or mechanism can be discerned and ascribed the role of the immanent source of *Konsumteror*.[20]

Whilst far less centralised and explicit, *Konsumteror* shares with classical Stalinist terror an almost self-negating momentum and a marked demonising dynamic. The inherent schismaticism of any creative community is accentuated and accelerated by the terrorising demands of the market for new niche markets. The more bitter and fragmented the internecine splits, the more clearly delineated and marketable are the resulting subgenres and the market ultimately profits from such chaos. Intriguingly, atomisation (of the consumer and creative communities) and overwhelming velocity are the common dynamics between even the most commodified gabber and other high-velocity electronic musics and *Konsumteror*. This is shown in Figure 9.1. It becomes possible to view the sonic celebration of terrifying velocity as a creative recapitulation and implicit critique of *Konsumteror*. The maximalism of gabber's 'more is more' ethos and the velocity of unrestrained consumerism are closely related. The rawness of pre-commodified gabber and industrial techno and their emphasis at least upon sonic terror (which is transcoded by its listeners into a token of authenticity and value)[21] can moreover be seen as an only rarely conceptualised attempt to 'fight terror with terror'. Specialisation is then both symptom of, and an attempt to resist, the terror of commodification.

1 Konsumteror (source: 'repressive market apparatus')

2 niche-ing dynamic (= atomization)

3 (technological development: over-genre: creative response)

4 sub-genre

5 sub-subgenre

6 counter-(sub)-subgenre

Figure 9.1 Konsumteror dynamics

At its least literal the concept of *Konsumteror* can be seen simply as a deliberate intensification of the ceaseless need to produce and consume new experience; in electronic music it has found both an extremely effective vehicle and a subverter. Whilst the price in over-production may be extremely high,[22] the sheer velocity of electronic music (both literally and figuratively) both frus-

trates and appropriates *Konsumteror* (as productive aesthetic force) in order to produce a higher proportion of scarcely commercialisable 'temporary autonomous zones' and cutting-edge experimental product than any other sphere of cultural production.[23] The speed of such processes and the tempos of some of the musics they produce no longer denote the speed and terror of classical industrial production as the original industrial music did, but the terrifying pace and proliferating dysfunctionalities of post-industrial consumption itself.

Notes

1 Quoted in the 1995 film *Predictions of Fire* (dir. Michael Benson, Kinetikon Pictures). The culturo-ideological diagnostics of the Slovene group Laibach can be applied as easily to the condition of popular culture as they can to that of totalitarian and market regimes.

2 In Germany and the Low Countries a reasonably sized scene based on this genre survives, with its own promotion, distribution and media networks. However, all of the most famous bands originally identified with the genre during its heyday (roughly 1986–8) such as Nitzer Ebb, Skinny Puppy, Cassandra Complex and others had discarded the EBM (sonic) template by the early 1990s and often returned to earlier paradigms of guitar-tinged or proto-industrial sounds. In a curious defiance of the *Zeitgeist*, a deeply retro EBM scene is serviced by a continual supply of new bands, often fetishistically faithful to the formulas of their heroes of the late 1980s. For contemporary examples of this see the compilation CD *Soundline Vol. 3* published in 1996 with the genre's main journal, *Soundline* magazine, which includes only one of the original bands (GRUMH) and several immaculate counterfeits of the earlier bands' work.

3 Released just as the Gulf War began and racism and recession returned to Europe, the album surprised (and perhaps relieved) many in that it not only did not intensify but discarded the group's quasi-fetishistic glamorisation of military equipment seen on 1980s tracks like 'Commando Mix', 'Special Forces' and 'Circling Overland' as well as their militia-like uniforms.

4 For an account of Italian and other musical futurisms see D. Toop (1995) *Ocean of Sound*, London: Serpent's Tail, pp.73–8.

5 Of all the terms devised for contemporary non-academic electronic music (the sense intended here), 'electronica' is one of the most loaded and controversial. While on the one hand it does seem the most convenient catch-all phrase, under any sort of scrutiny it begins to implode. In its original 1992–3 sense it was largely coterminous with the more explicitly elitist 'intelligent techno', a term used to establish distance from and imply distaste for, all other more dancefloor-oriented types of techno, ignoring the fact that many of its practitioners such as Richard James (Aphex Twin) were as adept at brutal dancefloor tracks as what its detractors present as self-indulgent ambient 'noodling'. In this context 'electronica' is used pragmatically as an interim term for all modes of contemporary electronic music and in effect includes forms such as gabber that some refuse to acknowledge can ever be understood as sufficiently 'serious' to deserve the term electronica. This is done for clarity's sake and also to demonstrate the problems worked through here and the fact that even the most obviously 'degenerate'/commercialised forms remain organisationally, a part of the genus 'electronica'.

6 Quoted, F. Jameson (1990) *Late Marxism: Adorno or the Persistence of the Dialectic*, London: Verso, p.194.

7 For an elucidation of the concept see S. Zizek (1994) 'East European liberalism and its discontents', in *New Human Critique*.

8 In fact, the diversity of developmental dynamics can easily be traced to much more specialised regional differences. The largely London-oriented trance scene and Scotland's status as Britain's hardcore heartland indicate regional bias in both the production, consumption and to an extent the distribution of the various subgenres. The antipathy between Rotterdam and the far more house-oriented Amsterdam can be seen in the same light.

9 Just as jungle diffused itself into the much lighter 'drum 'n' bass', gabber also spawned 'lo-calorie', 'happy' gabber and these less brutal forms are probably now more popular than the subgenres they originally emerged from. However, the implosive/narrowing dynamic is unstoppable and these are being usurped in their turn by 'new' sub-variants re-emphasising the harsher qualities of the original styles in the form of 'darkside/hardstep' jungle and 'speedcore' Gabber. The leading speedcore unit 'Nordcore GMBH' whose name seems to imply a belief in the existence of a *further* subgenre dramatised this schismaticism in their 1995 track, 'No more Happy Hartcore' ('hart' being the German for 'hard'). Thus the dynamic of division and re-division continues and moves inward even to the most microscopic of levels where genres are scarcely large enough to be autonomous and are themselves prone to be usurped at any moment.

10 This refers to the period before the various tendencies within (the European forms of) techno crystallised into distinct and even fratricidal subgenres.

11 The evolution (to some the degeneration) of jungle into 'drum 'n' bass' is not simply a type of linguistic cleansing that symbolises the depriviledging of electronic effects but an example of the almost terminal elasticity of what is still classed as either/or electronica or dance music. Its continued presence within these 'over-genres' is increasingly only an expression of its genetic descent and not its attitude or primary instrumentation. At its least electronic limits, jazz- or soul-oriented drum 'n' bass simply uses the generic (and extremely diluted) beat patterns of jungle to provide a veneer of topicality for much older and un- or even anti-innovative forms. Yet, simply by virtue of a sequenced rhythmic framework the new subtype continues to shelter under the cover of a paradigm it has almost completely discarded in practice. Within this exchange the older conventional sounds have unexpectedly (if not undeservedly) been handed a parasitic victory over their collaborators. A far healthier and less supine interaction between the forms of the 1990s and the (late) 1970s can be seen in contemporary examples of industrialist techno. 'Drum 'n' bass' can still be represented as a form of dance music but not in the generally accepted conventional sense of the term that implies a minimum tempo and only a limited use of traditional instrumentation. Rather it remains *technically* a dance music in the sense that swing, ragtime and other jazz, and even earlier forms were, and is thus relinquishing any of the claims to dynamicity still possibly inherent in the contemporary sense of 'dance music'.

12 Of course, even in print there are more un-suffixed references simply to 'indie' or to 'grunge' but some subgenres – 'progressive', 'post-', etc. – cannot be identified without their 'rock' tag whereas by far the majority of electronic/techno subgenres have autonomous identities: 'hardcore', 'acid', 'ambient', 'gabber', etc. and have no need of the support of a '...techno' suffix to maintain their identity.

13 The term is used by S. Frith and A. Goodwin (1990) in the preface to their *On Record. Rock, Pop and the Written Word* anthology, London: Routledge.

14 For a summary of their concepts of arborified and rhizomatic logics see the introduction to G. Deleuze and F. Guattari (1980) *A Thousand Plateaux*, London: Athlone Press. The work of Deleuze and Guattari is currently '*en vogue*' not just academically

but is also playing a vital role both in the production and analytical examination of contemporary electronica. This is exemplified by Frankfurt's 'Mille Plateaux' group of labels whose owner Achim Sczepanski and several of the artists, particularly Oval, are very heavily influenced by Deleuze and Guattari's thought. After the suicide of Deleuze at the end of 1995 the label released a compilation entitled *In Memoriam Gilles Deleuze* together with an essay on the interface between his work and that of the featured artists. Across a series of labels (Mille Plateaux, Force Inc., Position Chrome) and styles, ranging from abrasive breakbeat to neo-industrial noise to dark ambient to warped house, a sufficiently focused identity has been established such that 'Mille Plateaux style' has become a recognisable stylistic indicator for those familiar with its work. Perhaps most relevantly, the labels have helped reinforce the complementariness of every type of contemporary electronica from hyper-theoretical (Oval) to ultra-raw underground (Techno Animal *et al.*) with contemporary theory.

15 The term is used by Slavoj Zizek in his discussion of the group Laibach's interaction with totalitarianism. See Zizek (1993) 'Why are Laibach and NSK not fascists?', in *M'ARS* (Magazine of the Modern Gallery Ljubljana) 3(4), p.3.

16 In any field of cultural production the ethical and conceptual difficulties associated with the denotation or branding of new genres and styles are fairly unresolvable and it can certainly be an alien(ating) and impositional process, and artists included within any such category may well be unaware of the category and even dispute its existence or their inclusion within it. All of these issues are heightened within electronica, above all by its rate of development. Yet much as it does to evade such, it also demands and necessitates some minimum analytical framework, although terms as traditional as genre may well be only stopgaps in the absence of an entirely new terminology specific to the form.

17 For clarity's sake I choose to treat these artists as part of the wider techno scene and not as contemporary producers of industrial music, which is why the phrase *neo*-industrialist is sometimes used to emphasise that this remains techno, however remote it may sometimes sound from the accepted senses of the term. It should also be remembered that the dominant contemporary form of industrial music remains the 'industrial rock' exemplified by Die Krupps, Ministry, Nine Inch Nails and others with far less in common with the original industrial paradigm than the practitioners of industrial techno. The majority of them – Starfish Pool, Autechre, Aphex Twin – 'cut their teeth' within the techno context and operate within the infrastructural context of that scene, although to an extent we can only classify the most experimental non-dance-oriented types of industrial techno as even a subgenre of techno due to the fact that it is being produced now and not in the industrial 'golden age'.

18 Of course, at least within a fully post-modern market the 'pursuit' is a necessary illusion as well as evidence of the creative struggle against commodification. The 'culture industries' depend on both the appearance and substance of resistance and innovation in order to be able to sell what they eventually commodify under the banner of contemporaneity. Both pursuers and pursued are driven by the same velocities: of innovation, technological development, the imperative for instant short-term profits and the fear of missing out on the latest thing. Pursuit is therefore integral to both assimilation and resistance. The most compromising situation for the culture industries to reach would be one where they were able to fully succeed in their commodifying pursuit of creativity, as the extent of the cultural reification the industry constantly (re)produces and strives to transcend would become fatally apparent.

19 G. Marcus (1990) 'Corrupting the absolute', in Frith and Goodwin *On Record*, p.476.

20 This is an appropriation of Louis Althusser's schema of the ideological and repressive State apparatuses that were theorised in an attempt to explain the structures of State power. Within the contemporary context the increasingly deregulated market appears as the obvious locus of post-modern power, yet without the rigid division between repression and ideological production of Althusser's model. Obviously there is no (need for an) actual market-repressive apparatus as such, rather the nature of culturo-ideological production depends on and generates *Konsumteror* as symbolic repressive agency in itself.

21 In the political ethos of his Digital Hardcore Recordings and in his own work Alec Empire makes explicit the potentially vivifying and (hopefully) counter-commodifying effects of brutal beats, distortion and volume. The work of the London-based Praxis label also serves to draw attention to the productive potential of aesthetic terror and the fact that 'serious' (pre-commodified) gabber can sometimes be far more progressive than the dismissive 'techno for skinheads' image suggests.

22 The sheer volume of electronic music releases is overwhelming and it is impossible even for professionals to keep up with the full range of activity even within one or two subgenres and as ever quality and quantity have a strained relationship.

23 A more optimistic view of the fragmentation of techno appears in an article in the German music magazine *Spex*. The article, 'Wertgemeinschaft Techno' (the techno community of values), by Tobias Thomas looks back over developments within 'techno' in 1996 and concludes that the 'techno-underground' has only been strengthened by differentiation and segmentation. He goes further and ventures that in 1996 it became possible once again to speak of techno as such despite the 'total confusion' of recent times: 'So techno in 96 was finally a tangible definition again, it even became an independent genre once more, instead of ending up as the title for a stillborn youth culture.' What Thomas seems to imply is that the high point of fragmentation has passed and that the subgenres are sufficiently well-delineated as to once again (re)create a default category of 'techno' in itself. If his diagnosis is correct, 'underground' techno, (a term he never develops) will actually have emerged stronger, but as yet this remains to be seen. See *Spex* January 1997, p.49.

Selected audiography

Front 242 (1990) *Tragedy for You (Punish your Machine Mix)*, Play it Again Sam Records RRE CD10.

Front 242 (1991) *Tyranny for You*, Play it Again Sam Records RRE CD11.

Soundline Vol. 3 (1996), Side-line Records LC 8904.

Harthouse Records (1993) *The Point of no Return Chapter 1* ('über-trance' compilation), Eye Q Records LC 6450.

Alec Empire (1994) *Generation Star Wars*, Mille Plateaux CD 11.

Starfish Pool *Interference 96*, Nova Zembla CD 056 MCD.

Nordcore GMBH (1995) 'No More Happy Hartcore', from the compilation *Terror-drome VI Welcome to Planet Hardcore*, Edel Records 0041662CON.

In Memoriam Gilles Deleuze (Mille Plateaux tribute compilation), MPCD 22, 1996.

10

'IT'S LIKE FEMINISM, BUT YOU DON'T HAVE TO BURN YOUR BRA'

Girl power and the Spice Girls' breakthrough 1996–7

Jude Davies

> The answer to the question facing future pop historians became clear yesterday: If punk followed glam, and rave followed house, what pop phenomenon came after Britpop? The answer is the Spice Girls....With the Spice Girls' first single, Wannabe, set to go to number one in the US today, the group's role in boosting the UK music industry was revealed yesterday.[1]

> 'It is read closely. We are anxious to see which, if any, aspects of their "girl power" ideology could be used.' A Conservative Central Office researcher on its subscription to *Spice* – a magazine for Spice Girls fans.[2]

These two comments, appearing in the same British daily newspaper in February 1997, suggest two ways of thinking about pop music. The second comes from the women's page[3] in the culturally focused tabloid supplement of the *Guardian*. Here, pop is treated, albeit somewhat sardonically, as something with the potential to cohere a politics around a cultural form. The first is from the article 'Spice Girls help set a new record for Britain' in the Home News section of the broadsheet. The article uses bar charts and text to analyse the performance of the British music industry in 1996. Here, pop appears as a succession of entirely commodified products. Any subcultural connotations of the terms 'glam', 'punk', 'rave', 'house' and 'Britpop' are channelled into the procession of a series of pop phenomena. The pop historian's role seems to be a rather simple one, of tracing a sequence of trends, each of which displaces its predecessor. The article presumes an abyss between culture and economics; although culture is the realm where some identifications need to be made, these

159

definitions are then impermeable to the economic history of production and consumption. 'Culture' enters this discourse only in commodified form, even when popular music is constituted in terms of national identity, as in the title of the article itself and in references to the new 'swinging London' that proliferated in the British news media in the winter of 1996–7.

These two positions echo in untheorised language two strands of academic cultural studies. To oversimplify, on the one side are the varieties of cultural populism that pioneered the study of mass-disseminated popular culture via the crucial insight that acts of consumption are at the same time acts of cultural identification, appropriation, affiliation and the production of community. Seminal texts by critics such as Angela McRobbie, Dick Hebdige, Janice Radway, Ien Ang and John Fiske helped to justify the credentials of academic study of popular culture by showing the inventiveness of consumers in resignifying mass-disseminated commodities.[4] On the other side of the debate are those critics who like Jim McGuigan, Martyn J. Lee and Chris Jenks assert the primacy of economic structures and economic relations in determining the significance of acts of production and consumption.[5] It is no coincidence that some of the most lucid – and heated – debates over these issues have been generated over popular culture, magazines, books and music whose primary market is among young women. The case of the Spice Girls implies a greater permeability between culture as commodity and as signification than has often been theoretically allowed for. What makes the Spice Girls interesting in this context is the reciprocity they set up between the articulation of an explicit ideology, so-called 'girl power', and mass consumption. Their first release, 'Wannabe' was preceded by a full page ad in a July 1996 issue of teen bible *Smash Hits* proclaiming, 'Wanted – anyone with a sense of fun, freedom and adventure. Hold tight, get ready – girl power is comin' at you.'[6] The same slogan appeared on the packaging of the single. From their first appearance, girl power helped to sell Spice Girls product, while at the same time consumption of the group put girl power on the lips and in the minds of female youth.

This is not to deny of course the importance of ideology in the consumption of other pop commodities. The product of U2, Boyzone, Blur, Oasis, Robson and Jerome, *et al.* is not emblazoned with slogans, but it becomes meaningful only through ideology. In pop culture in general, especially at the young end of the market, ideological positions tend to be embodied rather than explicitly articulated, and if articulated they are never called ideologies. Nor am I arguing that the Spice Girls function in an entirely different way. The Spice Girls embody ideological positions also. Their refusal or failure to achieve the glamour expected of equivalent female performers (and embodied in subsequent girl groups such as All Saints) and absolutely necessary for comparable boy bands ensured a visual component to girl power. Images of their bodies, some of them tattooed and pierced, are usually offered up neither as conventionally glamorous nor as refusing conventions of female beauty and glamour, as have some female performers in the punk and heavy metal traditions such as

L7 and Courtney Love.[7] To my eyes, visually Spice Girls neither conform to nor negate conventional pop glamour but ignore it.[8]

The predominance of representation in Spice Girls material, including not just recording packaging, videos and the Spice Girls movie, but also magazine features and specials that are preponderantly composed of images of group members, signals the importance of images in their consumption, and will feature later in this discussion. It would be wrong though to underestimate the explicitly ideological elements of the Spice Girls phenomenon. In spite of the inconsistencies, the elusiveness and the playfulness with which, as will be seen, girl power has been articulated, it was and remains an integral part of the Spice Girls appeal. It has had to be, since the articulation of girl power played a crucial role in effecting a shift in prevailing relations between group and audience, without which the Spice Girls would never have attained commercial success.

The Spice Girls ideology is not a campaign tacked on to celebrity status, and neither is it a set of pre-existing convictions articulated in songs and music (as Rock Against Racism and Red Wedge were). Instead, girl power is an integral part of the consumption of the group, called into being by the nature of their prime audience, 12–17-year-old girls. Spice Girls are popularly understood to be the immediate successors to boy bands such as Take That, East 17 and Boyzone, who had dominated this market in the mid-1990s. Because their relation to their target audience was predicated on the dominant socio-cultural construction of heterosexually channelled desire, such groups had presented themselves simply as objects for desire. In order to secure the commodified purity of this economy, explicit ideology must be excluded. Members of such bands can have identities, because this helps differentiate one from another and adds to the appeal of the product by pluralising its attributes. But to maximise their availability within the circulation of commodities, members of such bands must simply be; they must not have opinions. The effects of these pressures are apparent in the historically brief life-span of these groups. Take That survived longer than most, but coincidentally even they split up within months of the appearance of the Spice Girls. In January 1997 after Brian Harvey of East 17 made some flippant and ill-advised comments on ecstasy use, the group's records were immediately and widely banned from the airwaves. Within days the band had sacked him. The offence of bringing the group into disrepute was exacerbated by their status in the commodity economy. Harvey's punishment was as much for stepping into a zone of ideological contest as for speaking out of turn, as much for having an opinion at all as for having the wrong one.

For their prime target audience, instead of being consumed as objects of desire, the Spice Girls were to be consumed in terms of identification, emulation and female collectivity. The means by which this shift in the relations of consumption was achieved is the explicit use of girl power ideology. What I want to do here is not so much to define the explicit or implicit ideological significance of the Spice Girls, but rather to examine and reflect on the relays

between the feminist and quasi-feminist components of the Spice Girls and of girl power, and the mechanisms of consumption. What follows therefore is a discussion of the following key issues in Spice Girls material: the relationship between heterosexual romance structures and constructions of female collectivity, the modes by which emulation of group members is structured, and the flexibility and elusiveness of girl power.

A central question for girl power is the relationship between a heterosexual economy in which young girls are interpolated as romantic and sexual consumers (the economy of the boy bands whose audience the Spice Girls targeted), and some kind of female collectivity or sisterhood. The lyric of the Spice Girls' first single, the upbeat 'Wannabe', pivots between heterosexual romance and same-sex friendship. The song has an obvious message that is summed up in a few of its lines, addressed to an unspecified potential lover gendered male (only) by the conventions of the discourse, and which imply that becoming the addresser's lover will depend on achieving first the more stable relationship of friendship. The lyric's gender politics, however, are complex. Quite explicitly the song privileges (implicitly female) friendship over (presumably heterosexual) romance. Yet, in addressing an implicitly male potential lover, it also prioritises the romance relationship, and may even be read as invoking the constancy of female friendship not to recognise its importance for itself but simply for use as a model for heterosexual relationships. These ambiguities are no doubt structurally determined to maximise appeal – boys can hear it as a love song, girls can consume it as a love song and/or a song about friendship. Yet, even in broaching the connection, the song goes further than the exclusively heterosexual economy of conventional girl group songs.[9]

Ambiguity in pop lyrics is more the norm than its opposite, but what was unusual about 'Wannabe' was that its ambiguities courted comment. In particular, it introduced an expression whose meaning was widely debated in school playgrounds and mass media.[10] The song opens with the now famous exchange in which the girls address the question of what they really really want, before 'I wanna (huh)' repeats four times towards the climactic 'zig-a-zig-ahh'.

Whatever the exact referent of 'zig-a-zig-ahh' (which does not even have a standardised spelling on the official lyric sheet), it is clear that its primary denotation lies in the field of female desire, ambiguously sexualised or broadly economic. Elusive as its meaning may be, this formulation decisively breaks with patriarchal constructions of 'the riddle of femininity', whereby female identity and sexuality are thought of as inherently mysterious.[11] Its ambiguity instead puts into circulation a range of identifications from the assertive to the flirtatious, while also suggesting that the answer to the question 'what do women (really really really) want' might be other women, sexually or not. If 'zig-a-zig-ahh' is read as an euphemism for the penis or phallus, two diametrically opposed meanings are constructed: desire for the penis, or desire *not* for the penis/phallus itself but for phallic power. *Smash Hits*, a pop culture magazine for teenagers, provided a gloss for potentially confused readers: '...if you were

wondering, a "Zigazigah" is meant to be a "cigar"!'[12] But rather than resolving the issue this prolongs the chain of phallic signification, while also connecting 'zig-a-zig-ahh' to signifiers of male capitalist power, an identification reinforced by subsequent reportage of the Spice Girls brandishing cigars. Over-sophisticated as this discussion may have been, it demonstrates both the ambiguity and the potentially subversive take on heterosexual romance of the lyric. More important than Spice Girls lyrics though, are the contexts constructed for their consumption.

As described above, girl power sloganeering predated the release of 'Wannabe'. In interviews band members such as Mel B and Geri (who was to leave the band in early 1998) articulated girl power as a kind of generalised female collectivity. During the immediate aftermath of the chart success of 'Wannabe', Geri was quoted in *Smash Hits* saying:

> We decided we wanted to be more than a band. We wanted the whole philosophy of the Spice Girls to be like a cult – Girl Power. We haven't invented it – we've just tapped into how girls are feeling. It's like feminism, but you don't have to burn your bra. And the message is: 'You can do what you want – look the way you want – as long as you believe in yourself.'[13]

While heterosexual males are not excluded from this discourse, they are marginalised. Female consumers are addressed in general terms and promised the means to a vague female collectivity. It is interesting to note that its entry qualifications exclude romantic constructions of sexuality. 'Fun, freedom and adventure' in the original slogan might be read either as referencing activity outside sexuality, or as constructing sexuality in terms analogous to the capitalist feminist ideology associated with Helen Gurley Brown, author of *Sex and the Single Girl* (1962) and long-time editor-in-chief of *Cosmopolitan*. In fact, girl power has much in common with what Hilary Radner terms Gurley Brown's rewriting of 'venture capitalism for a specifically feminine subject'.[14] In particular, the Spice Girls reiterate two of the major elements of *Cosmopolitan*-style capitalist feminism; the emphasis on the double empowerment of the development and articulation of female sexuality coupled with the economic independence associated with a career.[15] Yet, where *Cosmopolitan* prioritises (self-)satisfaction, poise and upward mobility, and is coded in terms of maturity, the Spice Girls' use of sexuality is presented as subversive of patriarchal power and is coded in terms of a refusal of propriety. 'Classic spice moments' listed in various issues of *Smash Hits* and elsewhere include a large proportion of narratives where sexual display or overt sexual behaviour is used as means of assertion and subversion. There are stories of streaking in hotel corridors, of flashing at 'middle-aged businessmen', of intimidating men by exposing breasts, of attempting to remove the trousers of the two male hosts of a live Japanese television show.[16] At the filming of a *Top of the Pops* appearance Geri is reported to

have persuaded the 42-year-old rocker/balladeer Bryan Adams to sit on her knee like a little boy. Such narratives are placed alongside accounts of the deliberate embarrassment and humiliation of male stars such as Jon Bon Jovi, Jas Mann of Babylon Zoo, and members of Boyzone and Kula Shaker.[17]

As with their appropriation of the women's magazines ideology of sexual expression, the Spice Girls also revisit the aspirational self-help ethos of Gurley Brown and *Cosmopolitan*. The 'message' articulated by Geri above that 'You can do what you want – look the way you want – as long as you believe in yourself' is echoed in many interviews and media appearances. The brief history of the Spice Girls published in *Smash Hits* offers a powerful myth of self-empowerment. According to this account, the members of the group were originally brought together by a 'manager...with a masterplan', who was subsequently ditched by the women acting collectively to resist his attempts to mould them – a tale that was retold in the following year, during the publicity campaign for the movie and second album, *Spiceworld*.[18] Whatever the truth of this story, it nevertheless stands as a myth of women becoming cultural producers by taking control of their own representation, which has implications both for cultural production and more widely.

A typical articulation of girl power as sisterhood is made in the opening pages of poster magazine *Hotshots!* After a summary of their chart successes, the introduction goes on:

> But the best thing about the Spice Girls is the girls themselves...the Spice Girls are the switched-on best mates every teenage girl dreams of. Always there for you, telling you to wear what you want, go where you want, be what you want...Tank girl meets Tiffany Eastender, the Spice Girls are the living embodiment of Girl Power. Your boyfriend says your skirt's too short, tell him to get lost! You want to be a singer and a dancer? Then get going, girl! You don't have to be Madonna, you just have to be yourself....Which is why the Spice Girls have been on the covers of everything from Smash Hits to NME to Elle. Not to mention every tabloid newspaper going. They're fascinating because they're not fake.[19]

While in many ways this discourse derives from the standard teen magazine, there is some pressure on the heterosexual economy of such material. The emphasis on emulation as well as inspiration does imply the supersession of heterosexual romance structures by female solidarity. Albeit superficially, the passage engages with style politics via power over dress and with the economic context of careers. Unlike in the capitalist feminism of mainstream women's magazines, the ideology of girl power links notions of emulation, of do-it-yourself, with notions of female solidarity. However, in the vast majority of cases, magazine features on the Spice Girls construct their emulation directly in terms of commodification. Features that promise to show how to 'Transform Yourself

into a Spice Girl' have much to say about make-up and little to give in the way of career advice.[20] These modes are almost exclusively orientated around patriarchal heterosexual constructions of femininity in terms of the to-be-looked-at. The commodified forms of emulation offered time after time under the rubric of girl power do not so much challenge patriarchal cultural and social structures as defer them. Given this, it may be asked if the notion of girl power is simply a marketing scam, that, like the capitalist feminism of mainstream women's magazines, appropriates ideas from feminism in the service of consumption, leaving patriarchal culture and power structures unchallenged.

Certainly, girl power is structured by its commodification. Its fragmentary and gnomic articulation on music packaging (the 'wanted' slogan quoted earlier and the similarly styled material on the insert of the debut album, *Spice*) is determined by needs for immediate appeal, and to open it to multiple readings and hence widen possible markets. At the same time its vague promise works to pique the curiosity of consumers and to prompt further acts of consumption, of music, or of magazines that promise to image and to explain girl power in more detail. By one set of criteria this could be read as liberating. Having given young girls the confidence that comes from collective membership they are allowed to develop in individual ways. As exemplified above, members of the group often articulate a wish to inculcate this kind of confidence. But the determination of modes of emulation by commodification, and the elusive and slippery nature of girl power determined by the need to interpolate the maximum number of potential consumers (including boys) undercuts such developments. Nevertheless, and especially in their authorised and official products, the Spice Girls can also be read as producing new and liberating interventions in culture via acts of consumption, along the lines described by critics such as Angela McRobbie and Elizabeth Wilson.[21]

It is important here to reconsider in more detail the meanings circulated by representations of the group and the modes of consumption that they set up. In many ways these differ from the dominant ways in which women are represented as pop performers and in women's and girls' magazines. The most striking aspect is the eschewal of the star fetishism and glamour usually associated with such representations. They are a girl band, there were five of them, since reduced to four, and there is no lead singer or other obvious leader. From the beginning then they pluralise femininity and make it difficult to fix on an essential gendered identity. It means also that photographs of the group are predisposed to disrupt the singular focus of fetishism. In practice this is taken much further, such that the group are often shown in motion, exchanging looks, or in other ways in a dynamic relation, and very rarely in static or in passive poses. The video for 'Wannabe' narrativised female collectiveness by dramatising what looks like a gentlemen's club or an upmarket hotel being taken over by the Spice Girls *en masse*. The beginning and ending of the video, featuring the group on a city street at night, from which at the end they board a bus, constructs them as proletarian females. The group follow some wealthy

boy children into the club/hotel, and proceed to take over this space by dancing and athleticism. While individual group members are occasionally spatially related to men, the focus throughout is on the inter-relations among Spice Girls. The form of the narrative, in what looks like one long take with no cuts, presents in terms of fun, safety and spontaneity the power of group collectiveness to take over space previously dominated by men.

In addition, the individual band members are renowned for looking ordinary. In a somewhat grotesquely laddish television spot, the comic David Baddiel has likened the Spice Girls to 'somebody you might see in Tesco's and think, "Oh, she's very attractive – for someone who works in Tesco's" '[22] There is a roughness to their individual and collective appearance that punctures the glossy surface of conventional representations of women. This roughness is further inflected by individual members of the group, who sport tattoos and piercings of the tongue and navel.[23] Mel C, nicknamed 'Sporty Spice' is perhaps the most transgressive in terms of traditional notions of pop femininity. Her high kicks are reconstrued from the discourse of choreography into those of sport, in terms of fitness and football (she is said to have played for Rickmansworth ladies football team and she is usually shown wearing sports leisure gear, including the replica kit of Liverpool FC).[24] In addition, Mel C is also often photographed with the band of an expensive brand of men's underwear visible around her waist, a look appropriated from solo boy artist Marky Mark.

This roughness distinguishes the group from established female artists who make strategic use of images of femininity, such as Madonna. It is no coincidence that Madonna is mentioned in the passage quoted above from the *Hotshots!* poster magazine. There, Madonna is constructed as a fetishistic icon, serving by contrast to point up the notion that the Spice Girls are basically ordinary and therefore can be emulated. Although Madonna, like the Spice Girls, articulates a form of the *Cosmopolitan* gospel of sexual empowerment for women, in many ways Madonna's pop persona works very differently. Both Spice Girls and Madonna play with the dichotomy between one-dimensional images of femininity and the sense of a producing presence behind them, but with very different results.[25]

Laurie Schulze, Anne Barton White and Jane D. Brown have described how Madonna's deliberate refusal to maintain patriarchal culture's dichotomy between virgin and whore has been read in antithetical terms, eliciting praise and vituperation from different audiences.[26] I would like to suggest that audiences' readings of Madonna as a cultural producer of her own image are also dichotomised. The continual promise of and deferral of self-revelation in her film *Truth or Dare* and book *Sex*, and Madonna's interpolation of herself as a conscious artist (a discourse elaborated within and around the same productions) function to frustrate attempts to read 'what she is really like' from the images she produces of herself. The result is that consumers read Madonna according to one or other term of a basic dichotomy. Either she is conflated

with her image, a construction often identified negatively, or Madonna is regarded as a prolific and self-conscious cultural producer (for which she can be celebrated or loathed). In the case of the Spice Girls, however, for a number of reasons this relationship is much less clear-cut.

First, as I have argued, the images of Spice Girls do not have the glossiness of those of Madonna. Second is the issue of the double-naming of members of the group. Each of the Spice Girls is known by her Christian name with an initial to differentiate the two Mels: Victoria, [Geri], Emma, Mel C and Mel B. But they also have semi-playful 'Spice' names: respectively Posh Spice, [Ginger Spice], Baby Spice, Sporty Spice and Scary Spice. The latter set of names help to blur the relationship between the members of the group and their roles as members. They could be read reductively as giving consumers the notion that they 'really know' the band members, but this is frequently frustrated by comments and actions that undermine the self-identification of the name. Thus, Emma 'Baby' Spice's blue belt at karate was publicised showing her working out in her karate gear, while elsewhere *Smash Hits* highlighted her comment that 'I may look sweet, but I wear leather underwear.'[27] At the same time as problematising the 'Baby Spice' identification, this assertion plays the double game of a sexual come-on to the boy readers of the magazine while also working in the discourse of sexual assertiveness discussed earlier. The blurring of their 'real' and representational selves ensures that, despite this level of play, the Spice Girls can be regarded, in the words of the *Hotshots!* introduction, as 'not fake'.

Further, the Spice names are contextualised by reference to the notion of girl power. Unlike Madonna's claims of artistic seriousness, the Spice Girls' self-transformation is authenticated by reference to girl power. The latter sets up the possibility of emulation, while the former is exclusive and solicits admiration for its achievements.

But what are the politics of girl power? The issue of ideological specificity came to a head in what the *Hotshots!* poster magazine called 'one of the strangest stories that tabloids seized on' and to which the second quotation of my epigraph is a comparatively late reference.[28] This was the political debate ignited by a Spice Girls interview published in the Christmas 1996 edition of the conservative weekly, the *Spectator*, under the heading 'SPICE GIRLS BACK SCEPTICS ON EUROPE. Opposition to Labour on tax, rejection of single currency. Important interview by Simon Sebag Montefiore.'[29] Widely reported in the tabloid and the broadsheet press, the interview was generally interpreted as aligning girl power with a 1990s version of Thatcherism. 'We Spice Girls are true Thatcherites', Geri (mis-spelled 'Gerri' throughout the article) was quoted as saying, 'Thatcher was the first Spice Girl, the pioneer of our ideology – Girl Power.'[30] Subsequently, Lady Thatcher was reported as having sent the Spice Girls a Christmas card, and Robert Hardman had no mixed pleasure in gloating over the alleged affiliations of the group in the *Daily Telegraph*.[31]

In fact, for all his evangelistic glee, Montefiore is clearly uncertain quite how

to portray the group. He does report the more overtly feminist and leftist comments of Mel C and Mel B, dubbing the latter the 'Clare Short of the Spice Girls'.[32] What he finds more difficult than their lack of unanimity is their gender, dress and occupation. Hardly a comment is relayed from a group member without some mention of Titian-hair or thigh boots, as if he is happy to find political fellow travellers but cannot take them seriously. In particular, the article's tone swings madly from patronising support to patronising ridicule in an attempt to pull together the binary opposition kept apart in the *Guardian* references with which we began. The parody-Elizabethan summary that '...a Spice Girl may have the thighs and hot pants of a feeble hussy, but she possesses the heart and soul of a Tory country squire'[33] gives quite a good idea of the fractured tonality of the whole piece. The same regard is reproduced in the Heath cartoon that accompanies the article, which caricatures each Spice Girl with exaggerated breasts and, except for the representation of Mel B, whose family is mixed-race, over-large red lips. There are probably several causes for the manifest misogyny of this discourse, though it may not be profitable to go into all of the reasons why the Spice Girls provoked such a hysterical reaction in Montefiore. In part at least he is surprised at their articulacy, astonished that popular cultural consumption can have political resonances, and still more so that they can be appropriated by the right wing of the Conservative party.

But the slipperiness of girl power as represented here does not just emanate from what might be Montefiore's ideological positions and personal hang-ups, and the mismatch between the cultural investments of the Tories and the need of a beleaguered party to have on board any kind of support in the run-up to an election campaign. A very different sense of the group's explicit politics emerged from an interview in the *Big Issue*, published a few days earlier, which mentioned NHS cuts and admiration for single-parent mothers as well as for Thatcher's career, and provoked a debate over girl power and cultural politics in subsequent letters pages.[34] Back in November 1996, the *Independent on Sunday* had run a dismissive and rather ill-informed piece by Eleanor Bailey that also failed to come to terms with the elusiveness of girl power.[35]

The power of the right-wing appropriations of girl power predicated on the *Spectator* interview may in itself be significant. But Conservatives mistake the nature of the relationship between ideology and consumption if they think it can easily be turned into votes. The notion of the Spice Girls as latter-day situationists may be far-fetched, though the unease and inconsistency of Montefiore's article do give credibility to later representations of the interview as a practical joke.[36] Nevertheless, the elusiveness of girl power does open it to political appropriation by the Right, by patriarchy[37] and to commodification. Like the capitalist feminism of mainstream women's magazines that it reworks and revisions, girl power ultimately de-historises feminist politics. This piece is headed by a quotation from the Spice Girls' definition of girl power: 'It's like feminism – but you don't have to burn your bra.' In the last instance, the most significant aspect of this comment may be its innocence of its own history.

What turns out to have been crucial is the function of the capitalist feminist ideology of self-help in the construction of girl power. Ironically there is an alternative tradition of empowerment that has been configured by some girl groups to produce a more dynamic synthesis of feminist ideas and popular music, a tradition best known by the label 'riot grrl'. Long after mass media pronounced the end of riot grrl, groups of women such as Tribe 8 (on Alternative Tentacles) and International Strike Force (on the British independent label Slampt), cross the punk tradition of do-it-yourself with a feminist take on mass popular culture.[38] ISF's début LP, *Romance for Every Mood*, comes with an insert referencing the photo-stories and fashion tips of teen magazines, and features a cover version of Take That's 'Whatever You do to Me' and a song about romancing another Take That idol, Robbie Williams. Albeit to a much smaller and older audience, ISF couple an ironic take on mass culture for girls with a corrosive deconstruction of patriarchal gender configurations. As the chorus of the LP's first track goes, with appropriate increase in volume and shift of tone, 'I was a little girl – AND NOW I'M A MAN.'

Postscript: 'Am I always going to be Baby Spice even when I'm thirty?'

Since this article was conceived and written much has happened in the collective life of the Spice Girls and in the lives of the individual band members. The group's productions have widened to include not only cultural artefacts from dolls to the 1997 film *Spiceworld*, whose knowing references to the Beatles in *A Hard Day's Night* were almost certainly beyond the vast majority of its viewers, but also performances such as kissing the Prince of Wales and pinching his bottom, and singing at the launch of a new British terrestrial television station, Channel 5. At the level of pop music history with which I began, the Spice Girls seem to have comprehensively displaced Britpop and initiated a youth-orientated genre of (mostly) girl-centred fun pop which remains hegemonic in March 1999. Without the Spice Girls, there would be no All Saints, no B*witched, no Steps, and probably no Billie.

The vitality of 'girl power' has helped to ensure the continued pre-eminence of the Spice Girls in this competitive field. It also holds out the possibility of connecting up the cultural 'feminisation' identified by commentators such as Angela McRobbie, Maria Pini, and Helen Wilkinson's 1995 'genderquake' study for the leftist think-tank Demos, with a politically deployed feminism. In making just this connection, Jeremy Gilbert has identified the Spice Girls with an aspirational woman-centred world-view heavily inflected by economic and cultural globalisation and the growth of the service sector.[39] The importance of this constituency was substantiated by New Labour's unprecedented success in attracting votes from women under thirty-five in the 1997 general election. As Gilbert points out, the Spice Girls are important here because they articulated demands for 'what I/we want', which are capable of being elaborated in the

political sphere.[40] Yet even from this perspective Spice Girls' material remains problematic in its channelling of desire in its broadest sense into fantasy and the pleasures of consumption. Spice Girls fan-dom considered as a multi-cultural, cross-generational female communality might work as a partial corrective to this. What is more interesting though is how, since the group's breakthrough, the lives of the band members themselves have become increasingly readable as demonstrating the inability of either the commodity economy or romance to accommodate full self-actualisation.

The most obvious example here is that of Geri Halliwell, who 'in real life' had to leave the band in order to reclaim her full name, dress down, and become a UN ambassador. In addition, the pregnancies and marital arrangements of Mel B and Victoria signalled adult responsibilities which firmly distanced their 'real life' selves from their performances as Spice Girls. With Mel B and Mel C having number one hits singing outside the band, Emma's question in *Spiceworld* gains added poignancy. Querying the viability of playing herself as Baby Spice forever, Emma's line also suggests that a total reliance on the commodity economy, as on the deployment of sweet and charming femininity, makes for infantilisation.

Their real-life narratives of maturation have undermined a major element of the Spice Girls' appeal. Where the playful and the serious had mixed in group activities and group personae, the realms of business and pleasure have become increasingly separated. As a feature in *OK!* magazine put it, the success of side-projects such as Mel B's duet with Missy Elliott 'simply showed Girl Power in action – the band are strong as a group *and* strong enough to allow individual members to pursue projects without weakening the fab four as a whole.'[41] What was at stake here was less the fragmentation of the group and the individuation of its members, than the fluidity of movement between group-personae and real selves. Whereas at first the performativity of being a Spice Girl bridged the professional and personal, maturation narrowed down performance and distanced it from personal identity. The film *Spiceworld* and its accompanying book can be seen to be pivotal in this respect. The film proliferated the hall-of-mirrors effect of the Spice Girls playing themselves. Kim Fuller's script took the form of a week in the group's existence. According to the book of the film, Fuller based the characterisations on his personal knowledge of the girls themselves, by whom the script was rewritten and reworked in advance and on location. Yet for all the ludic pleasures of self-performance in the film, the book of *Spiceworld* begins with serious consideration by each Spice Girl of her film role in terms of the authenticity of self-presentation. In the cast list at the end of the book, this seriousness was formalised by dropping character names; forenames are glossed by group members' full names.[42]

These developments are significant for the modes of consumption and the politics of girl power. During the breakthrough period discussed above, the commodified appeal of the group was enabled exactly by putting individual identity into play as performance. In a circular process, the ludic personalities

represented on screen, on paper and on stage were sustained by fantasies and promises of the group's economic success. This enabled a slippage between fantasy and real self-actualisation that ensured that the Spice Girls were understood not as pure play, as mere gender signification, but as mixing playfulness with political and cultural significance as spokeswomen and role models. The persona of Posh Spice enacted and disavowed this process. Her 'poshness' derived not from a class identity but from an aspirational performance; as the *Spiceworld* book states, 'she's not really posh posh';[43] not at least until she's successful. Variegated and multiple as they are, the more recent biographical developments can be read as showing up the limits of the Spice Girls' performance of femininity.

The central problematic here is maturation. At one level, personal sexual and romantic relations, marriage and maternity have been combined quite successfully with the professional activity of band-membership. Mel B and Victoria continued to perform on stage and in public while visibly pregnant without incongruity. What have become more difficult are the slippages between play and seriousness initially opened up and exploited by the Spice Girls' multiple performances of identity. If age is important here, so is class: once the economic success fantasised in the 'Wannabe' video has been realised, the performance of the Spice Girls becomes just a performance. In this sense, 'living through pop' is a peculiarly economically charged activity which, when it comes down to it, few can really afford.

Acknowledgements

I would like to thank the following for their help in producing this article: Jill and Amy Barnes, Andrew Blake, Phil and Anne Davies, Carol Smith and Alasdair Spark.

Notes

1 Dan Glaister 'Spice Girls help set a new record for Britain', the *Guardian* Thursday 13 February 1997, p.9.
2 The *Guardian* 2, Thursday 13 February 1997, p.5.
3 The *Guardian*'s solution to the dilemma of providing a focus for issues of special interest to women without the marginalising and patronising effects of the traditional 'women's page' is to simply by-line the relevant pages 'women'.
4 See A. McRobbie (ed.) (1989) *Zoot Suits and Second-hand Dresses: An Anthology of Fashion and Music*, London: Macmillan; A. McRobbie (1991) *Feminism and Youth Culture: From 'Jackie' to 'Just Seventeen'*, London: Macmillan; A. McRobbie (1994) *Postmodernism and Popular Culture*, London: Routledge; D. Hebdige (1979) *Subculture: The Meaning of Style*, London: Methuen; I. Ang (1995) *Watching Dallas: Soap Opera and the Melodramatic Imagination*, London: Methuen; J. Radway (1987) *Reading the Romance: Women, Patriarchy, and Popular Literature*, London: Verso; J. Fiske (1992) *Understanding Popular Culture*, London: Routledge; J. Fiske (1993) *Power Plays, Power Works*, London: Verso.

5 See J. McGuigan (1992) *Cultural Populism*, London: Routledge; M.J. Lee (1993) *Consumer Culture Reborn: The Cultural Politics of Consumption*, London: Routledge; and C. Jenks (ed.) (1993) *Cultural Reproduction*, London: Routledge.

6 As proudly memorialised in *Smash Hits* 4–17 December 1996, p.22.

7 D. Hebdige (1988) *Hiding in the Light: On Images and Things*, London and New York: Comedia/Routledge, p.29.

8 That I am a thirty-something White male heterosexual neither authenticates this observation nor the reverse, but I am not claiming it as definitive.

9 See Charlotte Greig (1989) *Will You Still Love me Tomorrow? Girl Groups from the 50s on...*, London: Virago, for a critical history of girl groups and a defence of their gender politics.

10 On debates over the meaning of 'zig-a-zig-ahh' see *Smash Hits* 18–31 December 1996, p.16.

11 Freud's articulation of female sexuality remains a touchstone for this problem. The principal references can be found in 'The question of lay analysis', in *Standard Edition of the Complete Psychological Works of Sigmund Freud* vol. XX, trans. James Strachey with Anna Freud, p.212, and 'New introductory lectures on psycho-analysis, lecture 33', in *Standard Edition* vol. XXII, pp.113, 116. See M. Macdonald (1995) *Representing Women: Myths of Femininity in the Popular Media*, London: Arnold, pp.23–5, and Chapter 4: 'Enigma variations', pp.105–31 for accessible critiques of Freud and of constructions of femininity as mysterious in recent popular culture.

12 *Smash Hits* 11–24 September 1996, p.22.

13 'Nice 'n' spicy', *Smash Hits* 11–24 September 1996, pp.19–22; p.22.

14 H. Radner (1993) 'Free enterprise and the marriage plot', in J. Collins, H. Radner, and A. Preacher Collins (eds) *Film Theory Goes to the Movies*, London: Routledge, pp.56–76, p.57.

15 In *Representing Women*, pp.171–3 Myra Macdonald has pointed out that the *Cosmopolitan* version of female sexual liberation owes more to sexologists such as Kinsey than to feminism, but I am retaining the term capitalist feminism in order to reference the complex of sexual and economic power produced to structure the aspirations of readers.

16 *Smash Hits* 11–24 September 1996, p.22; *Smash Hits* 4–17 December 1996, p.22; *Hotshots! Special: Spice Girls Hot Posters!* (1997), London: Dennis Oneshots Ltd, p.14.

17 *Hotshots! Special*, p.14.

18 *Smash Hits* 11–24 September 1996, p.19. L. Elliott and S. Ryle, 'Spice Odyssey', *Guardian*, 2 March 1997, pp.2–3.

19 *Hotshots! Special*, p.3.

20 See for example 'Girl Power! Transform yourself into a Spice Girl with *Shout*'s fab fashion and beauty tips', *Shout* 14–27 February 1997, p.24; 'Shine like a star', *Just Seventeen* 12 February 1997, pp.42–3.

21 See McRobbie texts listed above and E. Wilson (1985) *Adorned in Dreams: Fashion and Modernity*, London: Virago. For a good accessible overview of these positions and the debate surrounding them, see the Macdonald text quoted above, Chapter 7.

22 David Baddiel in conversation with Angus Deayton, *The End of the Year Show*, BBC One, 31 December 1996.

23 Mel C has a prominent celtic band tattoo on one forearm. The pierced tongue of Mel B is often displayed, while Geri's pierced navel and Mel B's stomach tattoos are discussed but not usually seen. Playing the game of sexual assertion, Geri is also quoted as winding up a boy band by telling them a story about obscene tattoos on her buttocks. See *Smash Hits* 4–17 December 1996, p.22.

24 *Hotshots! Special*, p.6.
25 Such practices in film were theorised first in J. Riviere (1929) 'Womanliness as Masquerade', *International Journal of Psycho-analysis* X, pp.303–13. For a sample of the large volume of critical literature on Madonna see C. Schwichtenberg (1993) *The Madonna Connection: Representational Politics, Subcultural Identities, and Cultural Theory*, Boulder, San Francisco and Oxford: Westview Press; F. Lloyd (ed.) (1993) *Deconstructing Madonna*, London: Batsford; L. Frank and P. Smith (eds) (1993) *Madonnarama: Essays on Sex and Popular Culture*, Pittsburgh: Cleiss Press; and F. Pullin and C. Colebrook (1993) 'The New Feminist Dispensation: from Betty Freidan to Madonna', in A. Robert Lee (ed.) *A Permanent Etcetera: Cross-cultural Perspectives on Post-war America*, London: Pluto, pp.43–55.
26 L. Schulze, A. Barton White and J.D. Brown, ' "A sacred monster in her prime": audience constructions of Madonna as low-other', in Schwichtenberg *The Madonna Connection*, pp.15–37; see especially pp.31–4.
27 *Hotshots! Special*, p.14; *Smash Hits* 11–24 September 1996, p.19.
28 *Hotshots! Special*, p.14.
29 Simon Sebag Montefiore 'Spice Girls Back Sceptics on Europe', in the *Spectator* 12–21 December 1996, pp.14–17.
30 Montefiore 'Spice Girls', p.14.
31 R. Hardman, 'Notebook: Lady Thatcher returns the spicy compliment', in the *Daily Telegraph* Thursday 19 December 1996, pp.8, 20.
32 Montefiore 'Spice Girls', p.14.
33 Montefiore 'Spice Girls', p.17.
34 Sheryl Garratt 'Spice grrls', *Big Issue* 16–29 December 1996, pp.14–19.
35 Eleanor Bailey 'Girl power – who's buying it?', the *Independent on Sunday* Real Life section, 24 November 1996, p.3.
36 *Hotshots! Special*, pp.14, 16.
37 As for example elsewhere in the Deayton/Baddiel exchange quoted above, which focuses on which band member Baddiel wants to 'shag'. Whatever the possibilities opened up for female-centred and feminist readings, clearly the Spice Girls are fairly easily recuperable to the gaze of male power.
38 Alternative Tentacles products are readily available. Slampt records are distributed by SRD. At the time of writing, Slampt can be contacted by sending a stamped addressed envelope to PO Box 54, Heaton, Newcastle Upon Tyne, NE6 5YW.
39 A. McRobbie, '*More!* New sexualities in girls' and women's magazines', in A. McRobbie (ed.) (1997) *Back to Reality? Social Experience and Cultural Studies*, Manchester: Manchester University Press, pp.190–209; M. Pini, 'Women and the early British race scene', in McRobbie (ed.) *Back to Reality?*, pp.152–69; H. Wilkinson (1995) *No Turning Back: Generations and the Genderquake*, London: Demos; J. Gilbert, 'Blurred Vision: Pop, populism and politics', in A. Coddington and M. Perryman (eds) (1998) *The Moderniser's Dilemma: Radical Politics in the Age of Blair*, London: Lawrence & Wishart, pp.75–90.
40 See Gilbert, 'Blurred Vision', pp.84–5.
41 'Spice Girls: Fab Four talk exclusively to *OK!* about "the split" ', *OK!* 130, 2 October 1998, p.8.
42 *Spiceworld*, dir. Bob Spiers, UK 1997; *Spiceworld The Movie By the Spice Girls* (London: Ebury Press, 1997), pp.9–20, 96.
43 *Spiceworld The Movie...*, p.18.

INDEX